Alexi Lubomirski

diverse beauty

Preface by Lupita Nyong'o

Design by Takaaki Matsumoto

DAMIANI

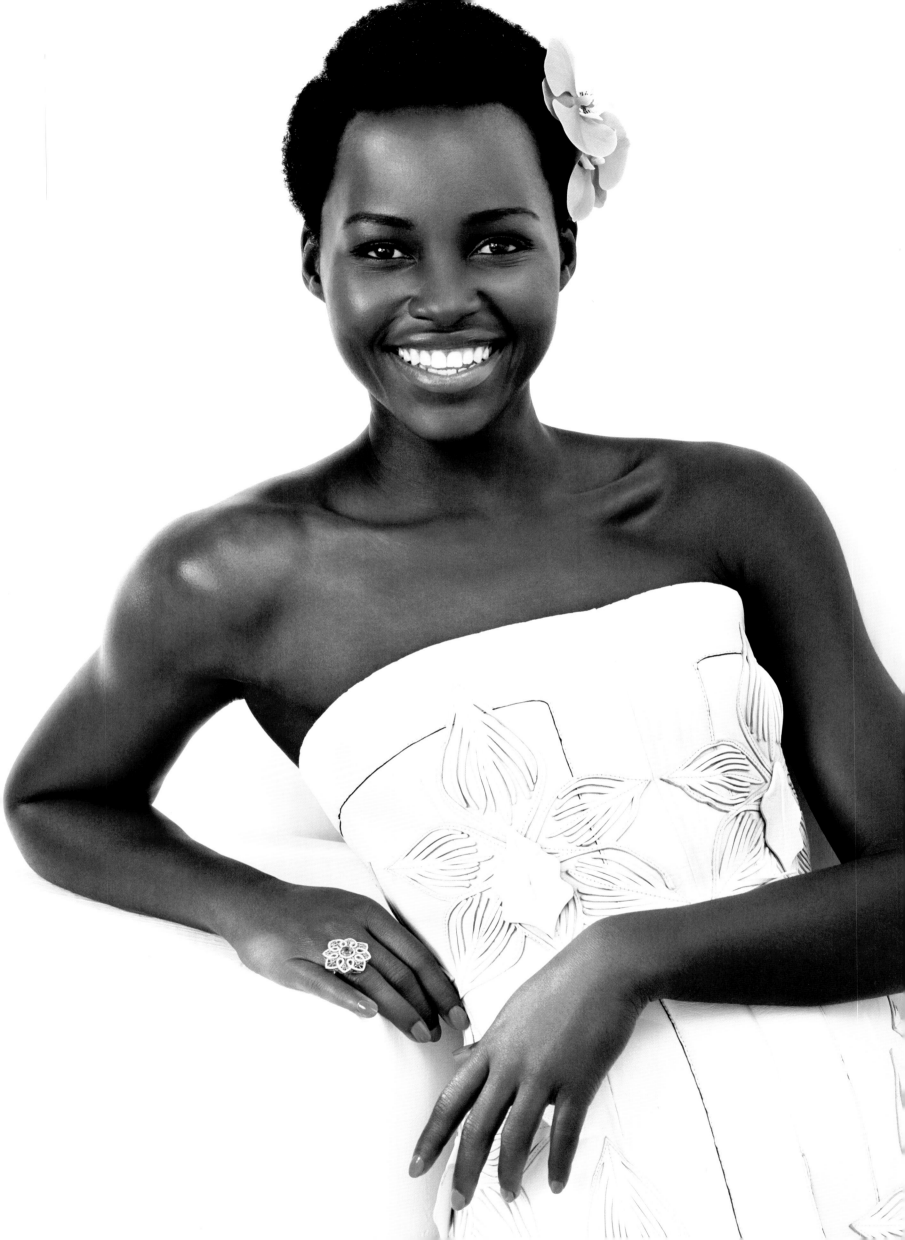

PREFACE

When I first heard Alexi Lubomirski was working on a project that was inspired by me in some way, I was deeply moved. I have worked with Alexi on a handful of projects, and every time it has been rejuvenating. You see, the thing about a photo shoot is, in the right hands, it can be a very life-affirming process because you feel *seen*.

Now, not every photographer and subject have great chemistry. The first meeting can be a lot like a first date, with a wide margin for potential awkwardness and odd little ice-breakers. It can be a very vulnerable experience, and you never know how you're going to connect with a new photographer, or what he might bring out of you. With Alexi, however, his warm and generous spirit was immediately knowable. From the moment I walked into the room, I felt his presence permeating the space with not only joy but an intangible sense of something shared. When Alexi greeted me, I could sense in him an intense curiosity but a calm core. He was interested but at ease. And moments later he was gushing to me about his beautiful wife and kids, showing me picture after picture, inviting me as much into his life as he was about to peer into mine.

Alexi's shoots are always joyful because he imbues them with his spirit. He plays great music, encourages you to dance, and he will always dance too, in tandem to your movement. He lets you know through his actions "We're in this together." Every time I am his subject, I know he is interested in who I am rather than who he needs me to be.

This is a beautiful and rare thing. Alexi is in many ways a gatekeeper in the fashion industry; his very job is to direct a lens onto beauty and hold up a definition for the world, but he is also determined to have his subjects own their stories. I remember seeing the pictures from our first shoot and thinking "That's me—that's me in very good lighting!" He had seen me and allowed me to show myself.

I am so thrilled by this project. I think of myself when I was a child and how impactful a book like this might have been, how impactful this will be now for people around the world. Alexi is changing the visibility and definition of beauty ideals, not just by finding a variety of subjects, but by seeing them through his unique heart. In Alexi's eyes, we all have a beautiful story to tell.

Lupita Nyong'o

You are beautiful.

When you look in the mirror
I hope you see what I see . . .

I see the glory of the world
and its intricate tapestry.

When you see yourself as different,
I see you as brilliantly unique.

Each curl, freckle, curve and hue
are dazzling rays, shining from within you.

The shape of your eyes, color of your skin
and texture of your hair,
are the accents that define this radiance.

Your beauty is not just what you see in a photograph.
It is your smile, that mirrors your heart
and your warmth, that fills others with joy.

Those same people that misunderstand your look today
will be the same that laud it tomorrow.

So, do not be swayed by their opinions of you.
They will change as often as the shifting winds.

Know in your heart, that you are beautiful.
And that no one else has shone like you do today.

—AL

For Giada

INTRODUCTION

The idea for this book came about for two reasons, and they both involve Lupita Nyong'o.

First, I had shot her a few times and was struck by her beauty inside and out. It was a beauty that I had only experienced a few times in my photographic career. One where, instead of her being a subject that needed light to be shone on her and shot from a particular angle, she actually beamed light from within.

She was also a natural beauty. When I say natural, I mean that I believe that what was in front of me was essentially "her." She was a beautiful African woman who had not been, and was not willing to be, "whitened" to fit into the normal beauty paradigms, either by straightening her hair or lightening her skin. She even made a point of asking me not to lighten her skin in post-production, as she had unfortunately experienced this in the past.

Looking at the pictures taken from those first few shootings, I realized how rare it was that I got to take pictures of beautiful African, Asian, Indian, or Latin women. Whenever I submitted a list of models who I wanted to work with on assignments, the African and Asian women (or any "diverse" look) were the first to be pushed off the list. "We love her, but . . ."," too dark . . .", "too light to make a statement . . .", "her hair is a problem . . ."," too many freckles . . .", "too ethnic . . ." The list would go on, and we would end up shooting a "safer" Caucasian girl.

I decided that I wanted to make a body of work that represented a more realistic spectrum of beauty than what the fashion industry typically presents to us.

I wanted to celebrate beauty in fashion, with no boundaries or limitations, and to put every type of beauty on a pedestal. If a girl was "too freckly," I wanted to flip it and celebrate her freckles. If her hair was "too wild," I wanted to celebrate her hair. If she was "too quirky," I wanted to celebrate her uniqueness.

The second reason that I wanted to complete this book was again because of Lupita. Someone showed me her speech at the Essence awards, where she described how in her youth she never saw anyone in magazines that resembled her. She spoke about praying every night that she would wake up with lighter skin, but every morning she woke up with the same rich, dark skin and would be left feeling disheartened. Then the Sudanese model Alek Wek came on the scene, and all of a sudden Lupita saw in the fashion bibles someone that looked like her. She suddenly felt that her type of beauty was validated, and her young self was allowed to feel beautiful.

This story touched me deeply as a new father—understanding how society's perception of beauty could have such a profound effect on a young person's self-worth. I therefore wanted to make a book of beautiful fashion images, one that someone could page through and see that beauty can come in a vast range of different shapes, sizes, colors and looks. A book where that same person could find a page and recognize themselves in that photo and feel represented, and if needed, validated. I wanted to push the idea that the more we showed and celebrated different types of beauty, the more this range would just become an accepted norm.

I also wanted to challenge the quick labels that society applies to people, which essentially assign everyone to certain boxes, whether they like it or not: Black. White. Asian. Latin. Gay. Lesbian. Transgender. Albino. Sexy. Edgy. Ginger. Plus-size.

A specialist in this subject, Dr. Sandra K. Chapman, mentioned to me that if you were to ask these people to describe themselves, more often than not, they would never use the words listed above. Instead, they might say: Mother. Sister. Artist. Activist. Scholar. Lover. Poet. So I asked my subjects to describe themselves, allowing each individual to "own" their labels rather than have labels thrust upon them.

The end result of the entire project is just a scratch on the surface of what is a gloriously colorful and textured tapestry of beauty in the fashion world, one that we are all part of but have not yet all fully appreciated.

A. Wren

Crystal Anderson	Michelle Harper	Tasha P
Bianca Balti	Salma Hayek	Karmen Padaru
Tyra Banks	Erin Heatherton	Marquita Pring
Hanaa Ben Abdesslem	Carolina Herrera	Cipriana Quann
Li Bingbing	Chaunté Howard	TK Quann
Jerrra Blues	Candice Huffine	Rain
Grace Bol	Rosie Huntington-Whiteley	Lais Ribeiro
Michelle Buswell	Chanel Iman	Maggie Rizer
Cassie	Jetli	Linda Rodin
Pat Cleveland	Rashida Jones	Isabella Rossellini
Shannan Click	Sabina Karlsson	Anja Rubik
Amy Fine Collins	Julie Kauss	Elliott Sailors
Meghan Collison	Liya Kebede	Gabriela Salvadó
Anna Davolio	Philomena Kwao	Olga Sherer
Andreea Diaconu	Padma Lakshmi	Jenny Shimizu
Jourdan Dunn	Robyn Lawley	Ma Sichun
Karen Elson	Jennifer Lopez	Sharika Simpson
Cora Emmanuel	Sessilee Lopez	Arlenis Sosa
Marga Esquivel	Demi Lovato	Iris Strubegger
Isabeli Fontana	Giada Lubomirski	Sunghee
Diandra Forrest	Rhiannon McConnell	Candice Swanepoel
Torraine Futurum	Jaunelle McKenzie	Katrin Thormann
Luca Gadjus	Catherine McNeil	Guinevere Van Seenus
Toni Garrn	Jillian Mercado	Kerry Washington
Bianca Gittens	Coco Mitchell	Lauren Wasser
Saufeeya Goodson	Pooja Mor	Alek Wek
Kris Gottschalk	Carolyn Murphy	Elaine Welteroth
Ashley Graham	Hari Nef	Liu Wen
Bethann Hardison	Lupita Nyong'o	Alees Yvon
Naomie Harris	Nneka Okafor	Jane Zhang

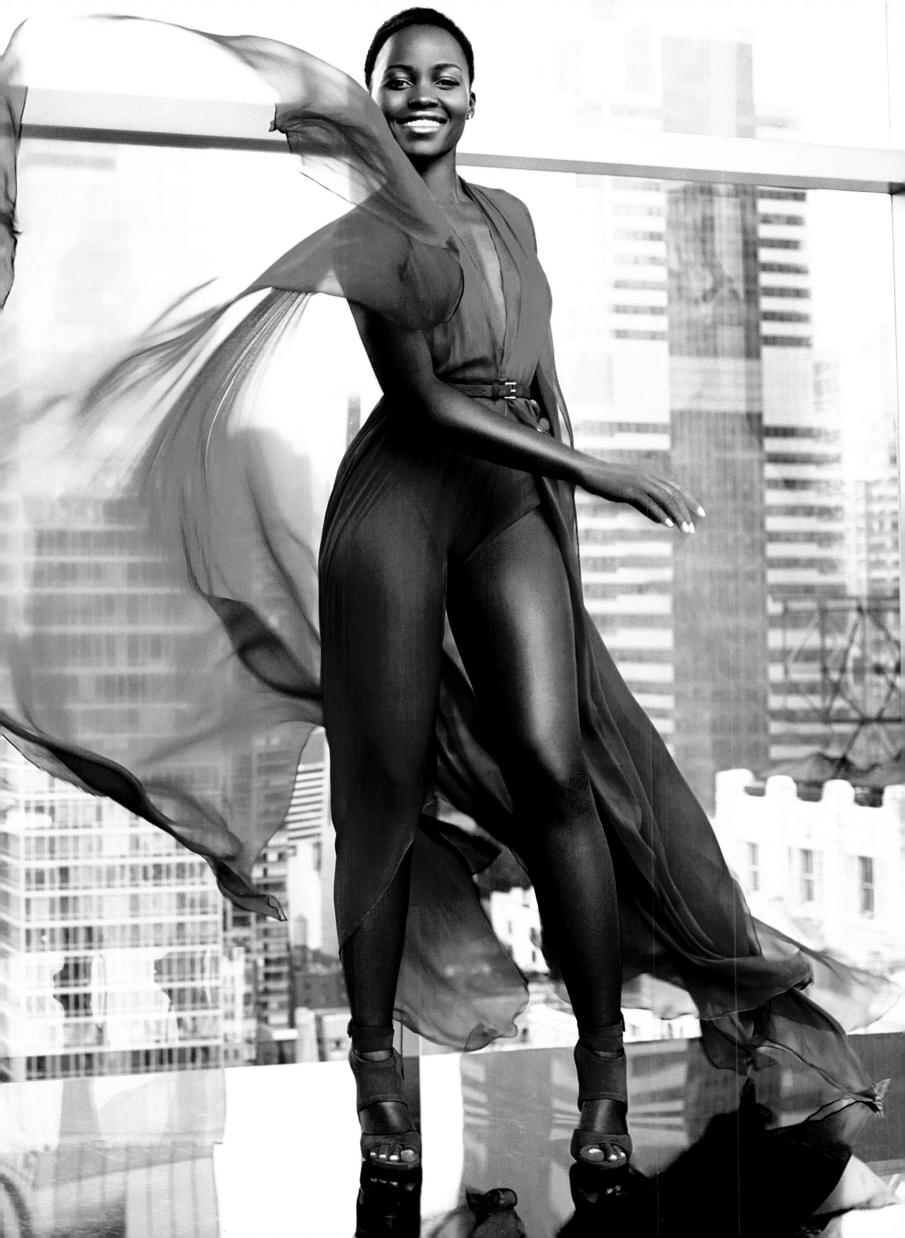

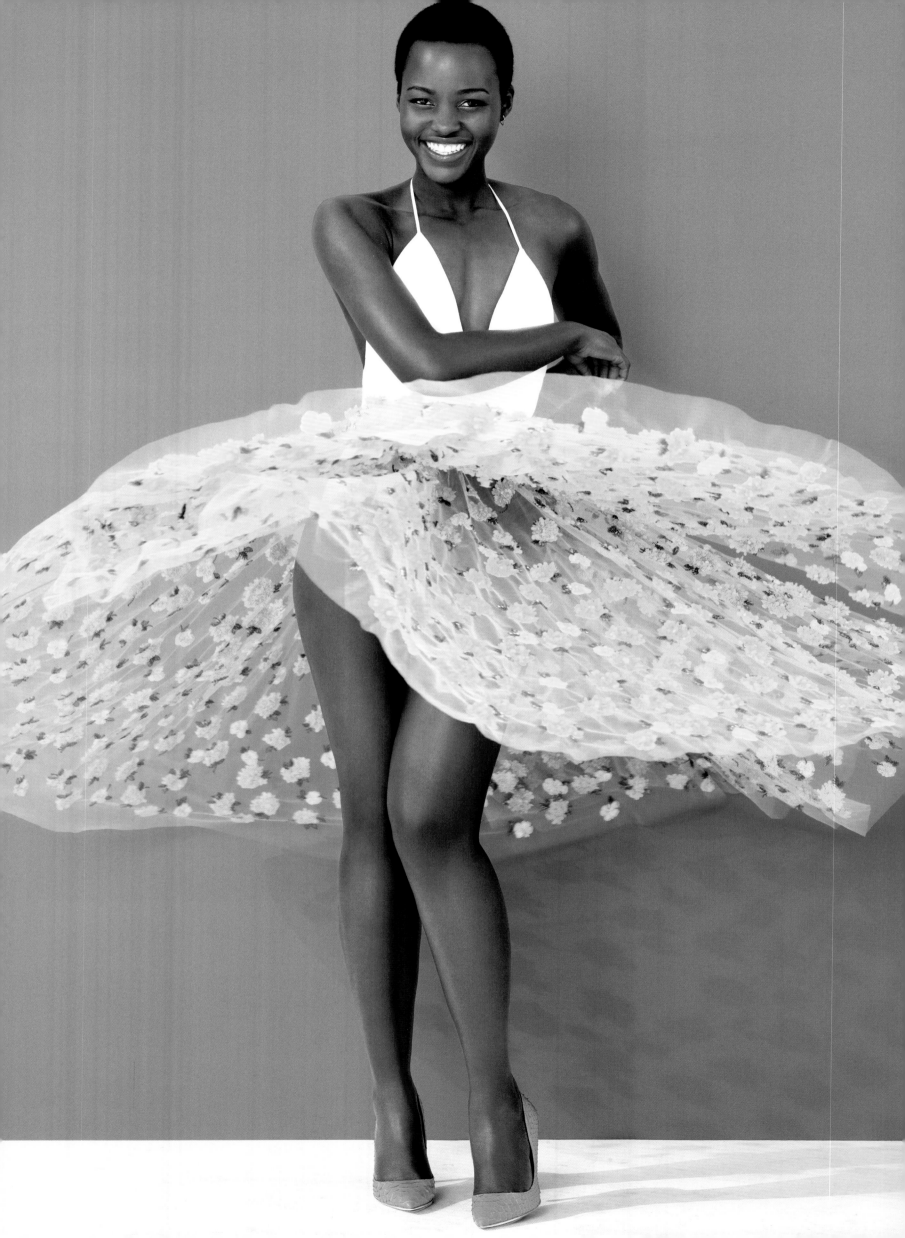

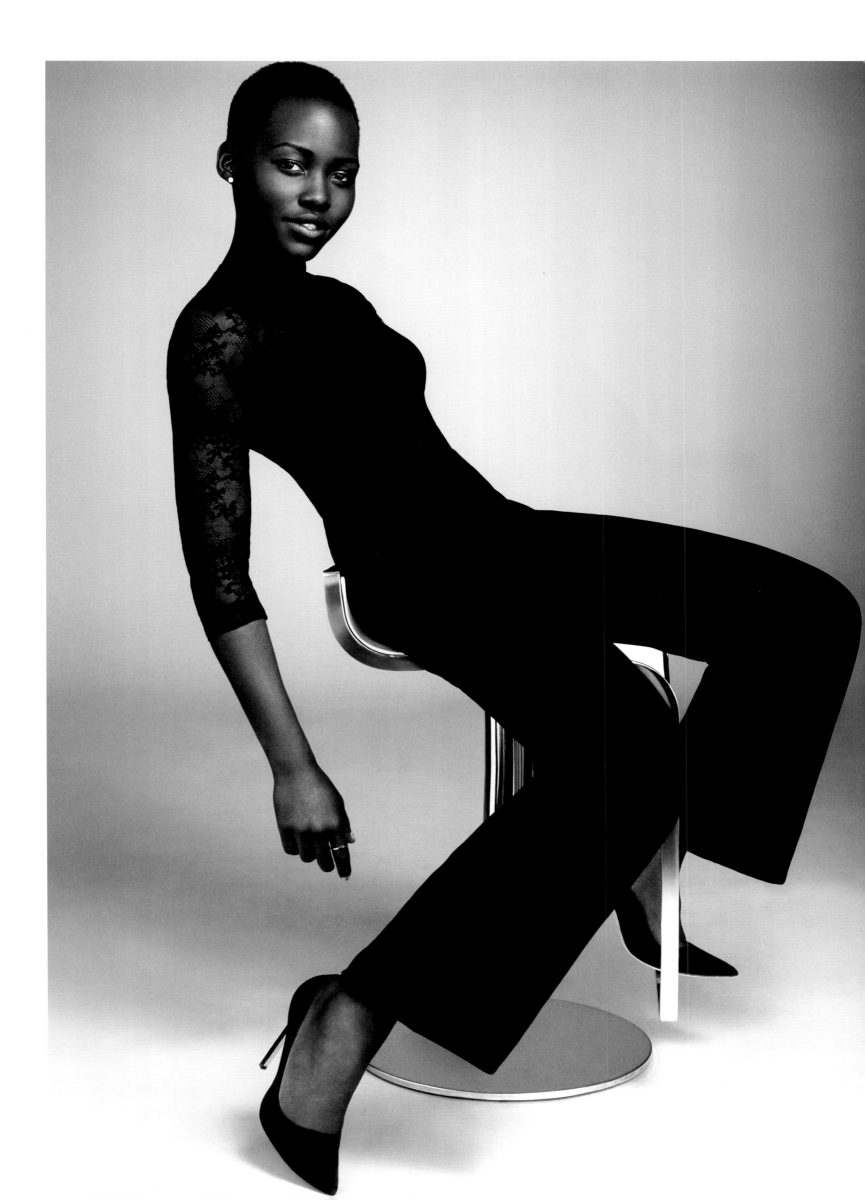

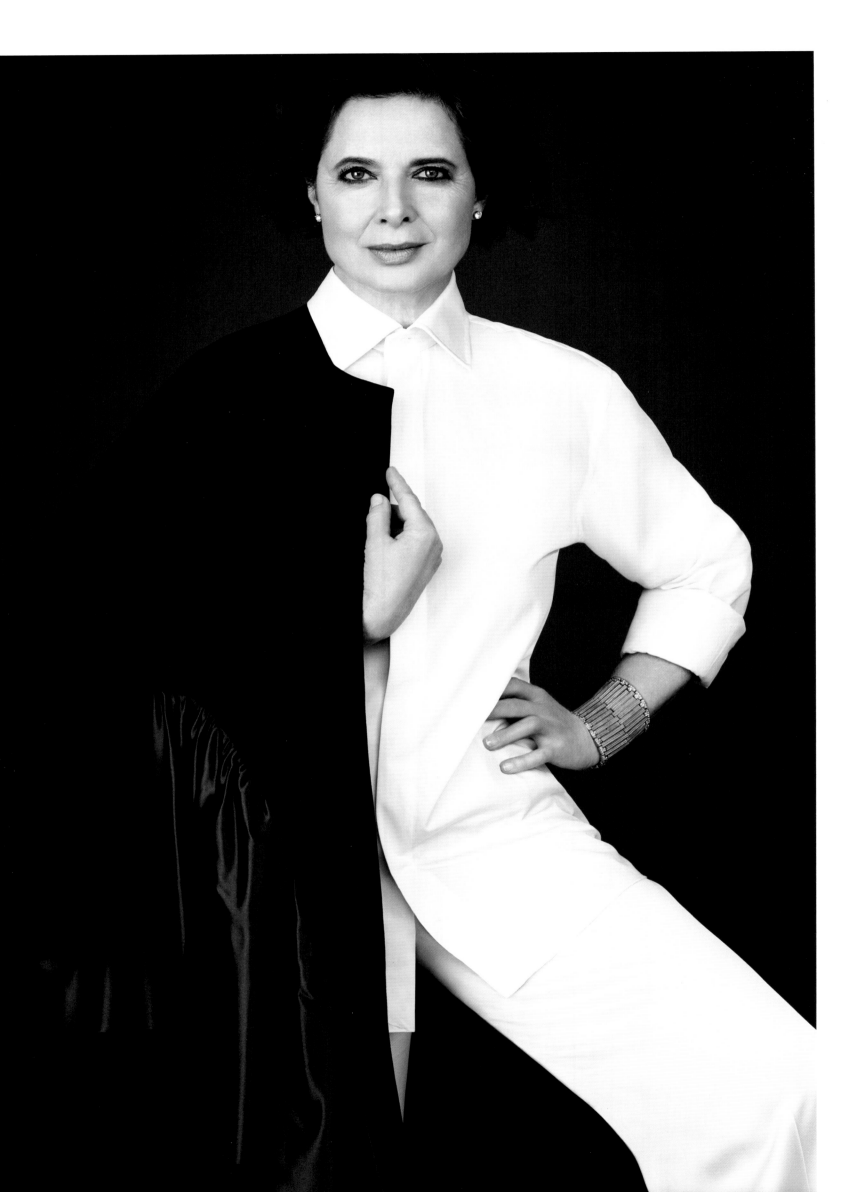

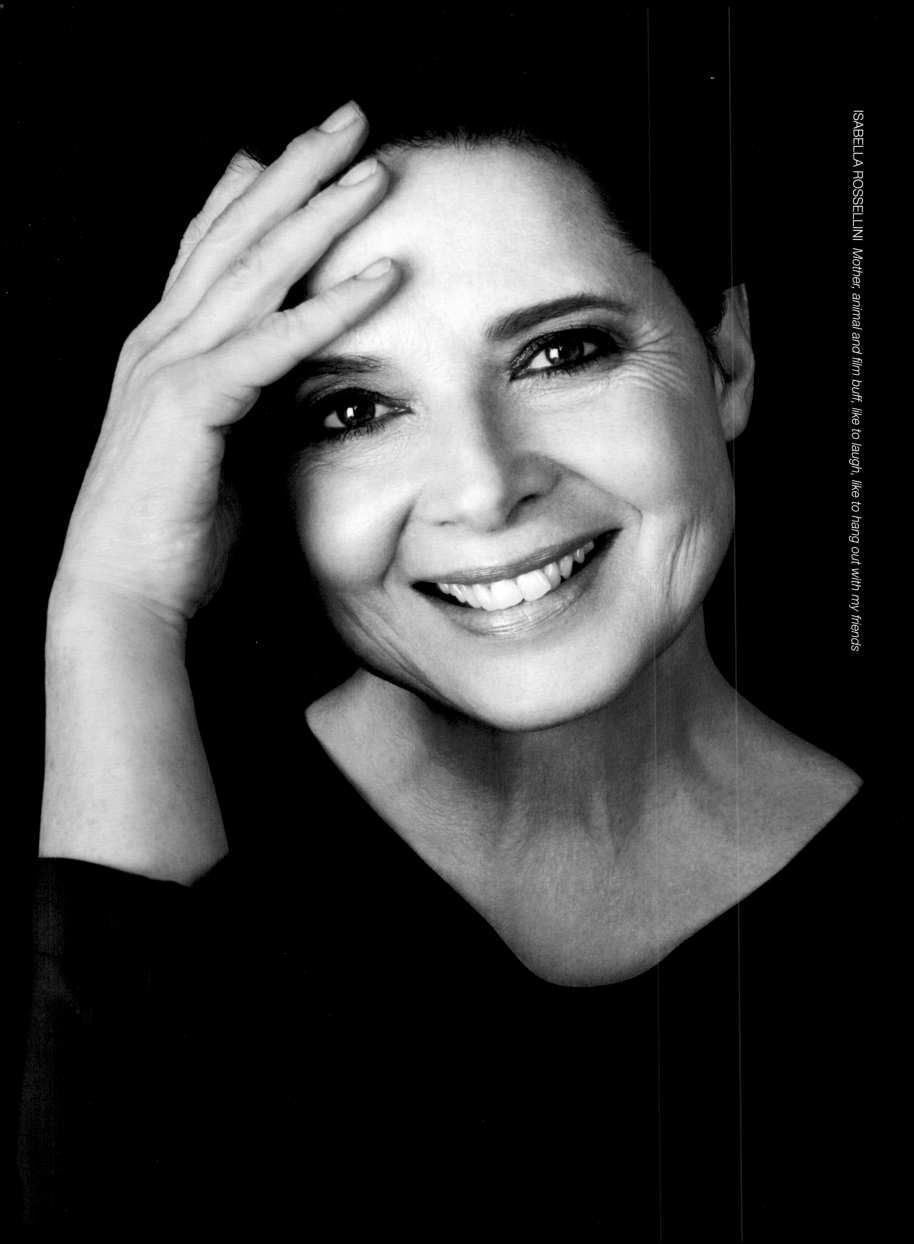

ISABELLA ROSSELLINI *Mother, animal and film buff, like to laugh, like to hang out with my friends*

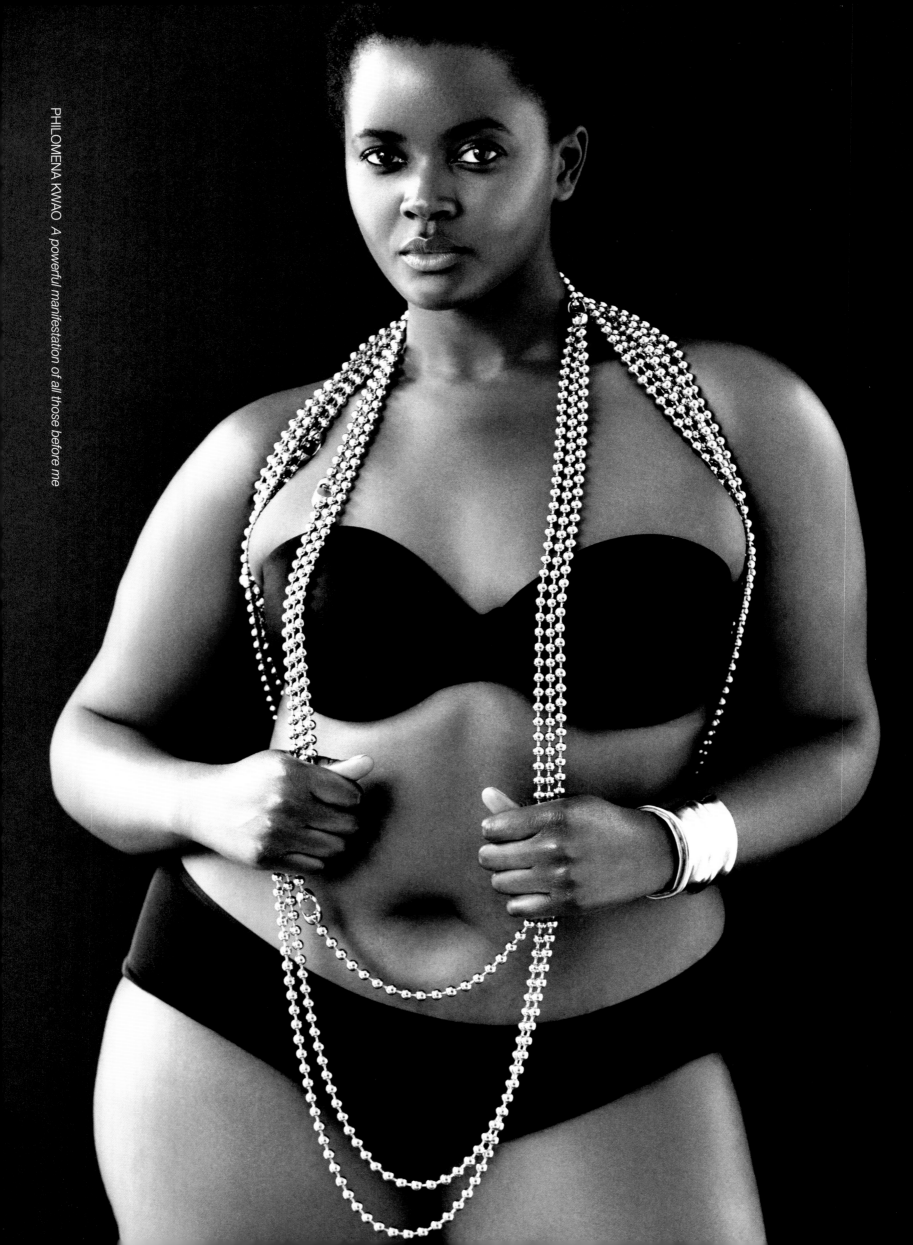

PHILOMENA KWAO *A powerful manifestation of all those before me*

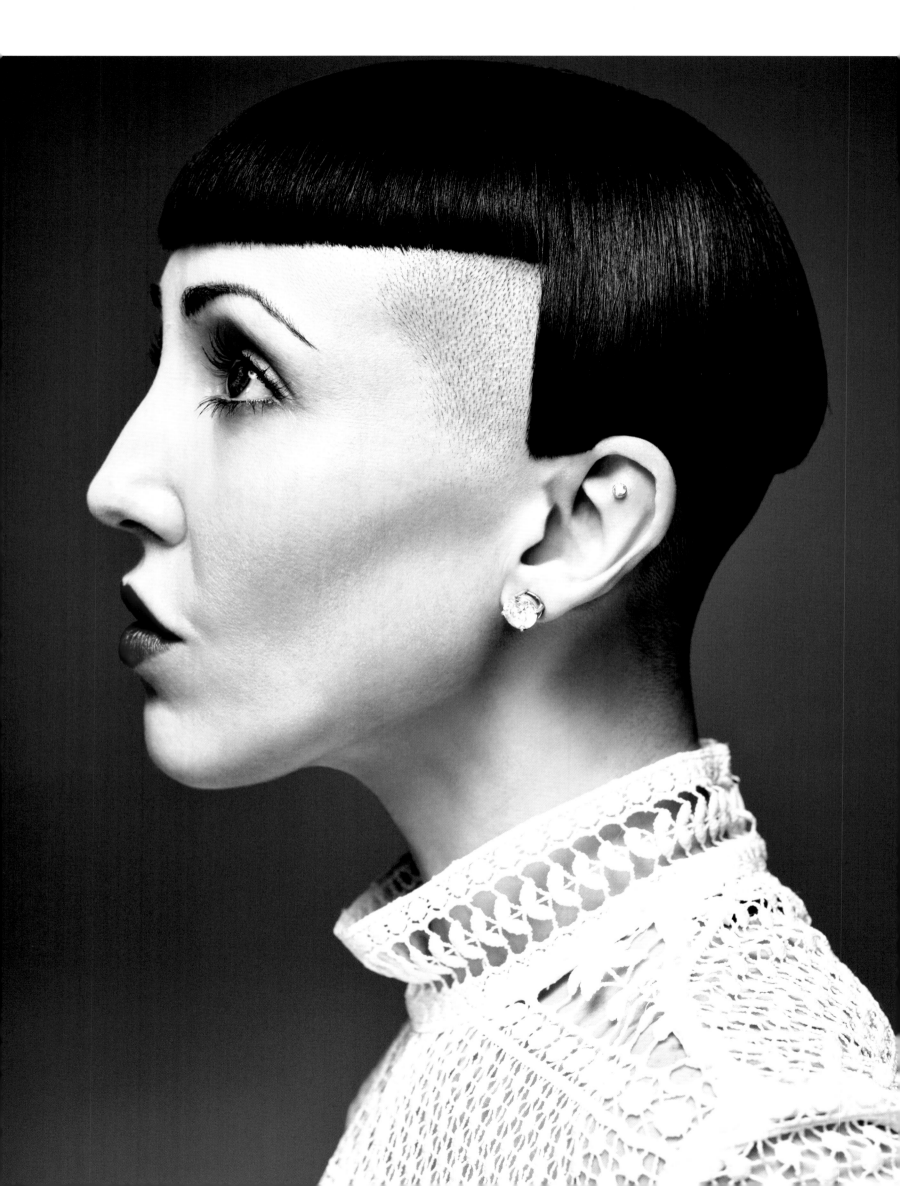

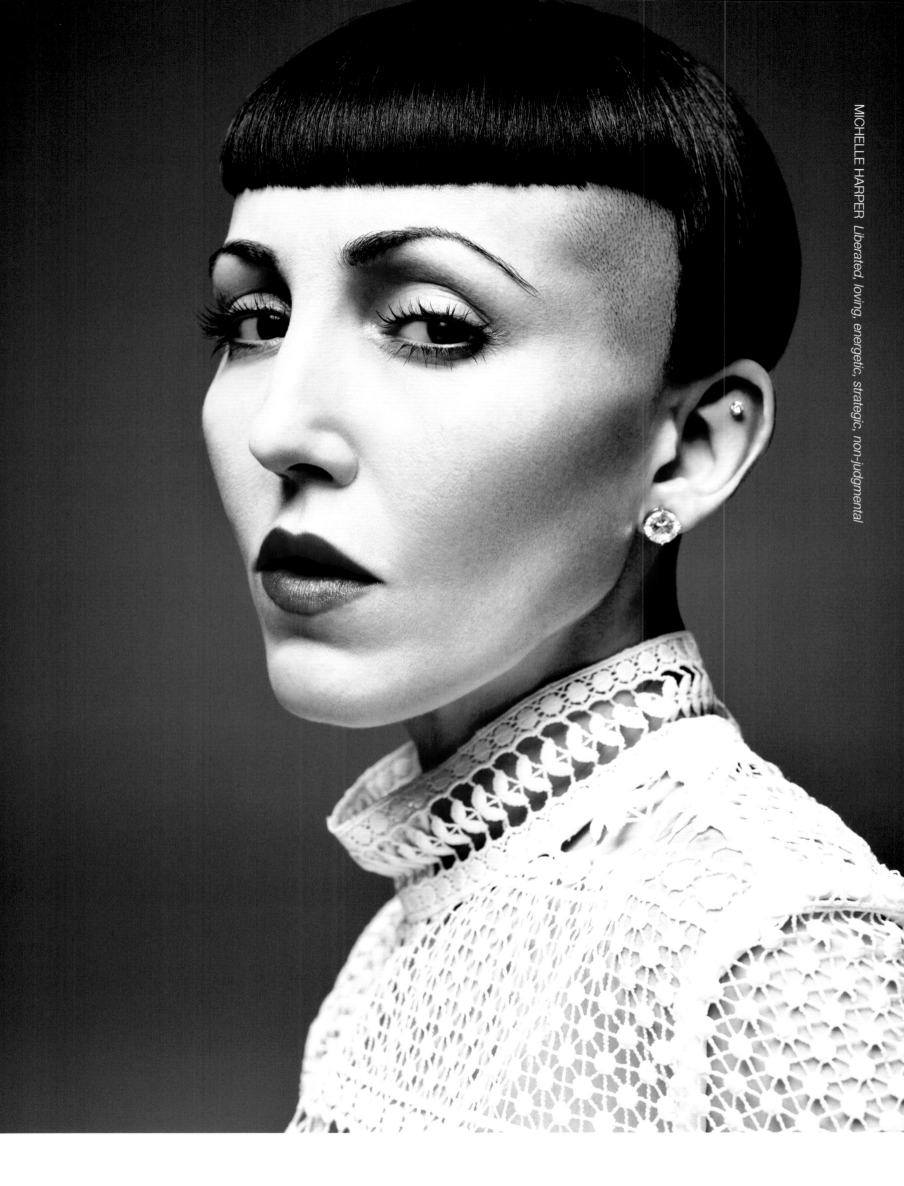

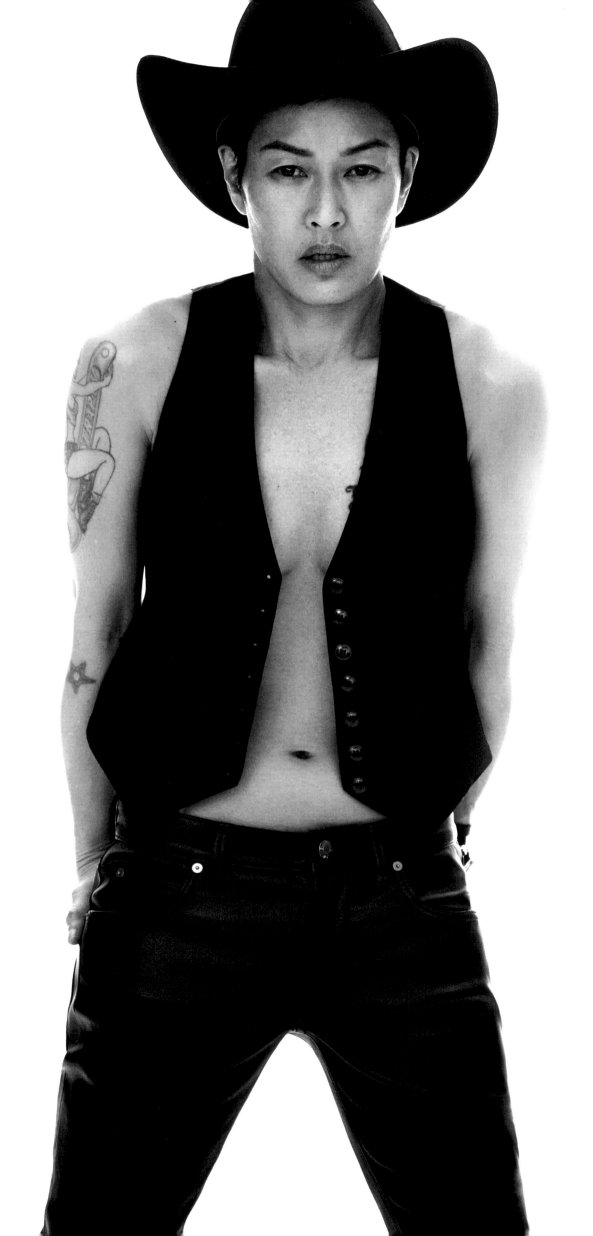

JENNY SHIMIZU *Grateful, highly curious, team player*

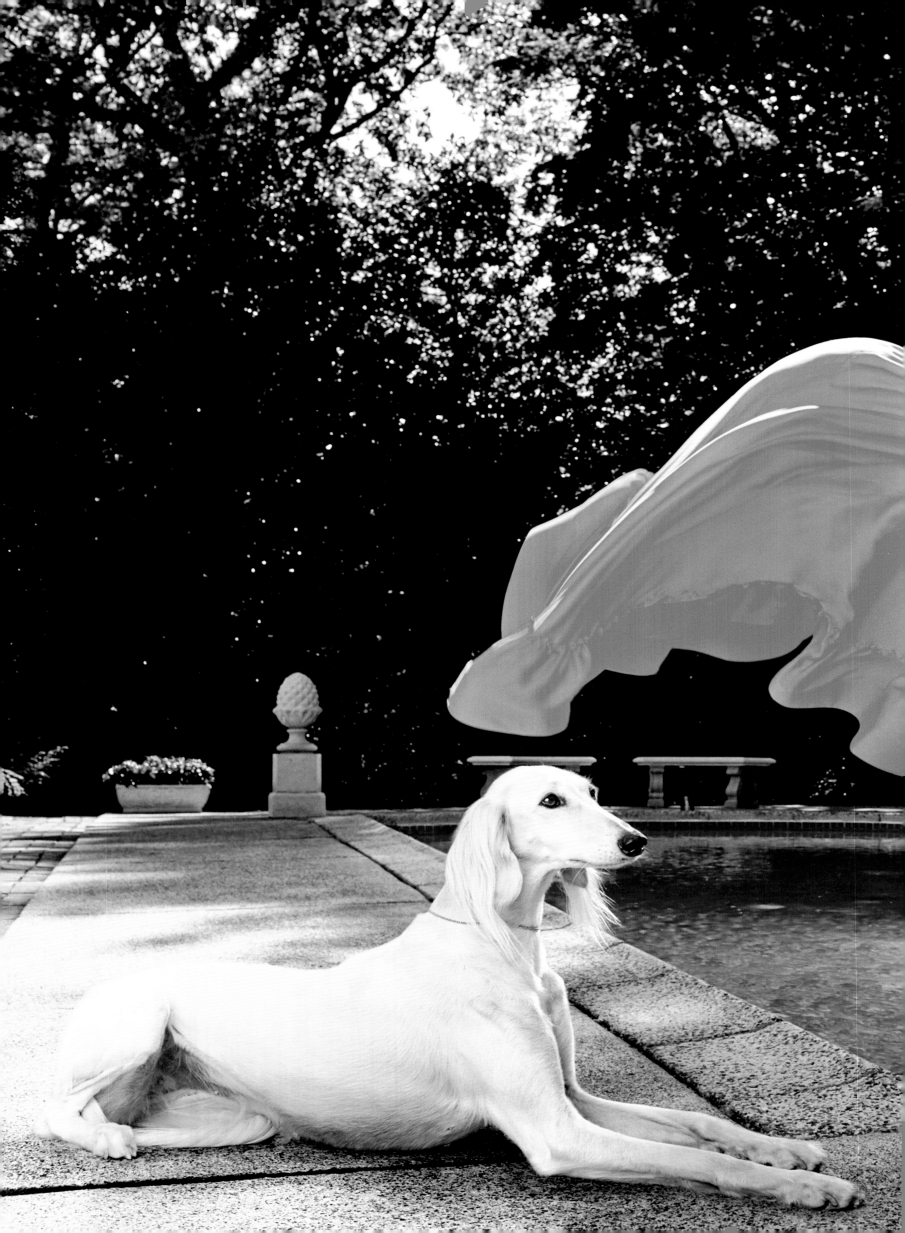

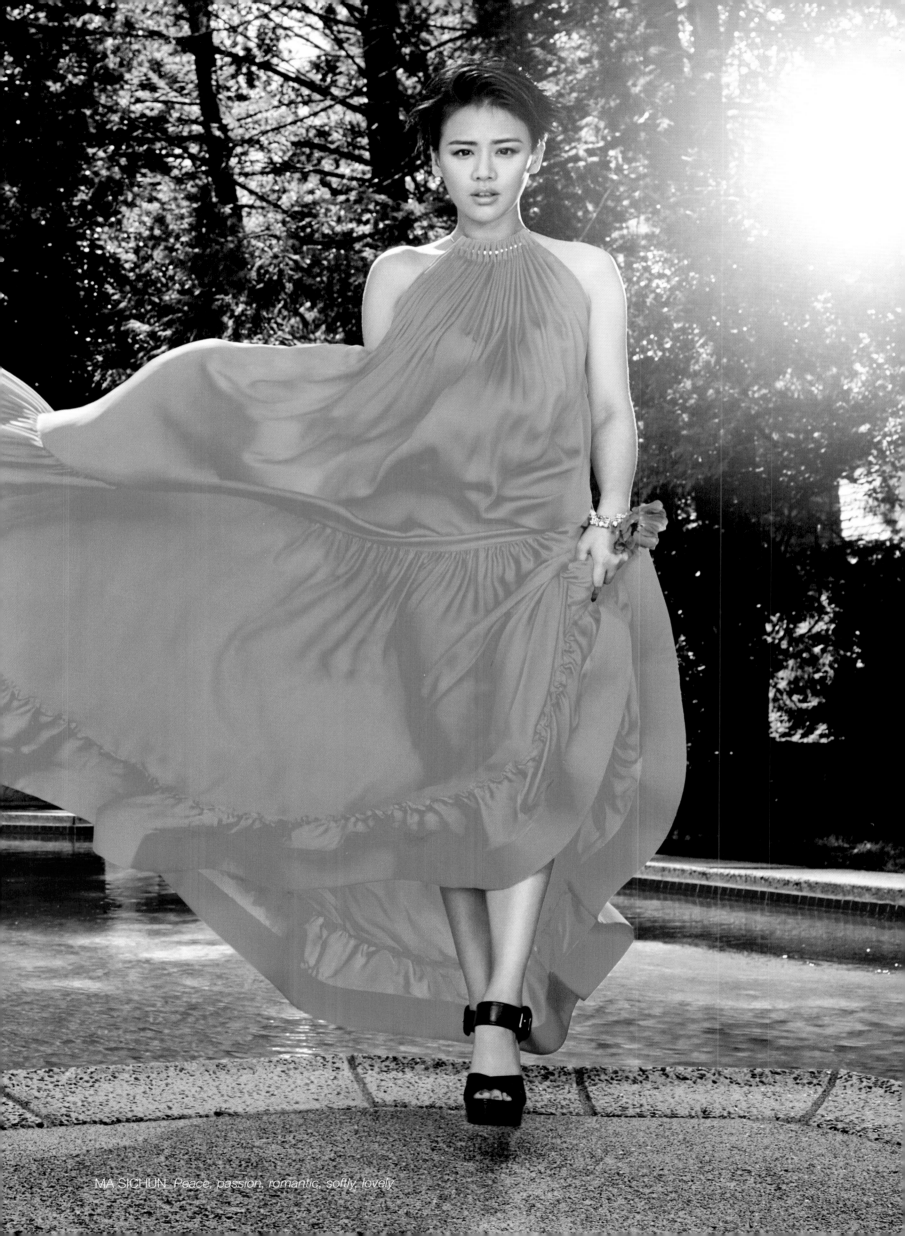

MA SICHUN. *Peace, passion, romantic, softly, lovely*

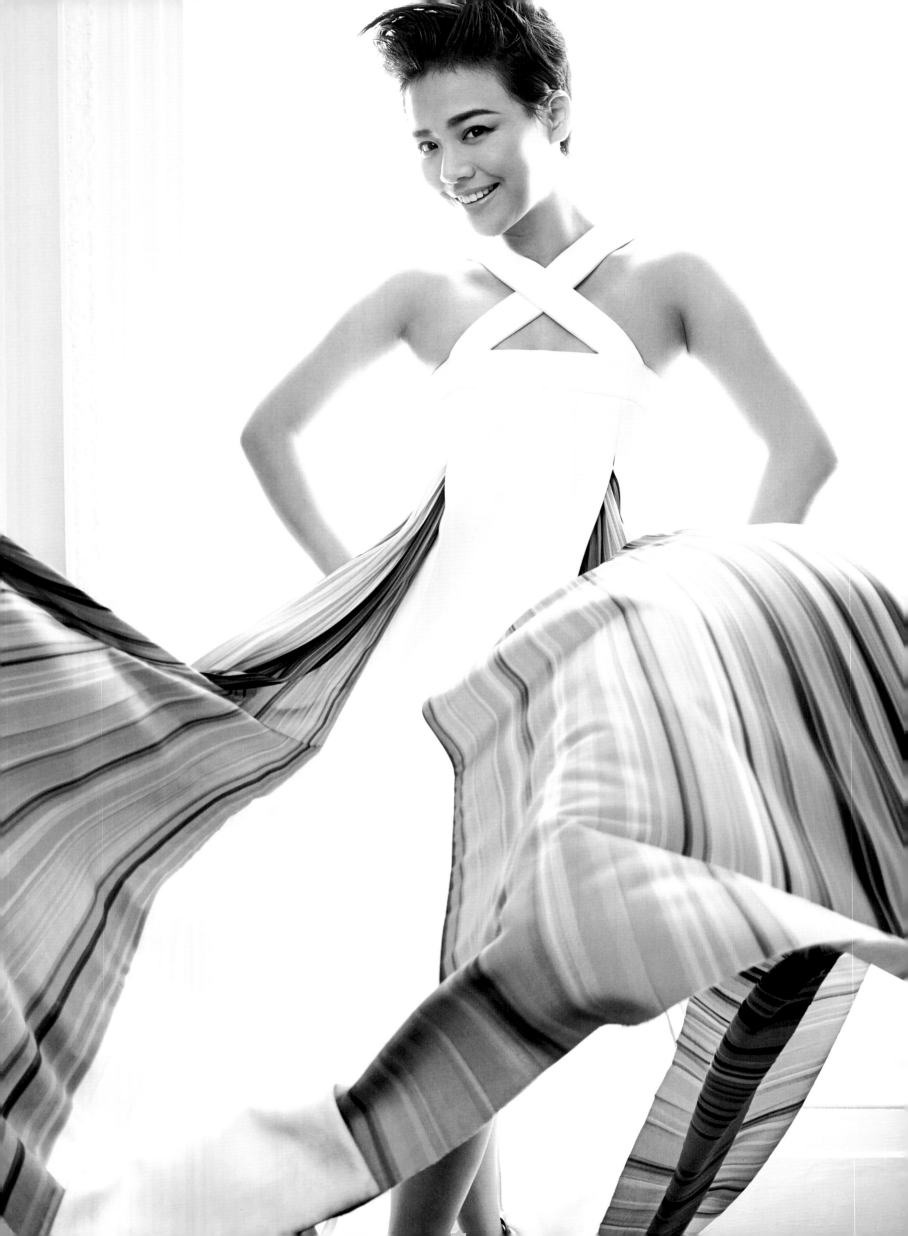

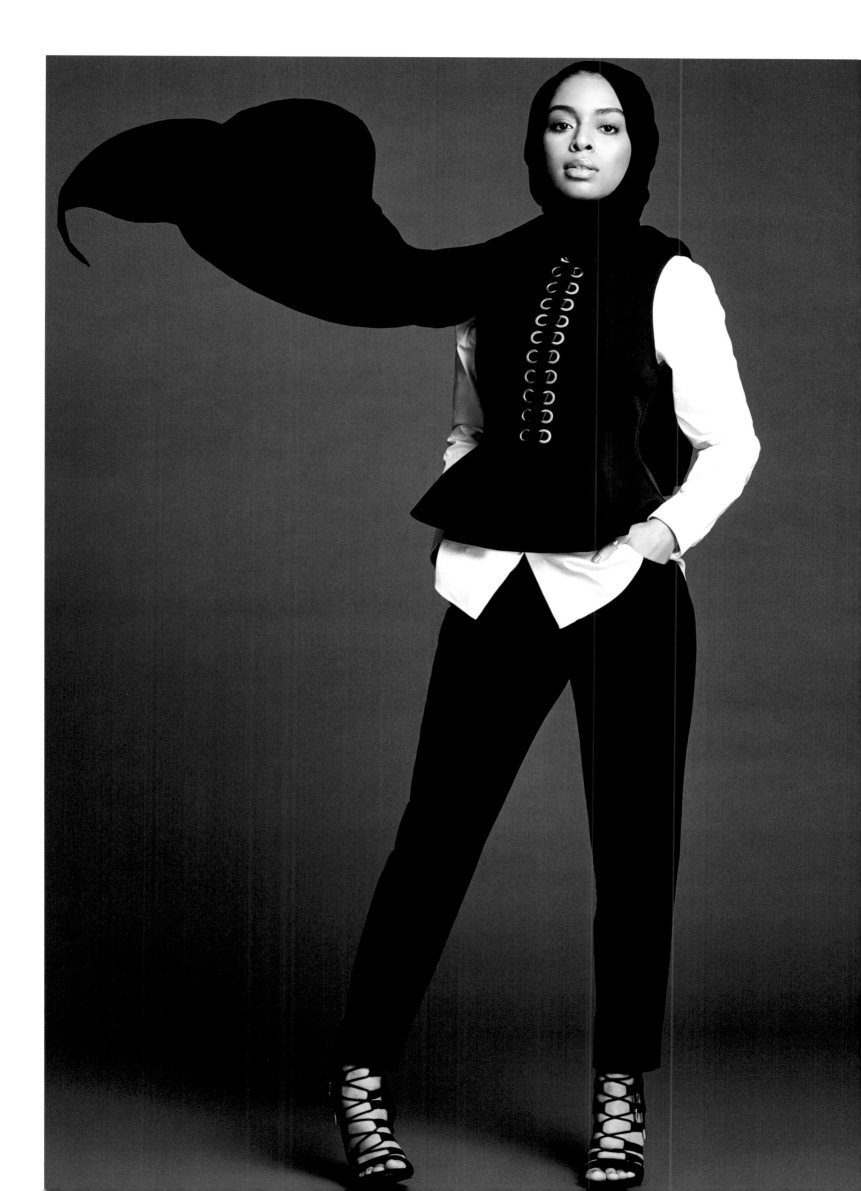

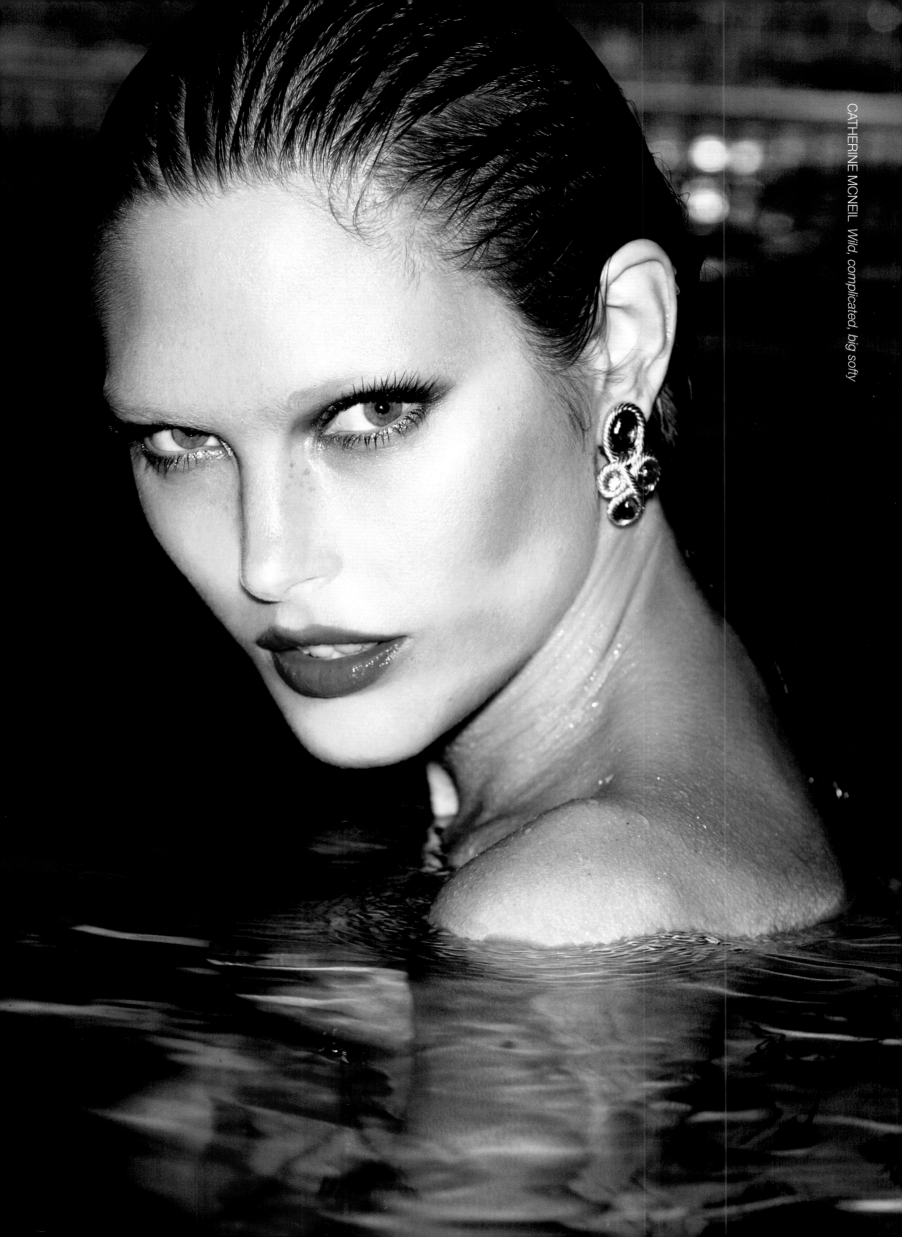

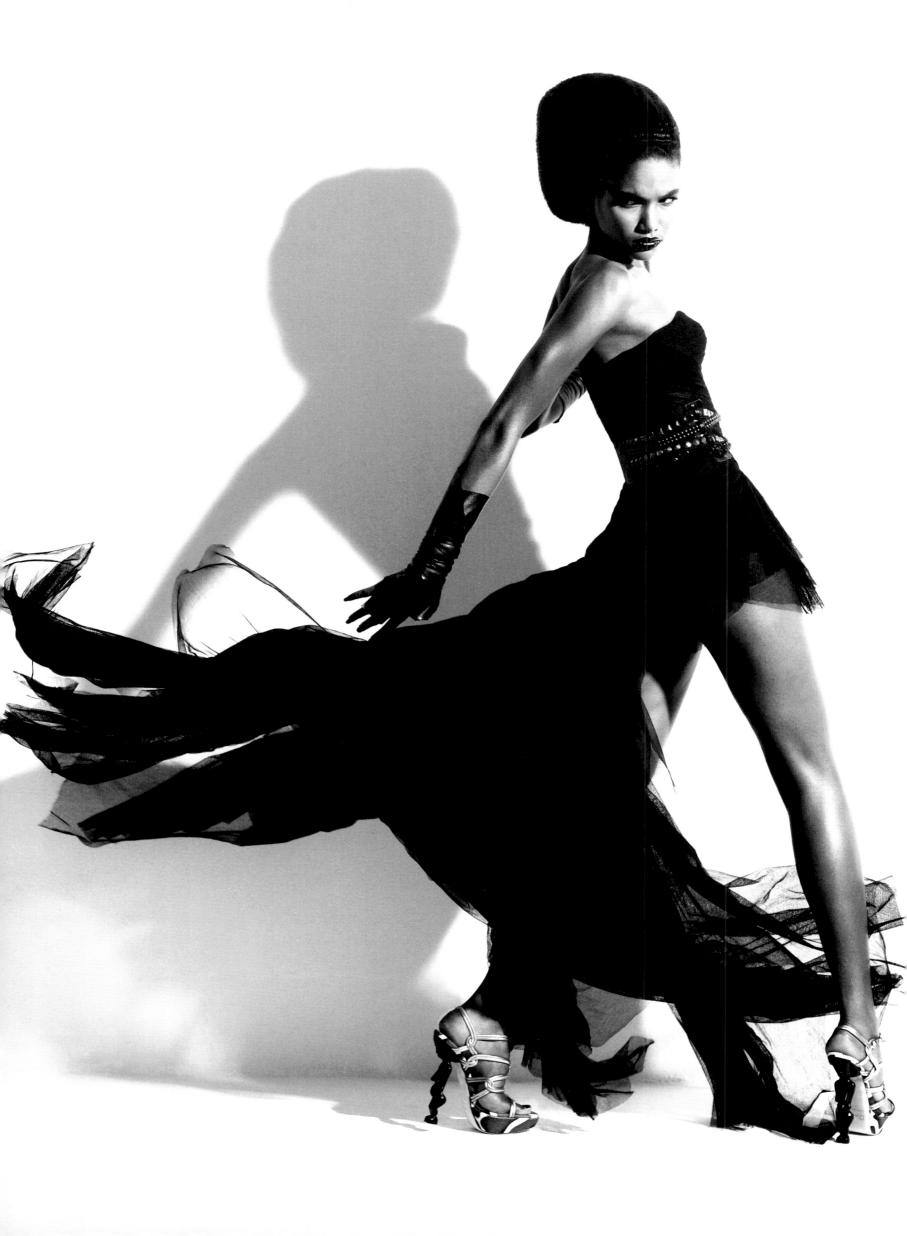

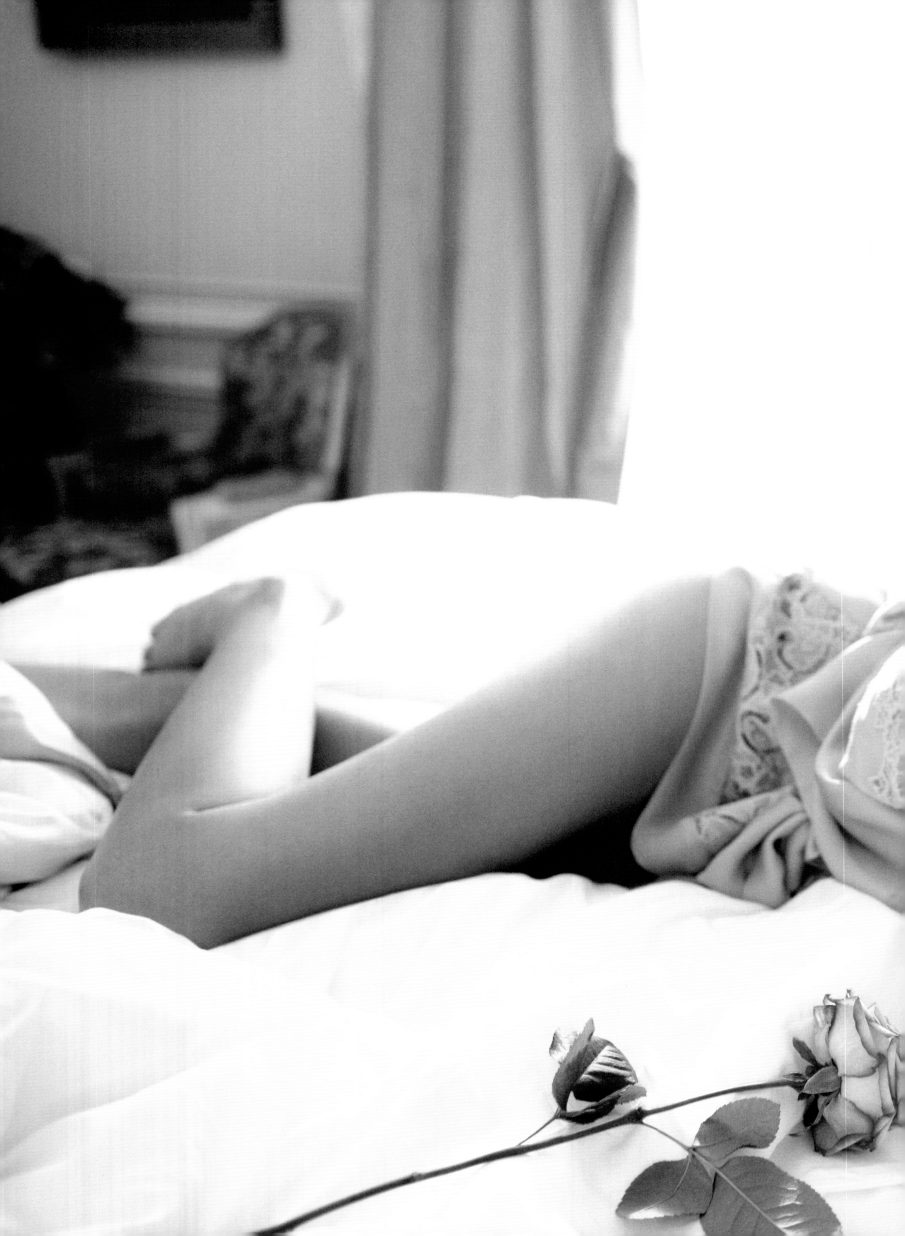

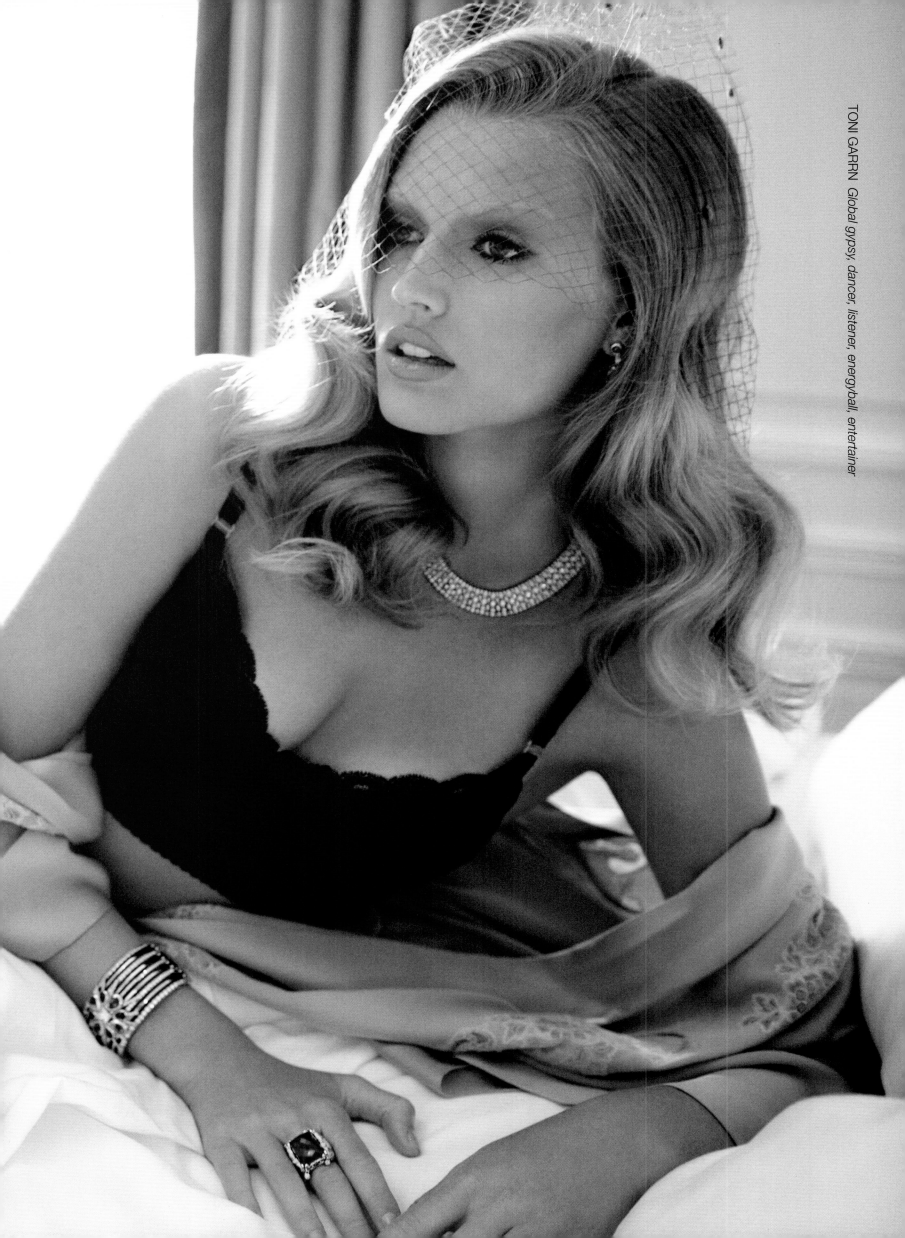

TONI GARRN *Global gypsy, dancer, listener, energyball, entertainer*

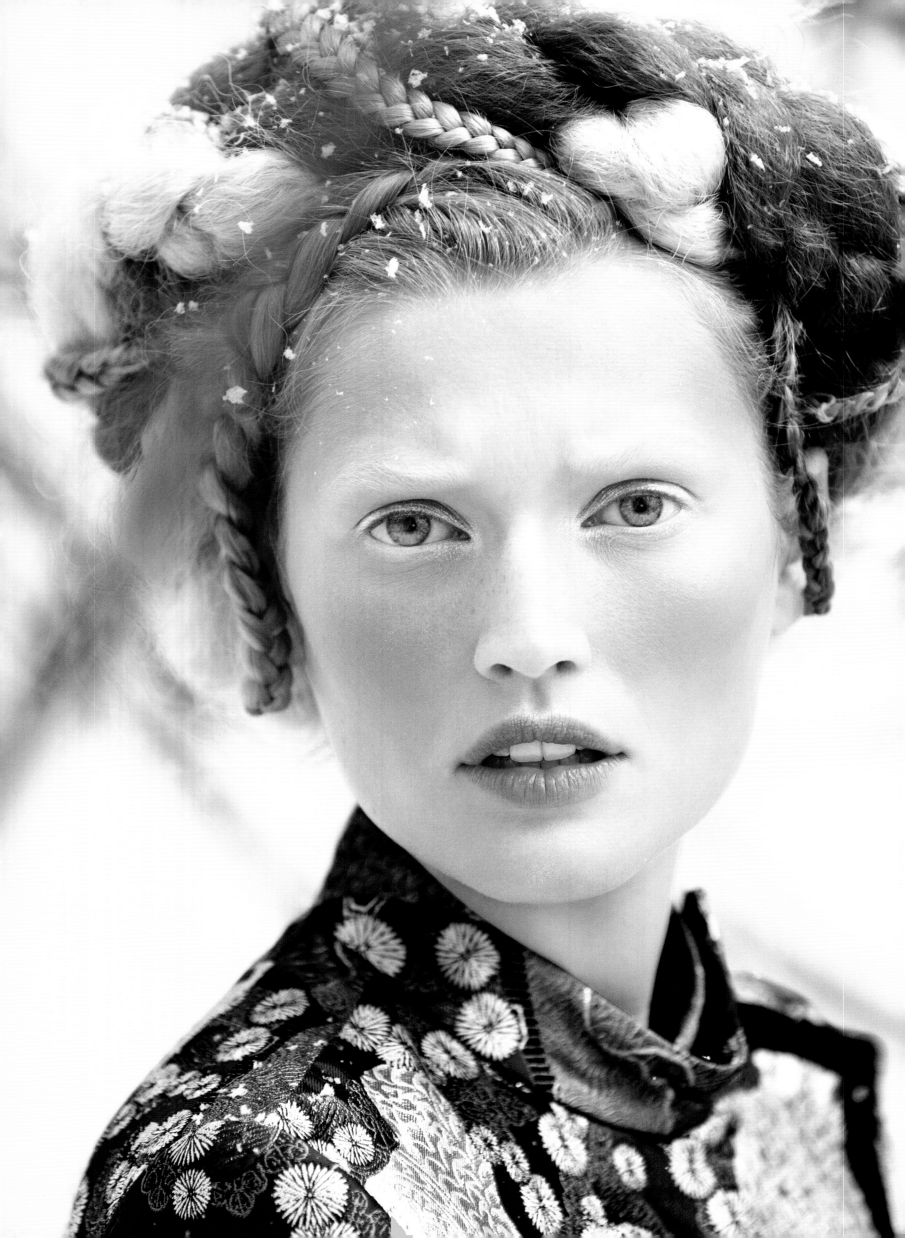

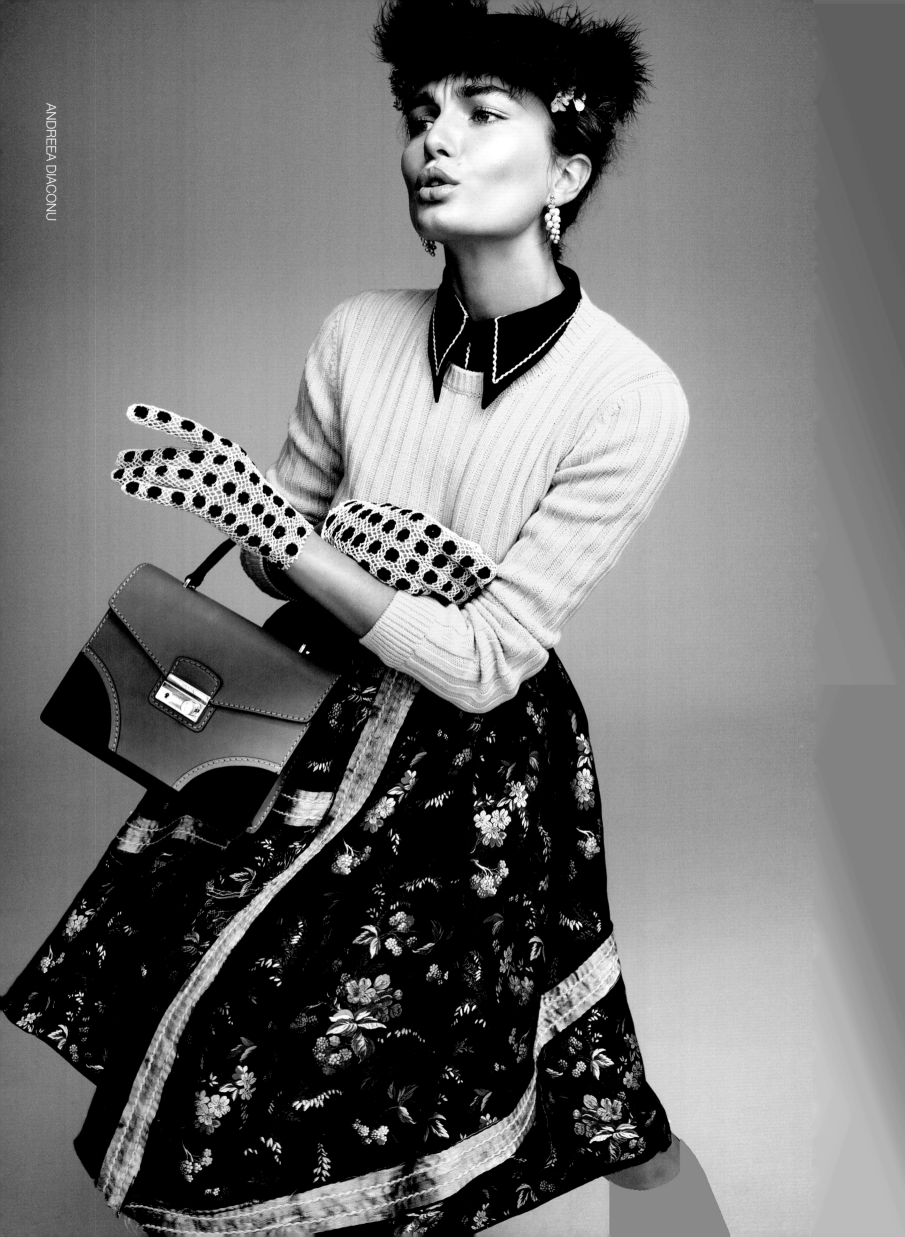

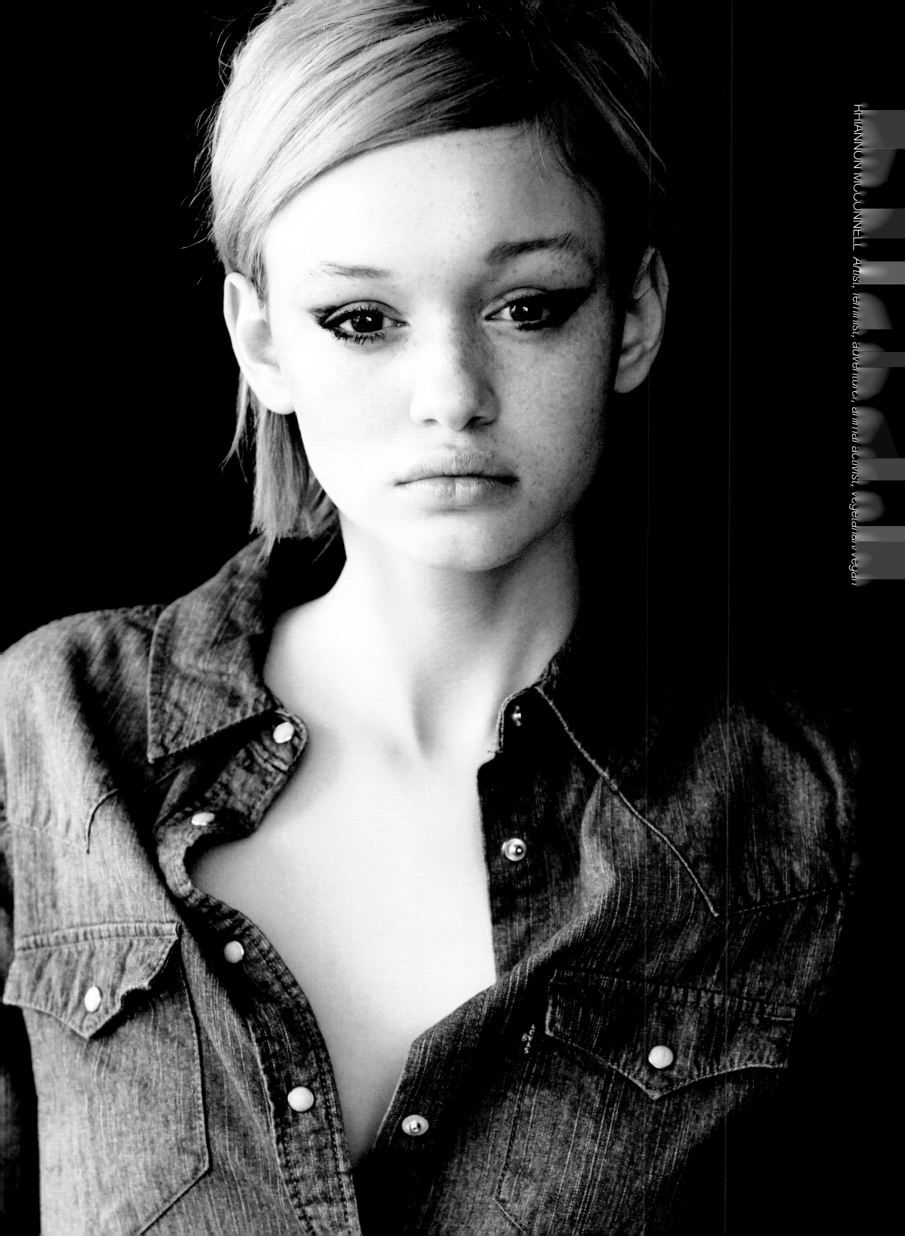

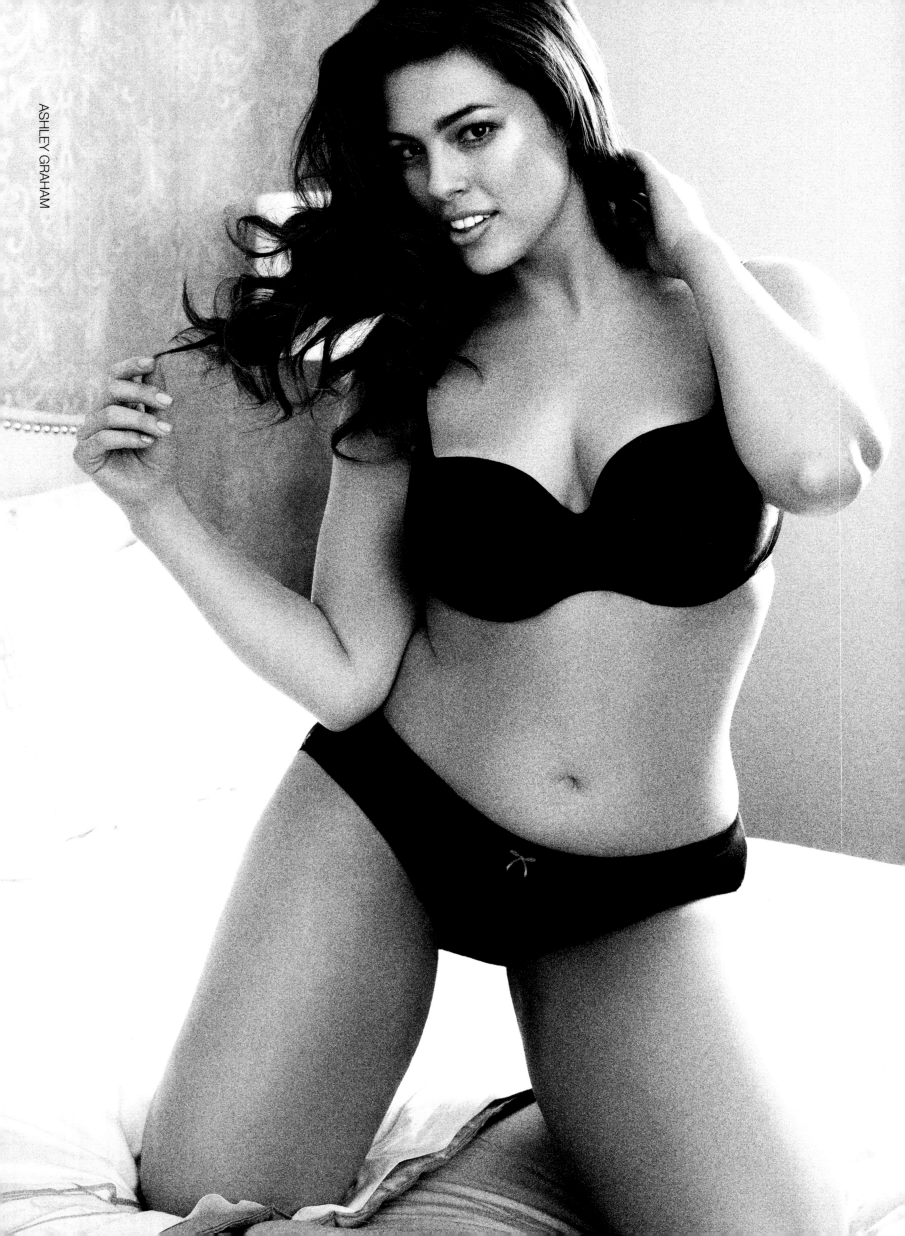

ASHLEY GRAHAM

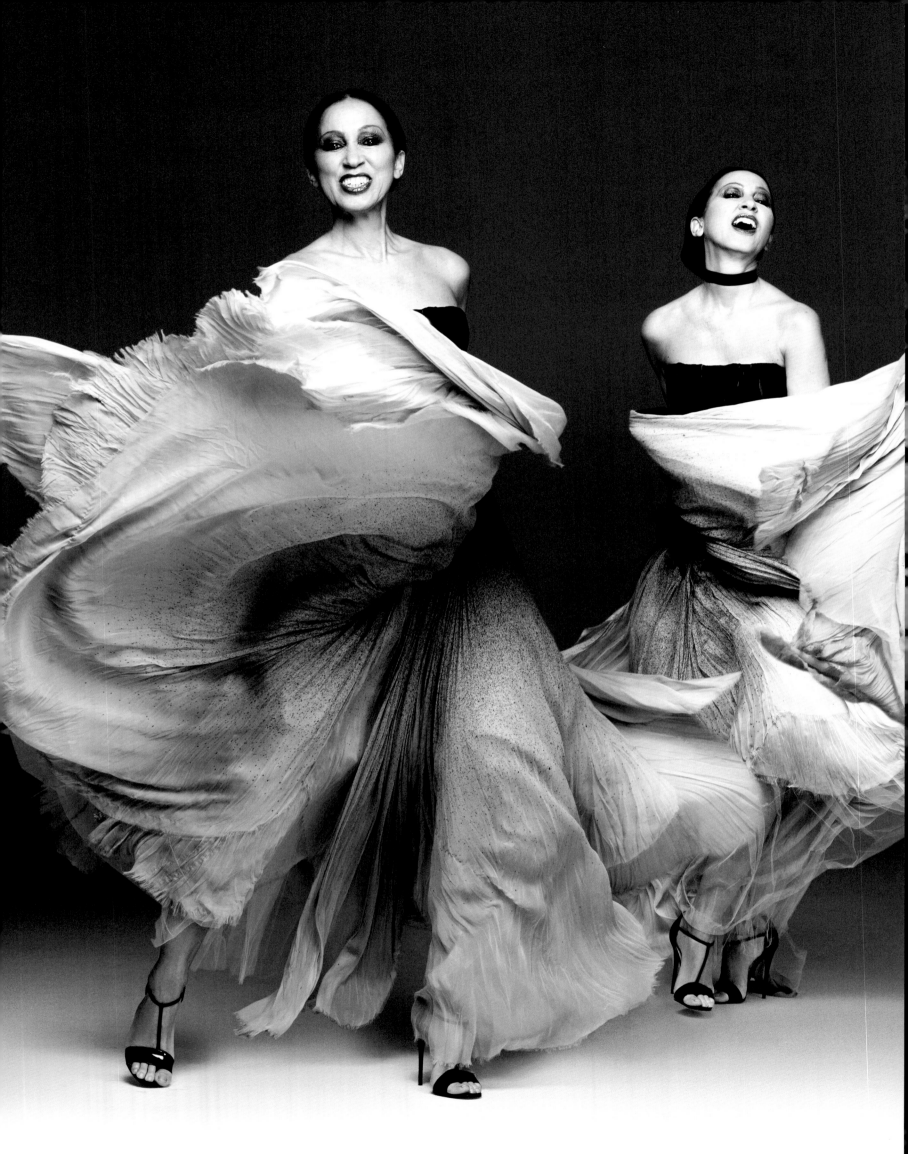

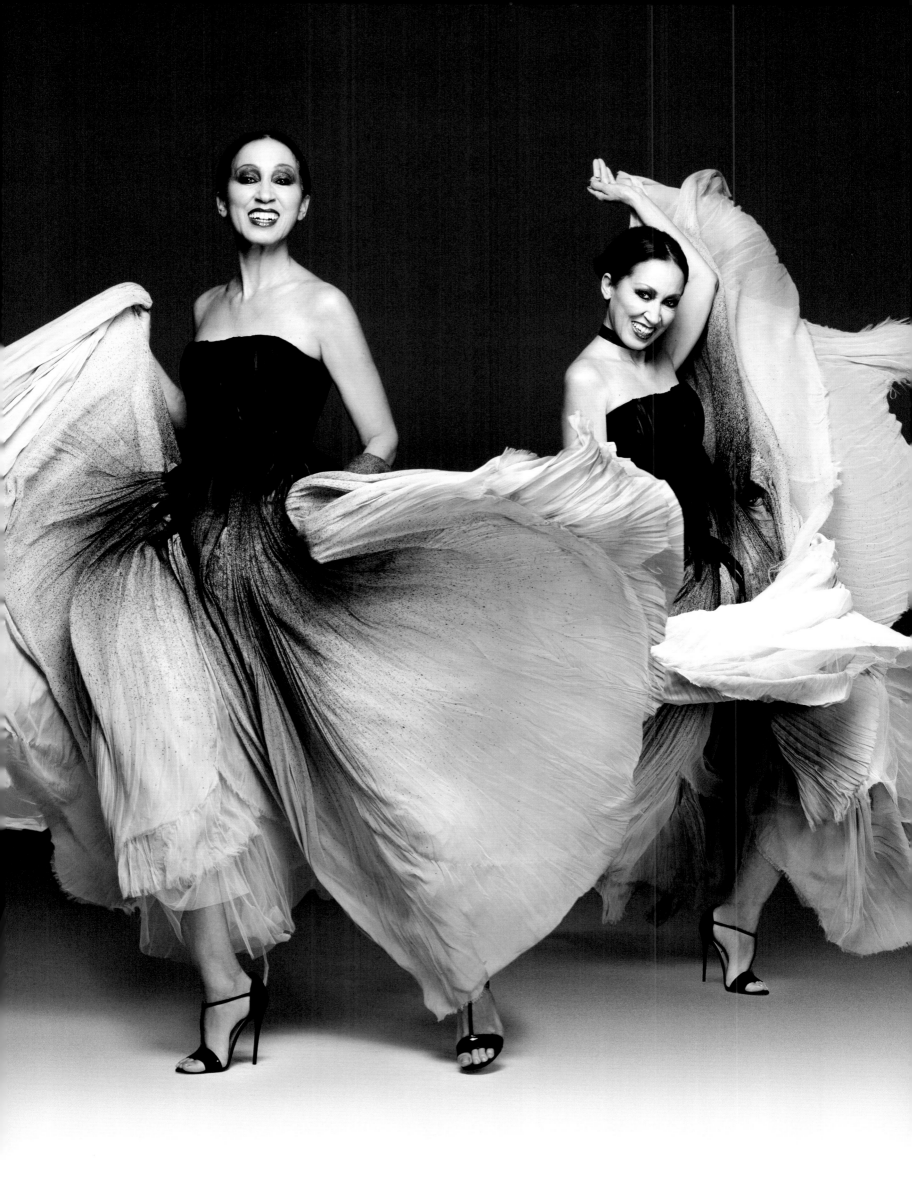

PAT CLEVELAND *Tomboy, irreverent, nonchalant (about fashion), a being of possibilities and a witness of potential*

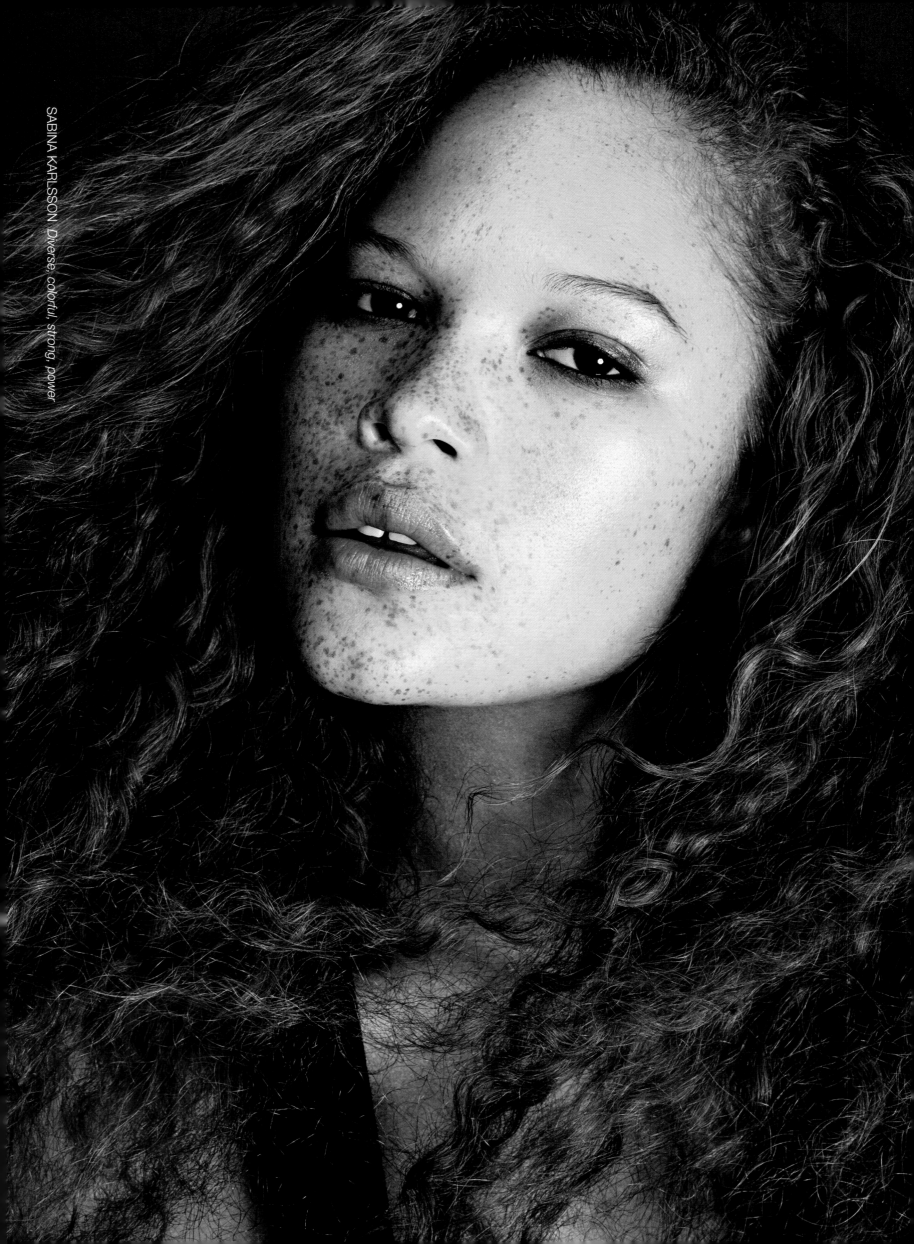

SABINA KARLSSON *Diverse, colorful, strong, power*

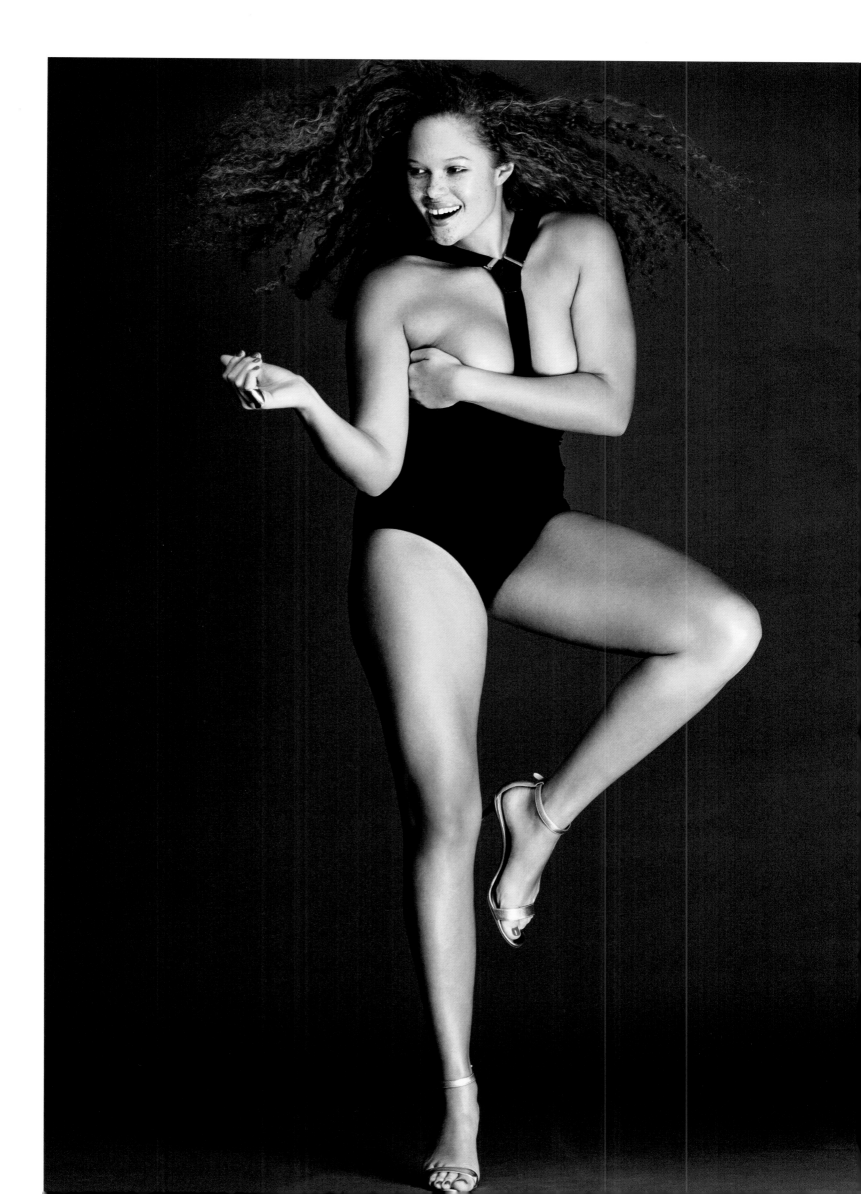

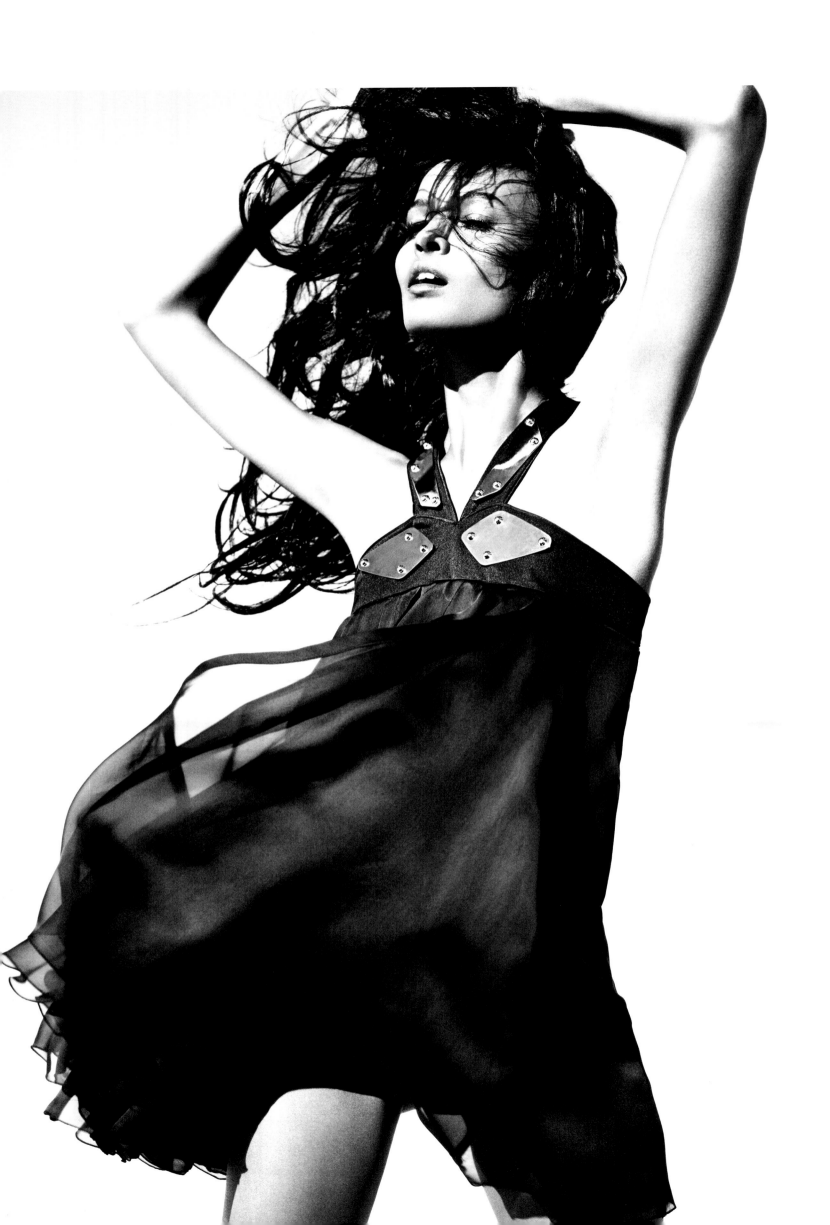

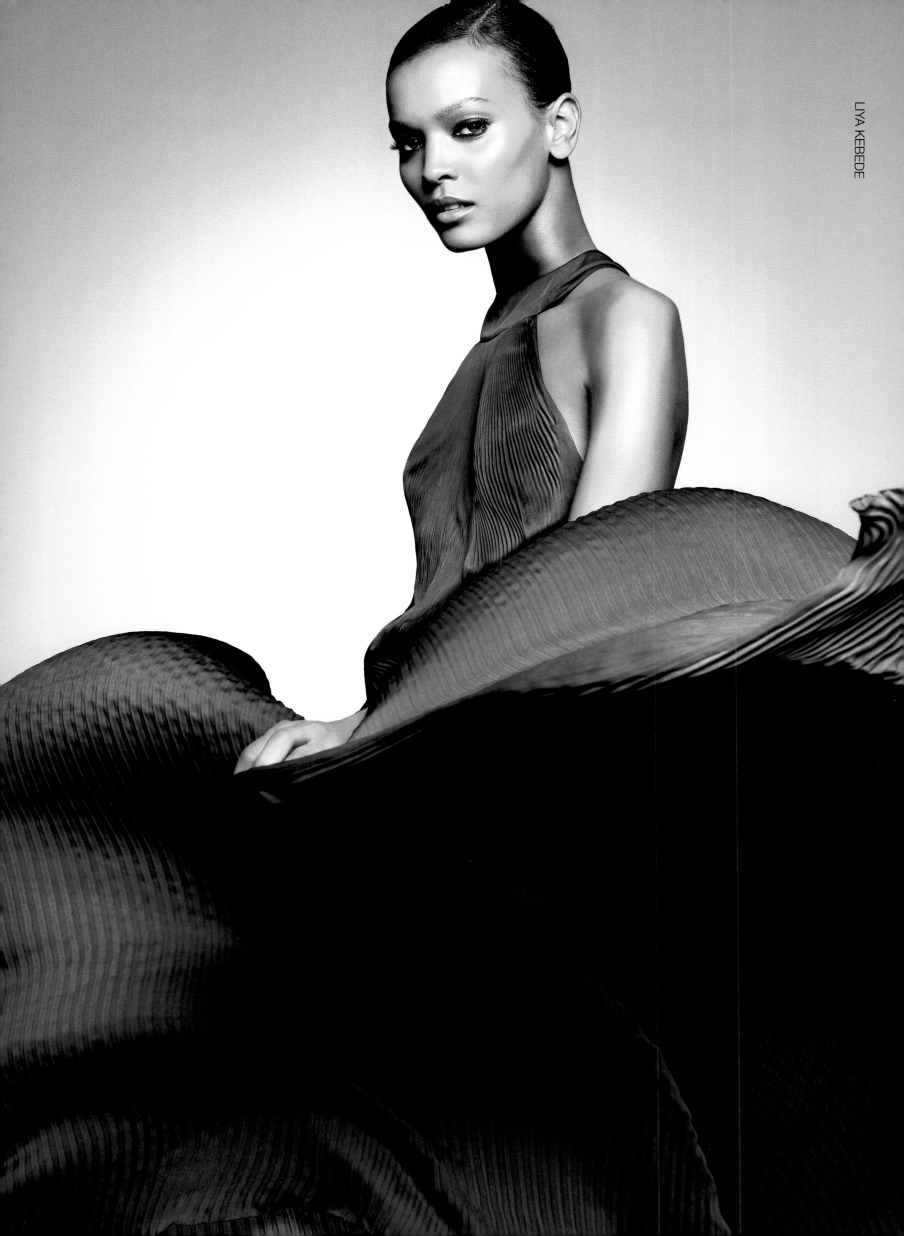

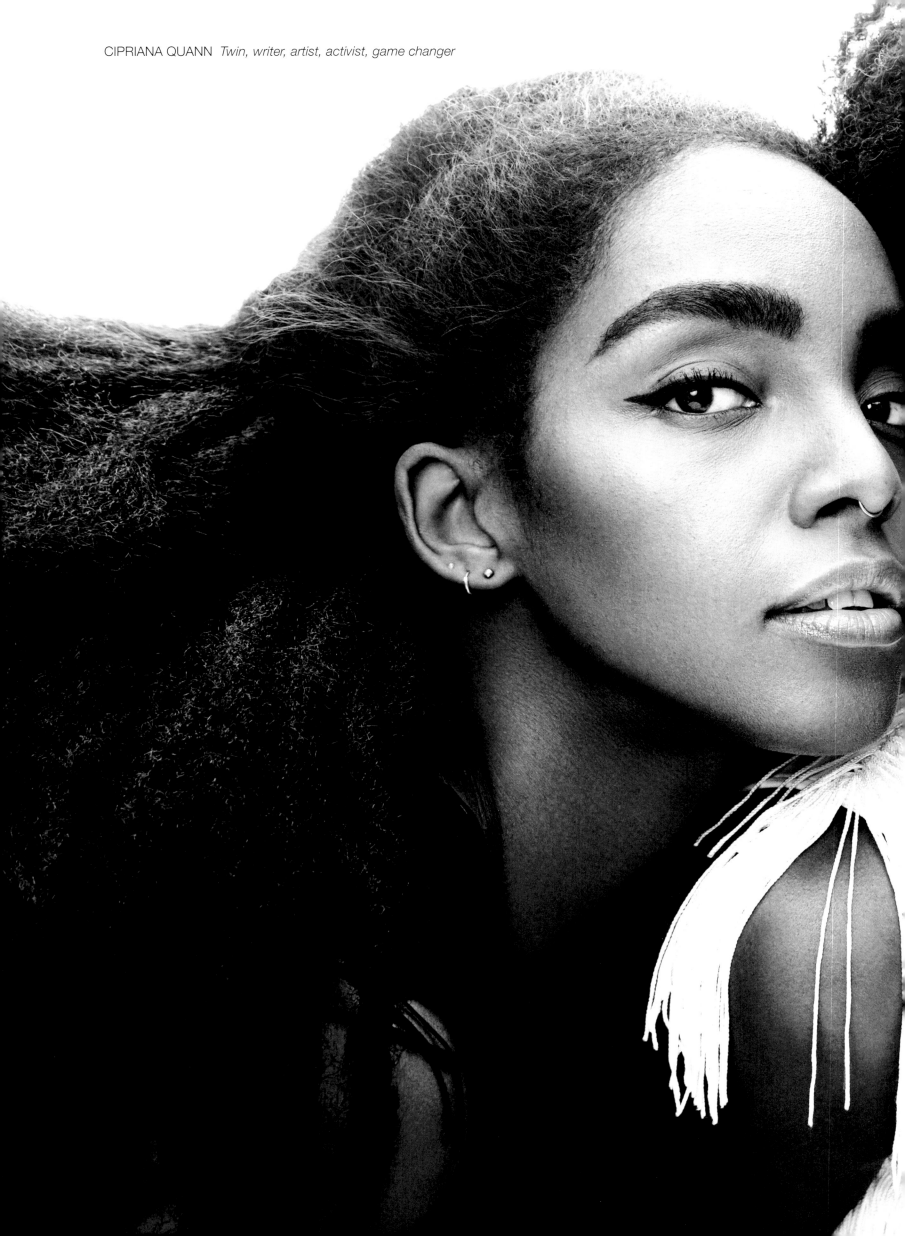

CIPRIANA QUANN *Twin, writer, artist, activist, game changer*

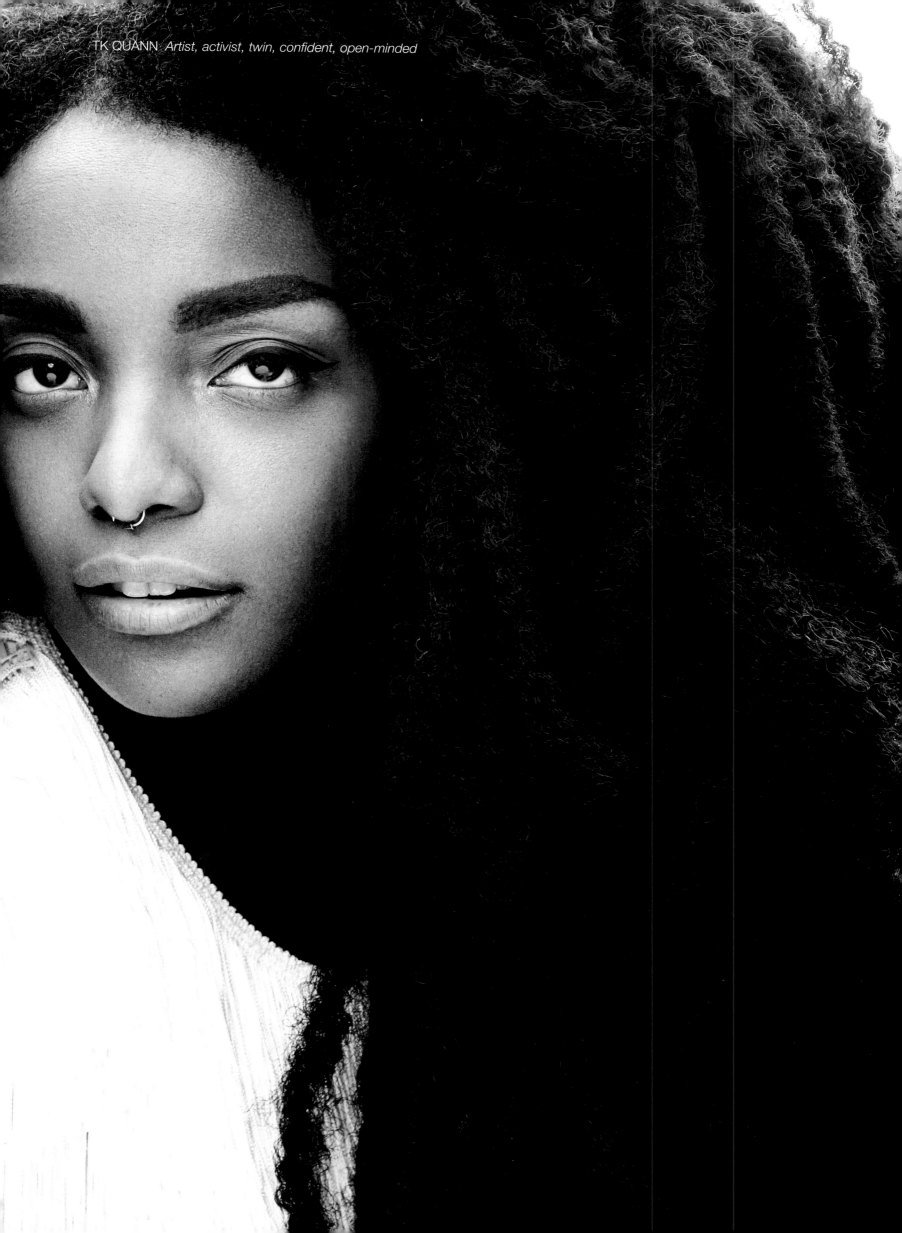

TK QUANN *Artist, activist, twin, confident, open-minded*

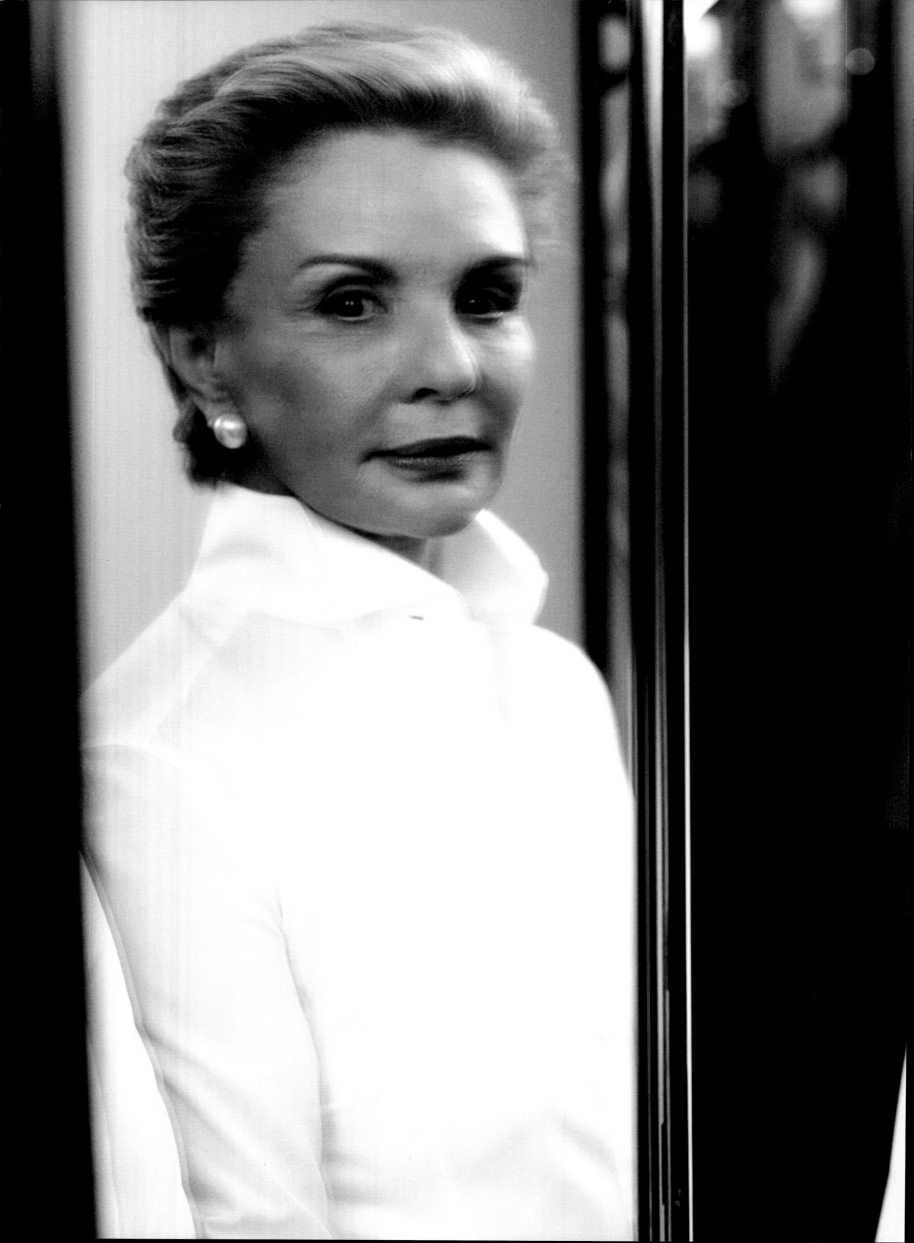

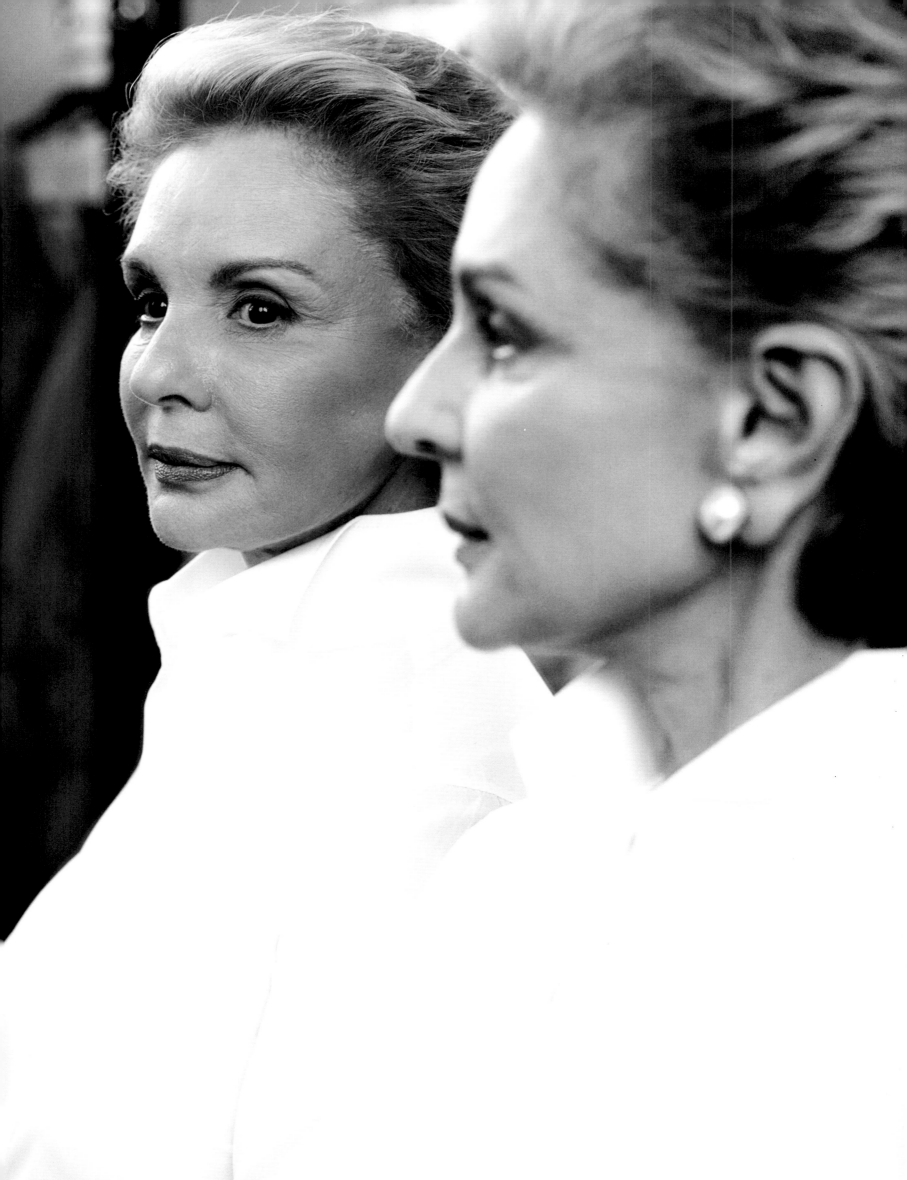

CAROLINA HERRERA *Fantasy, curiosity, discipline, love, Capricorn*

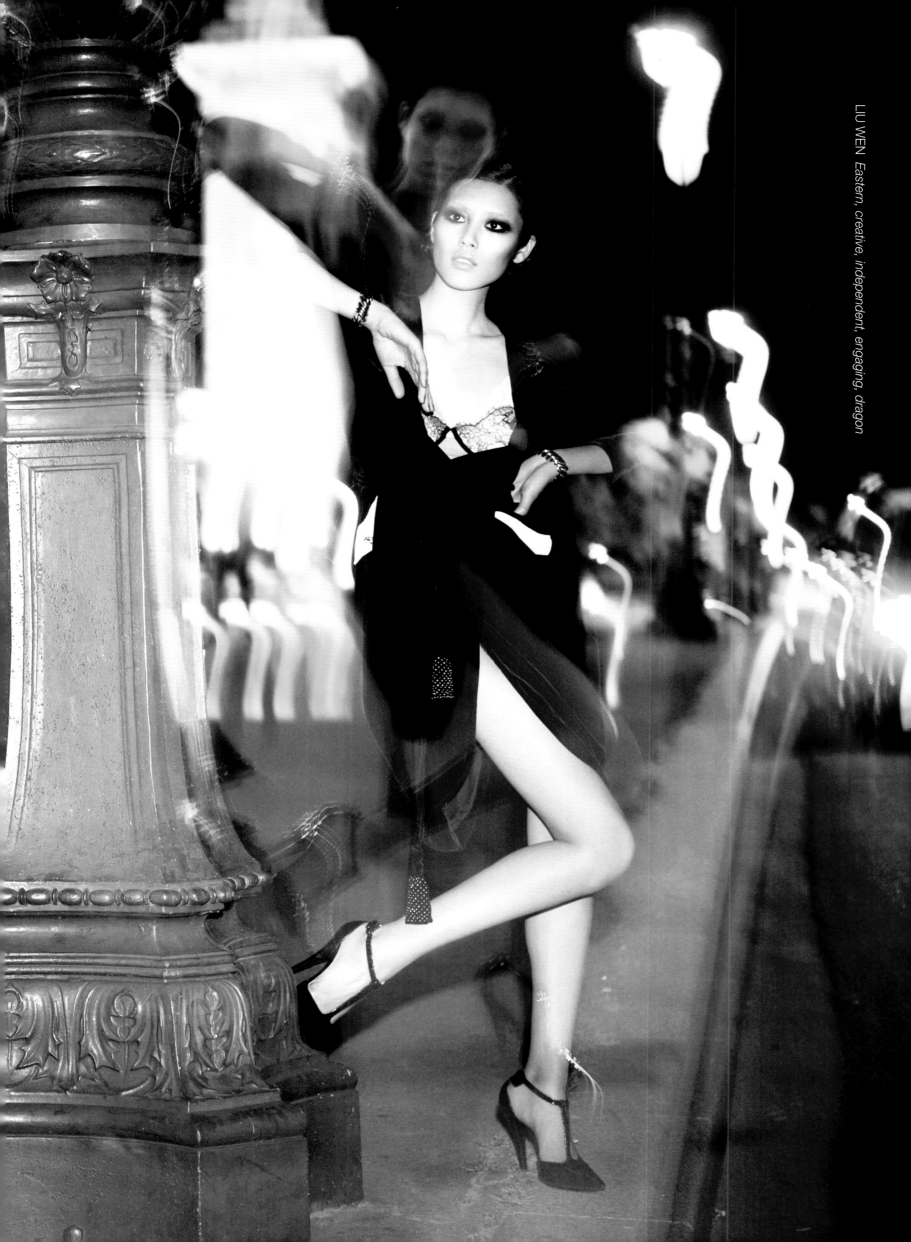

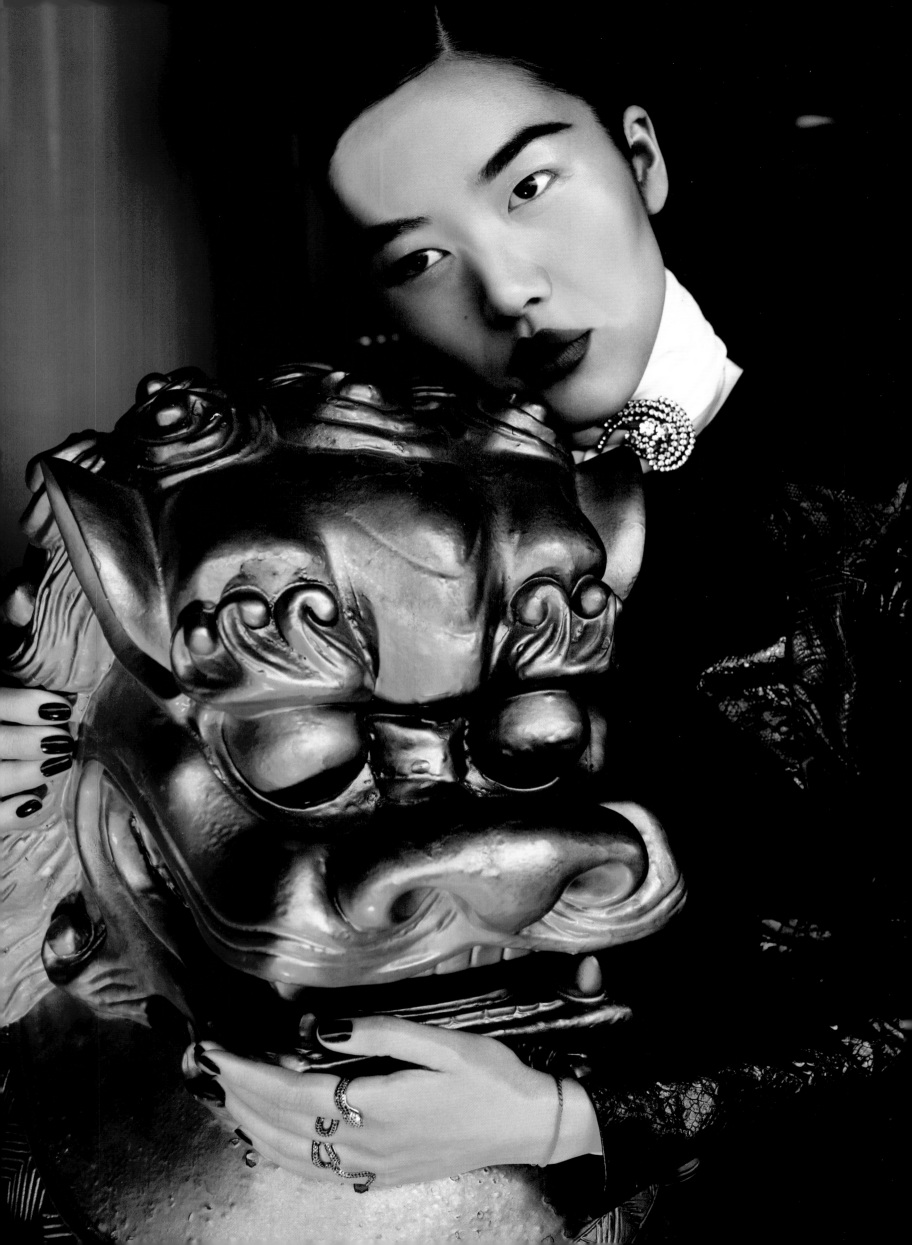

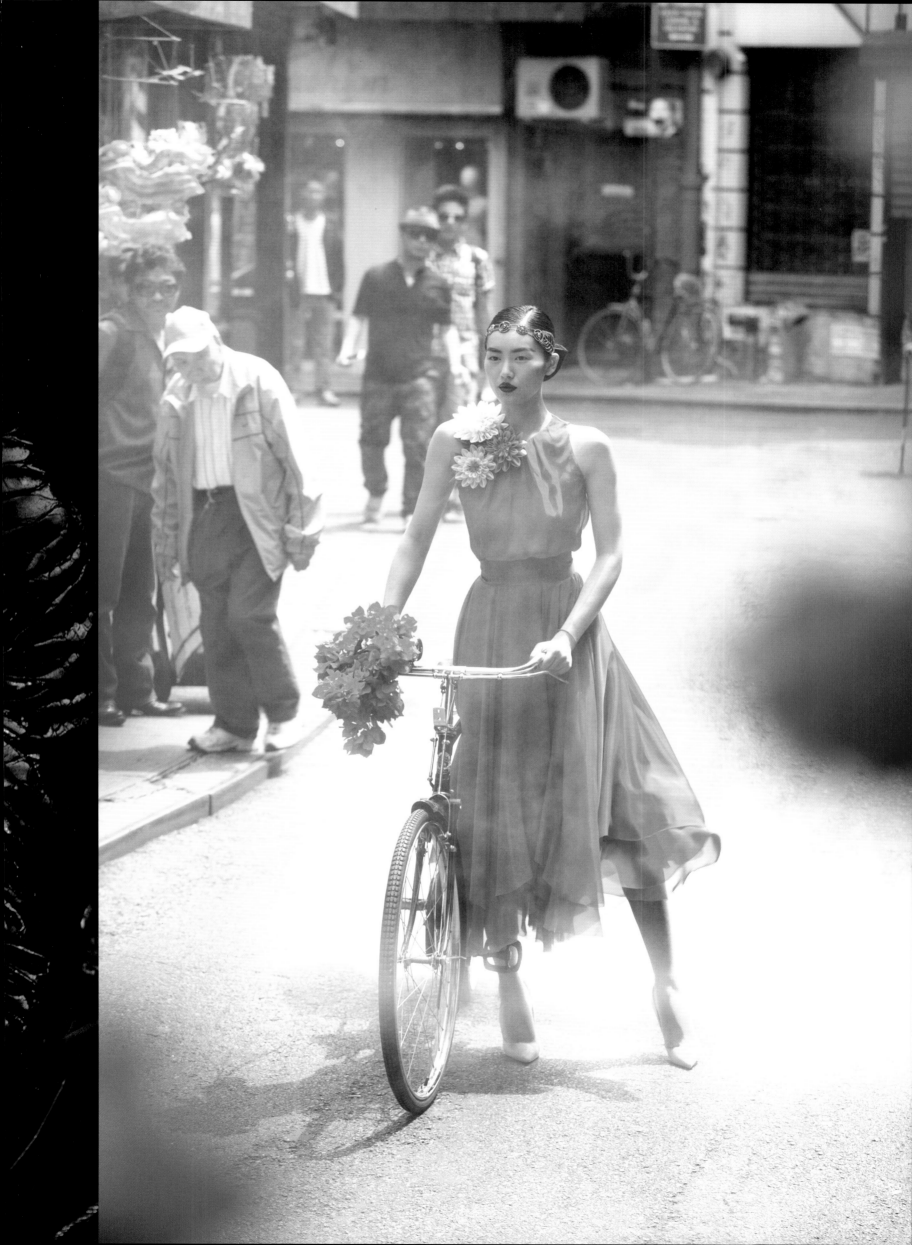

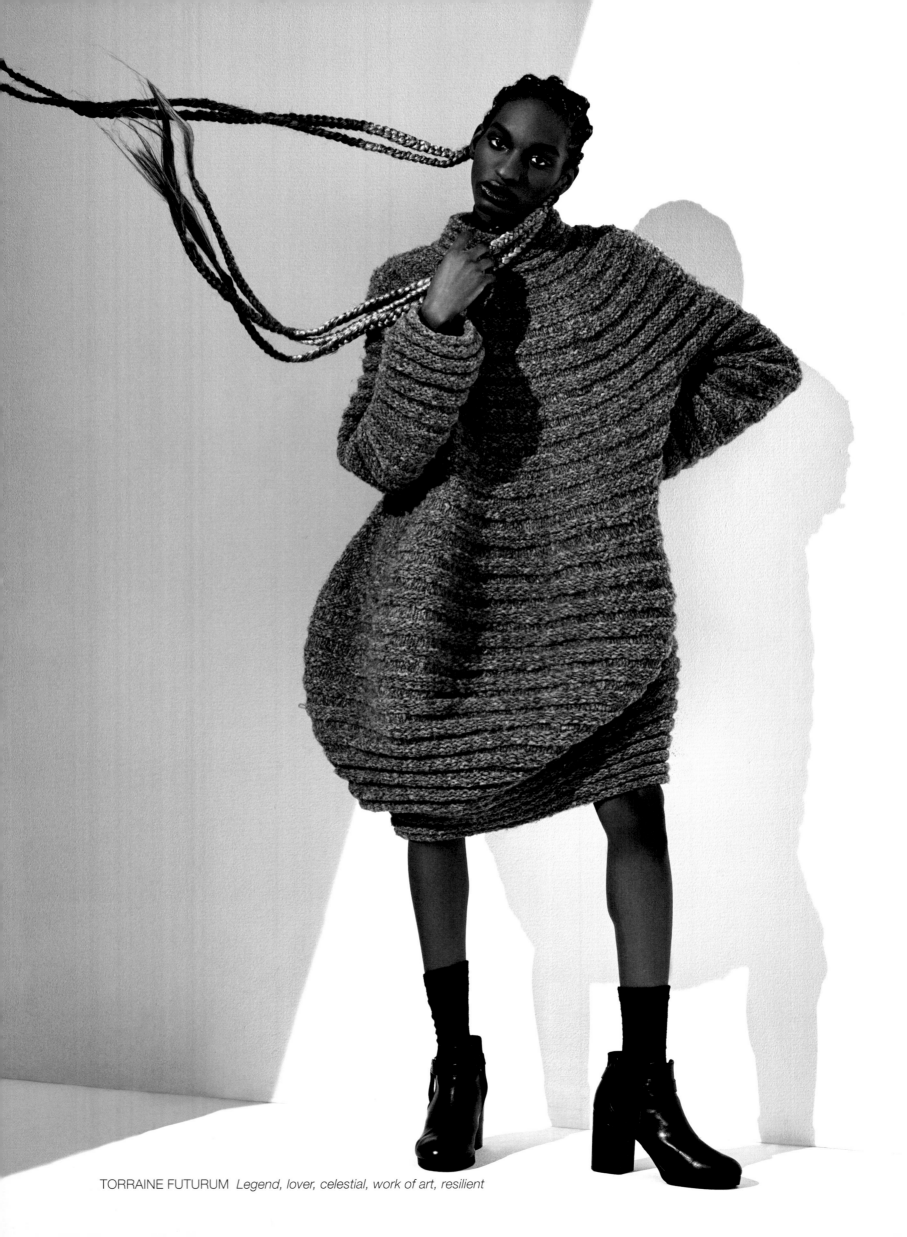

TORRAINE FUTURUM *Legend, lover, celestial, work of art, resilient*

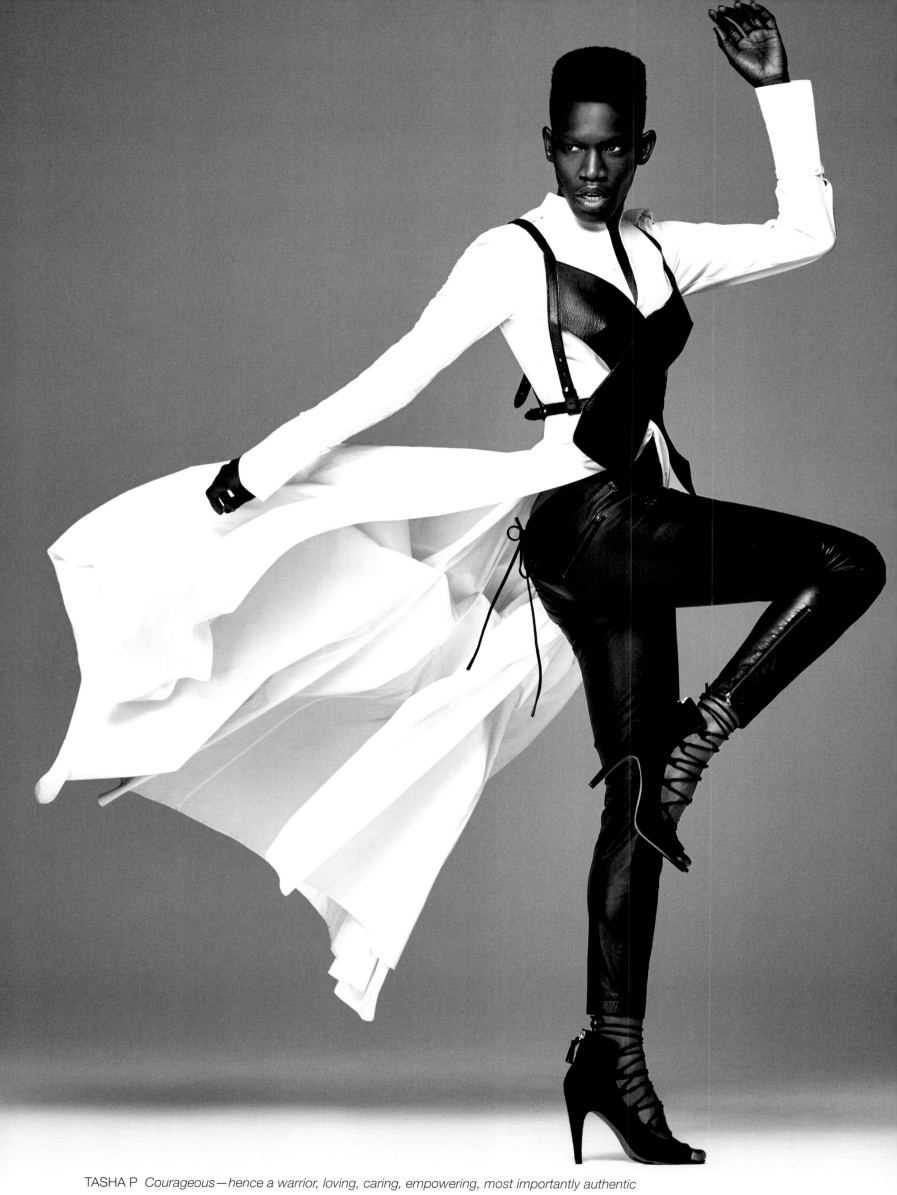

TASHA P *Courageous—hence a warrior, loving, caring, empowering, most importantly authentic*

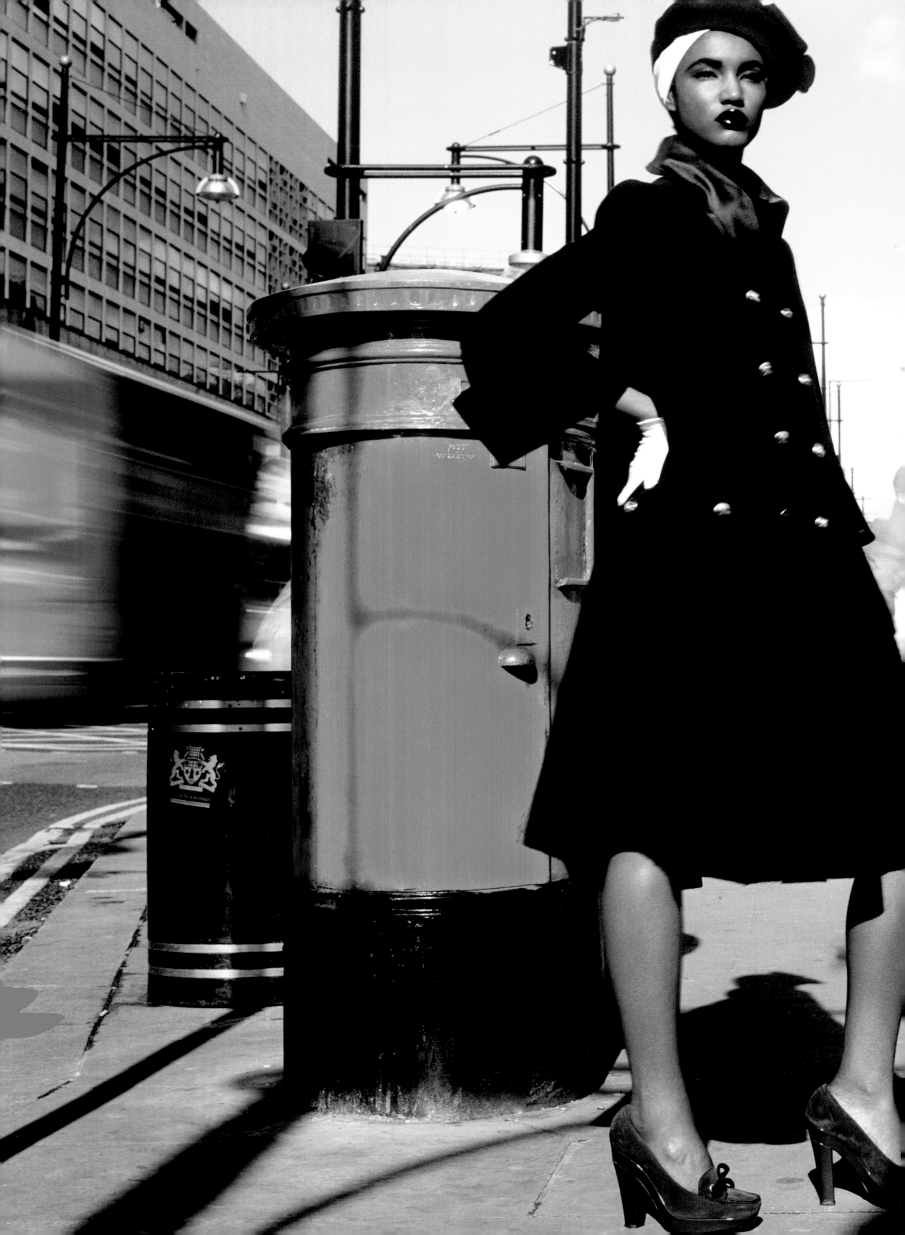

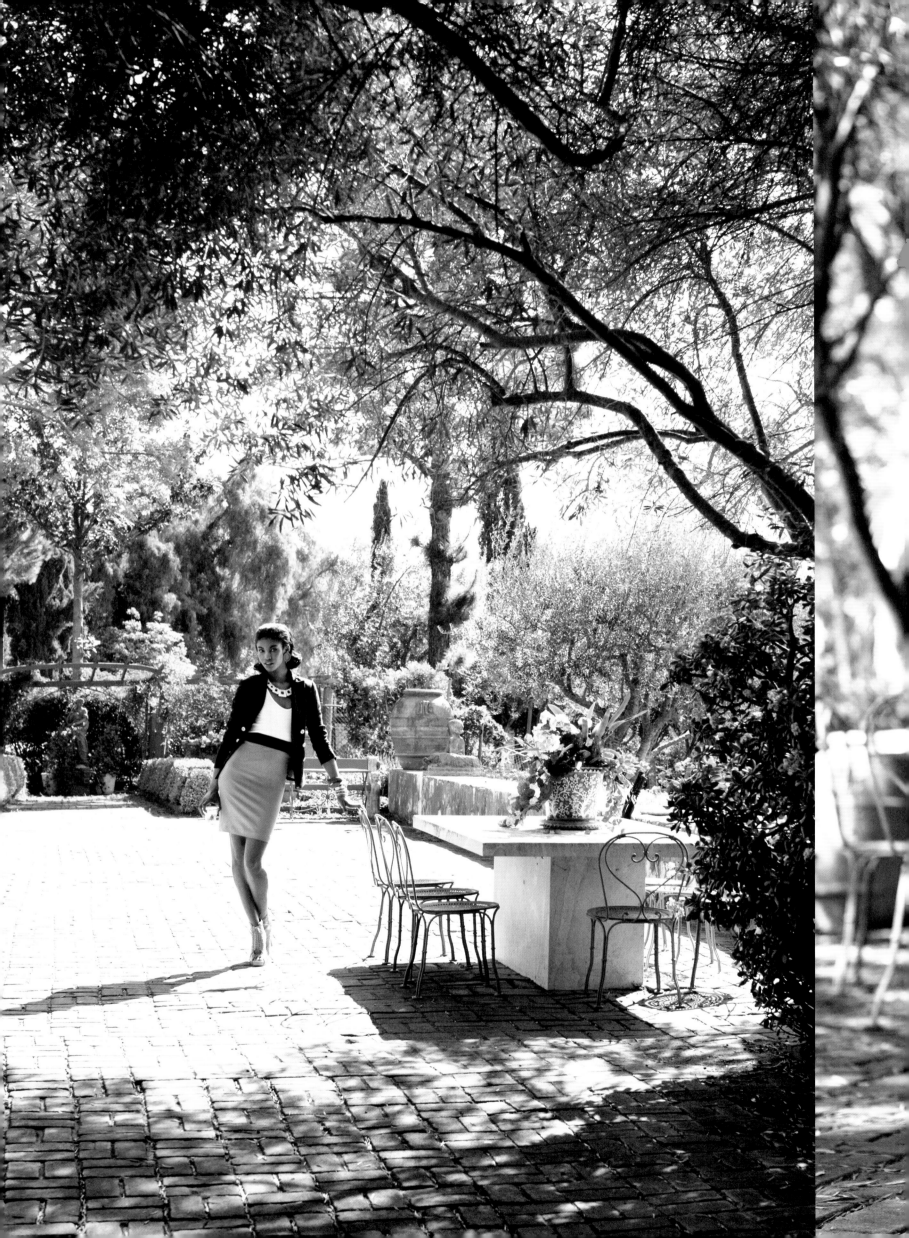

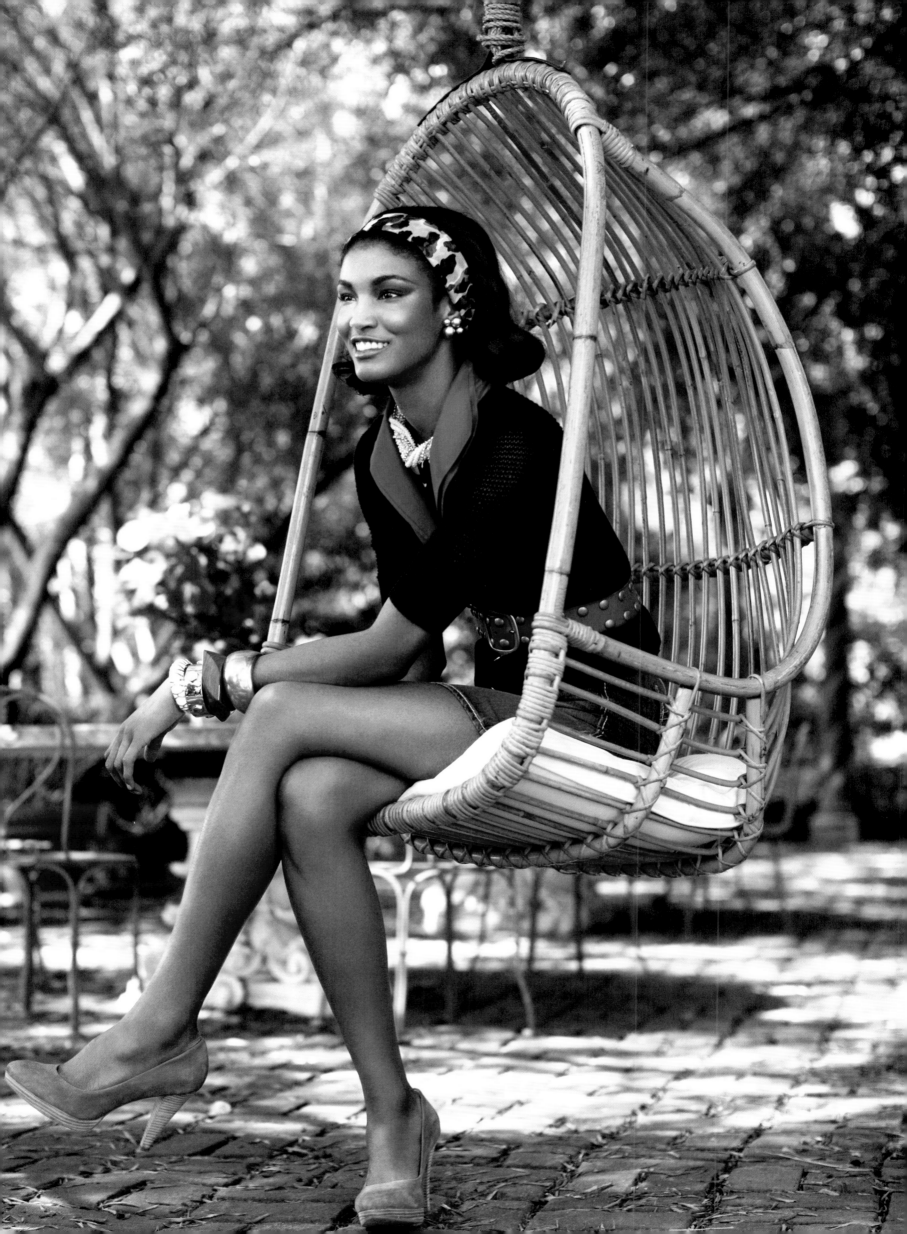

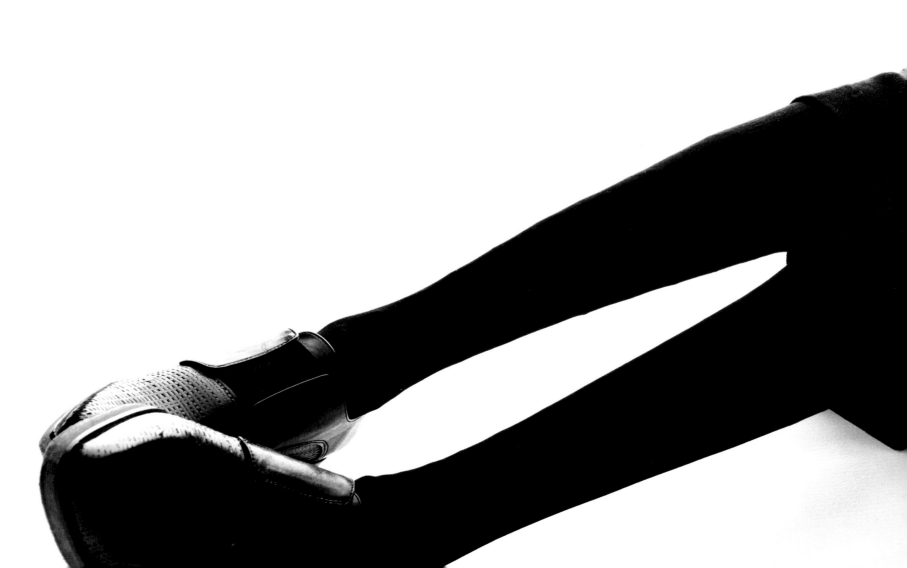

JILLIAN MERCADO *Creative, activist, feminist, boss, life-lover*

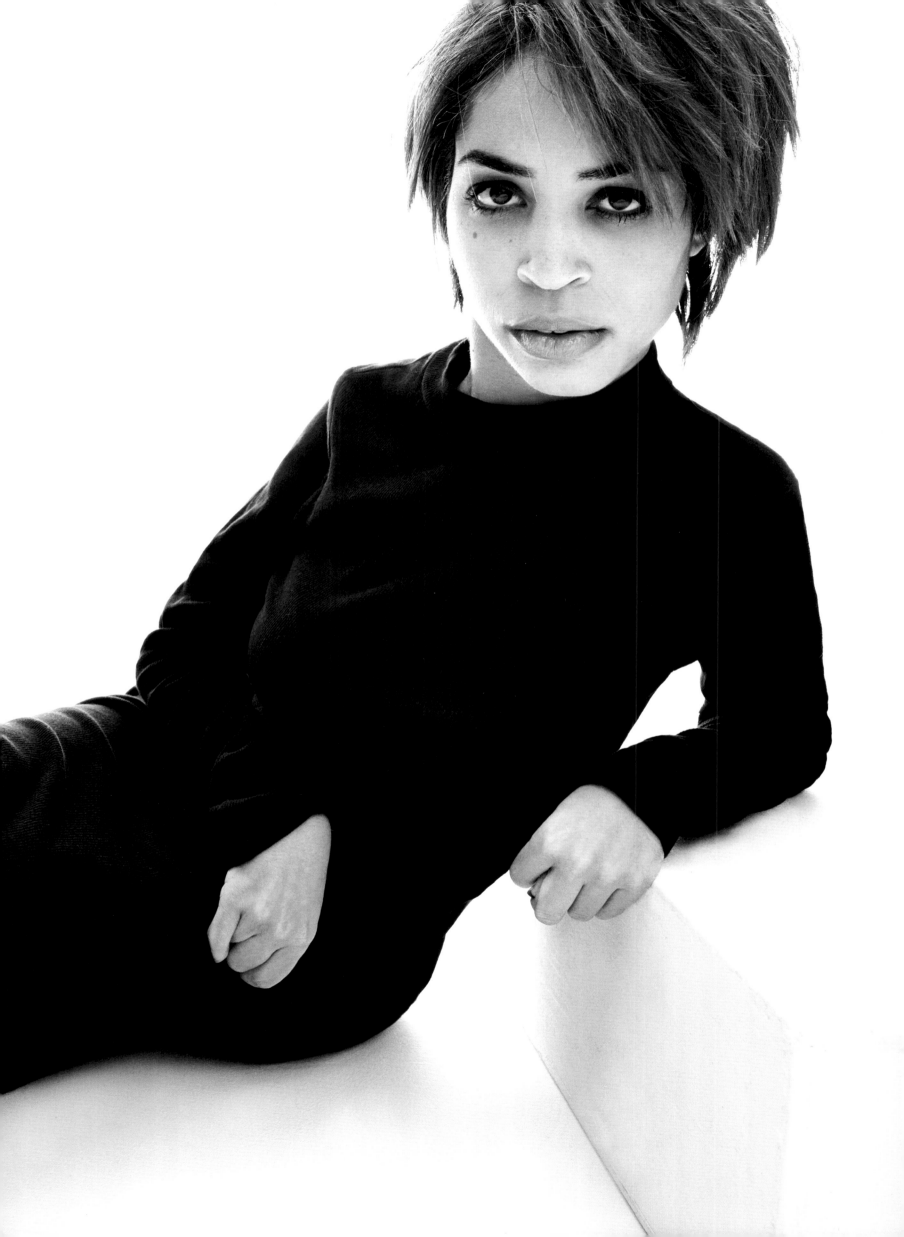

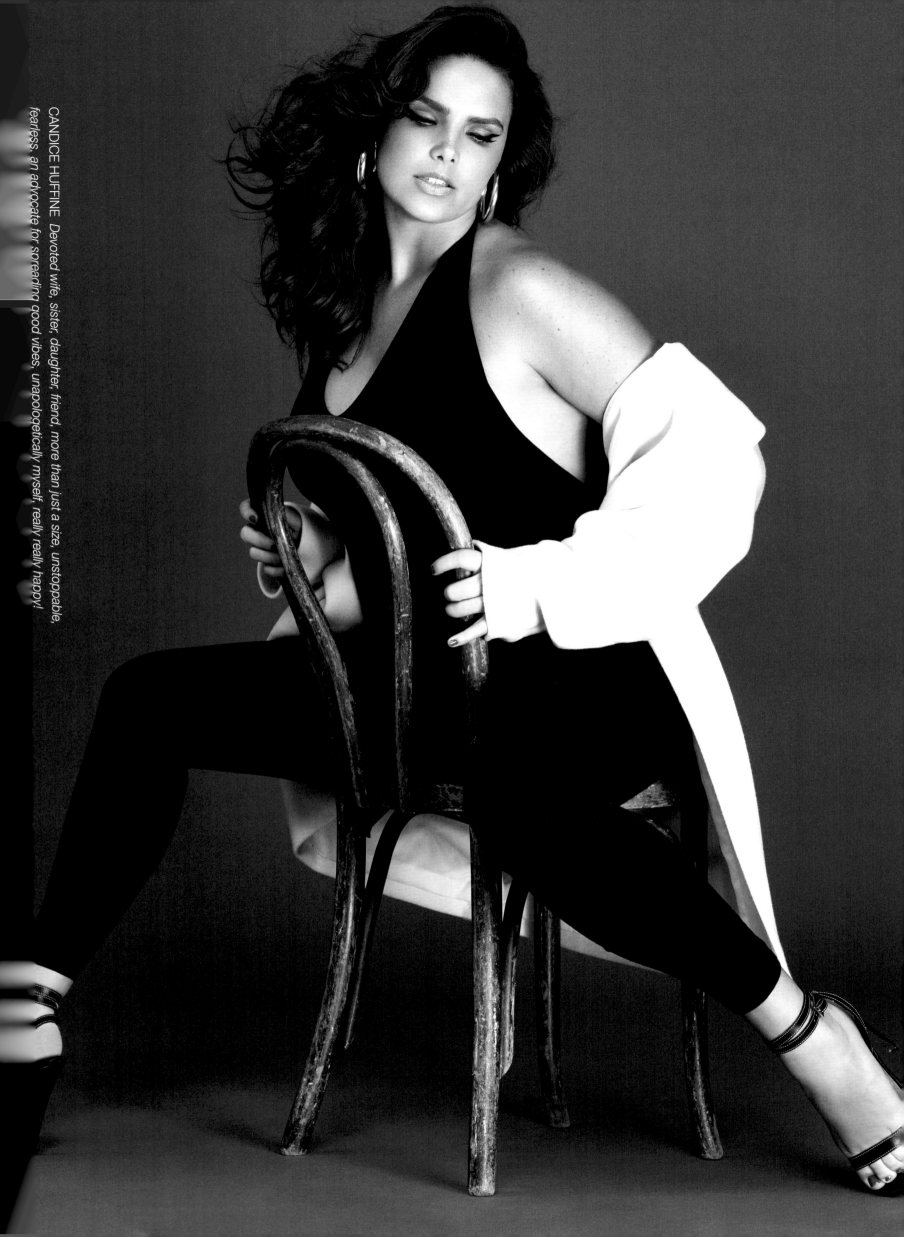

ELAINE WELTEROTH *Writer, editor, director, buoyant, genuine, woke, advocate, exuberant, multicultural*

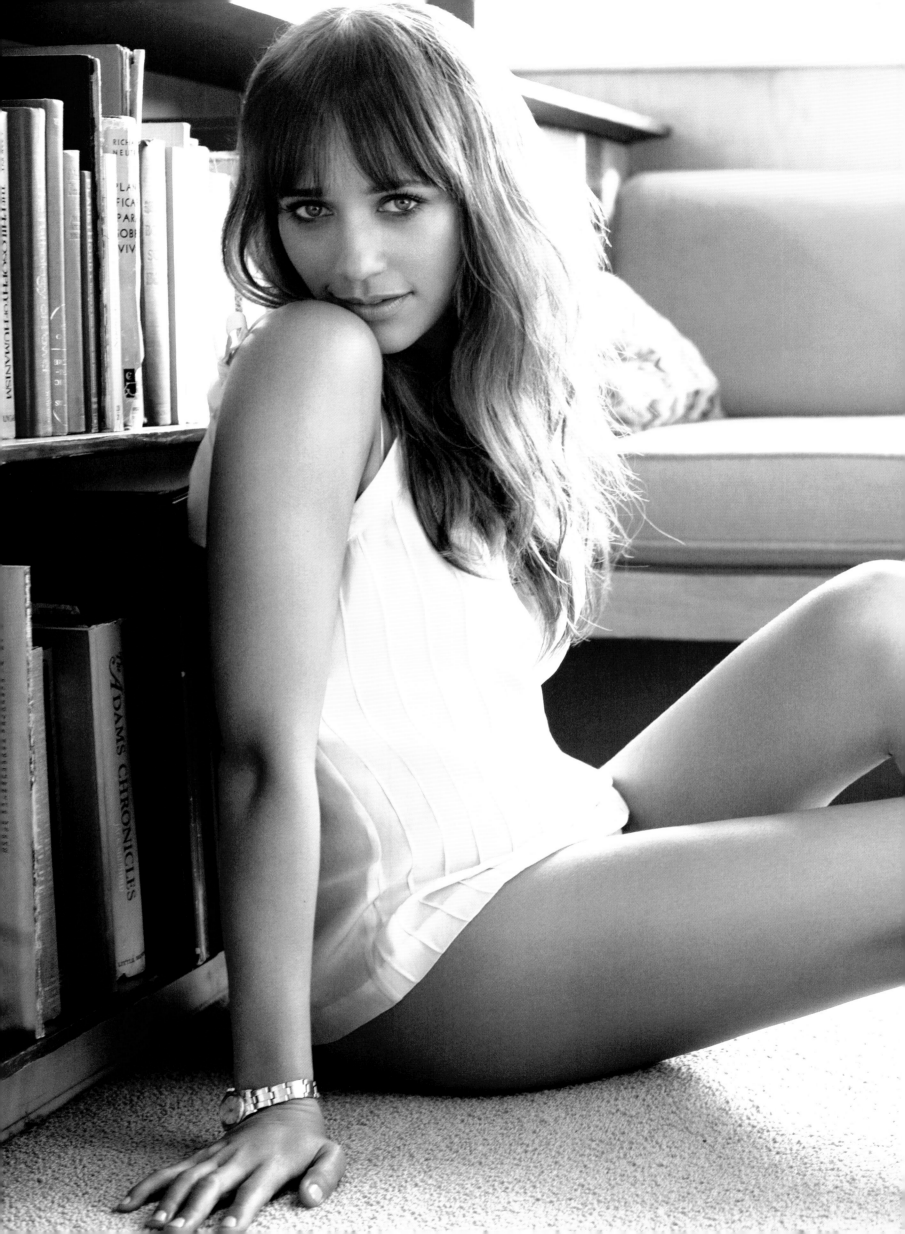

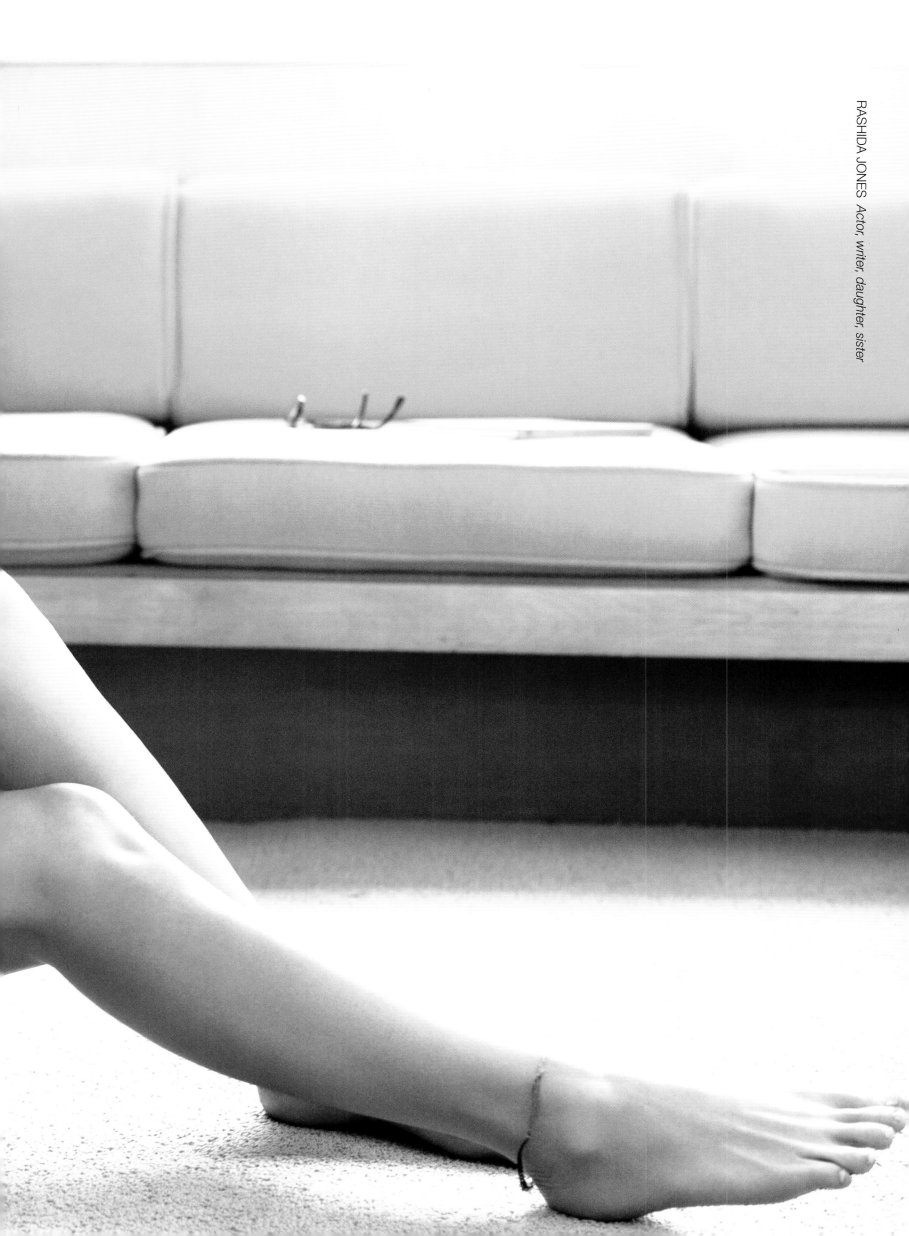

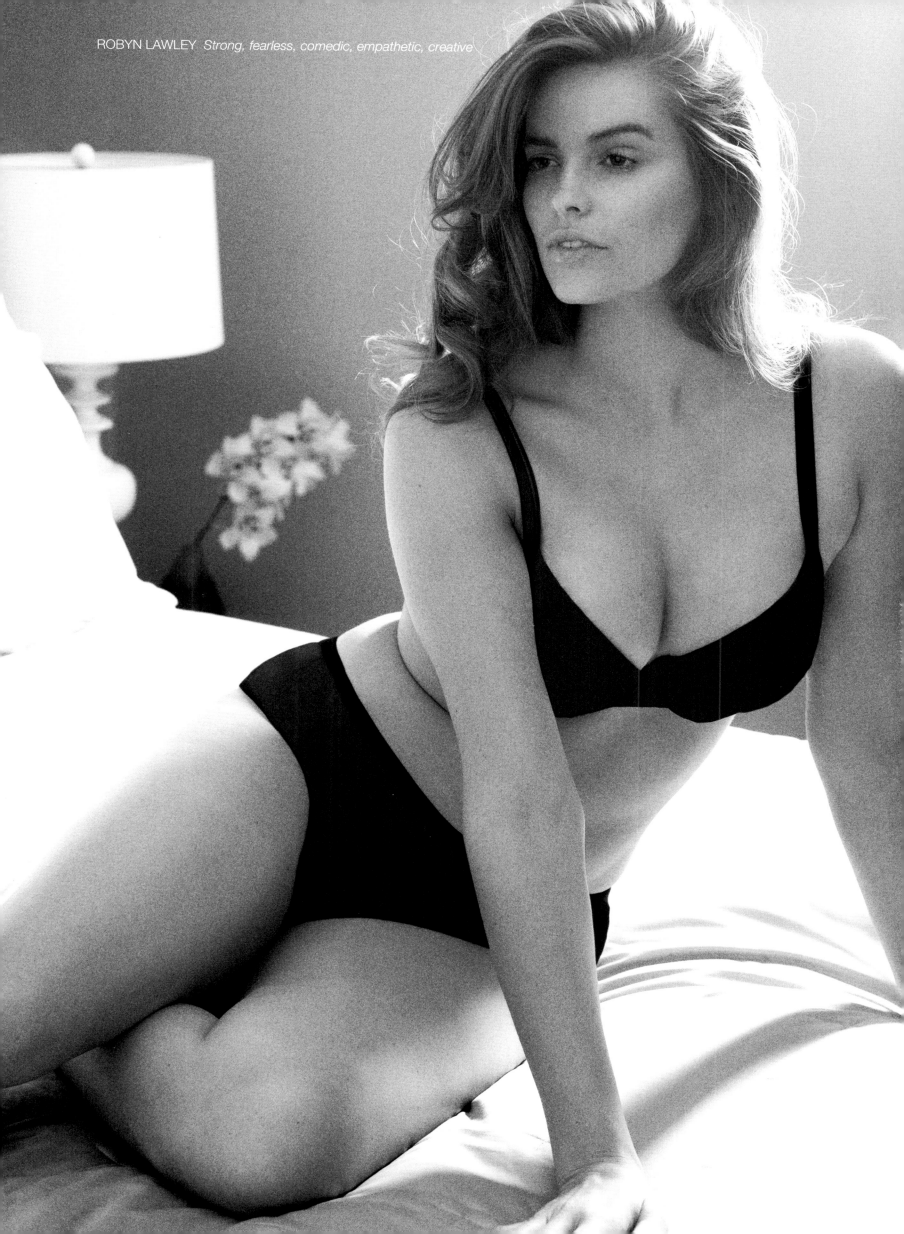

ROBYN LAWLEY *Strong, fearless, comedic, empathetic, creative*

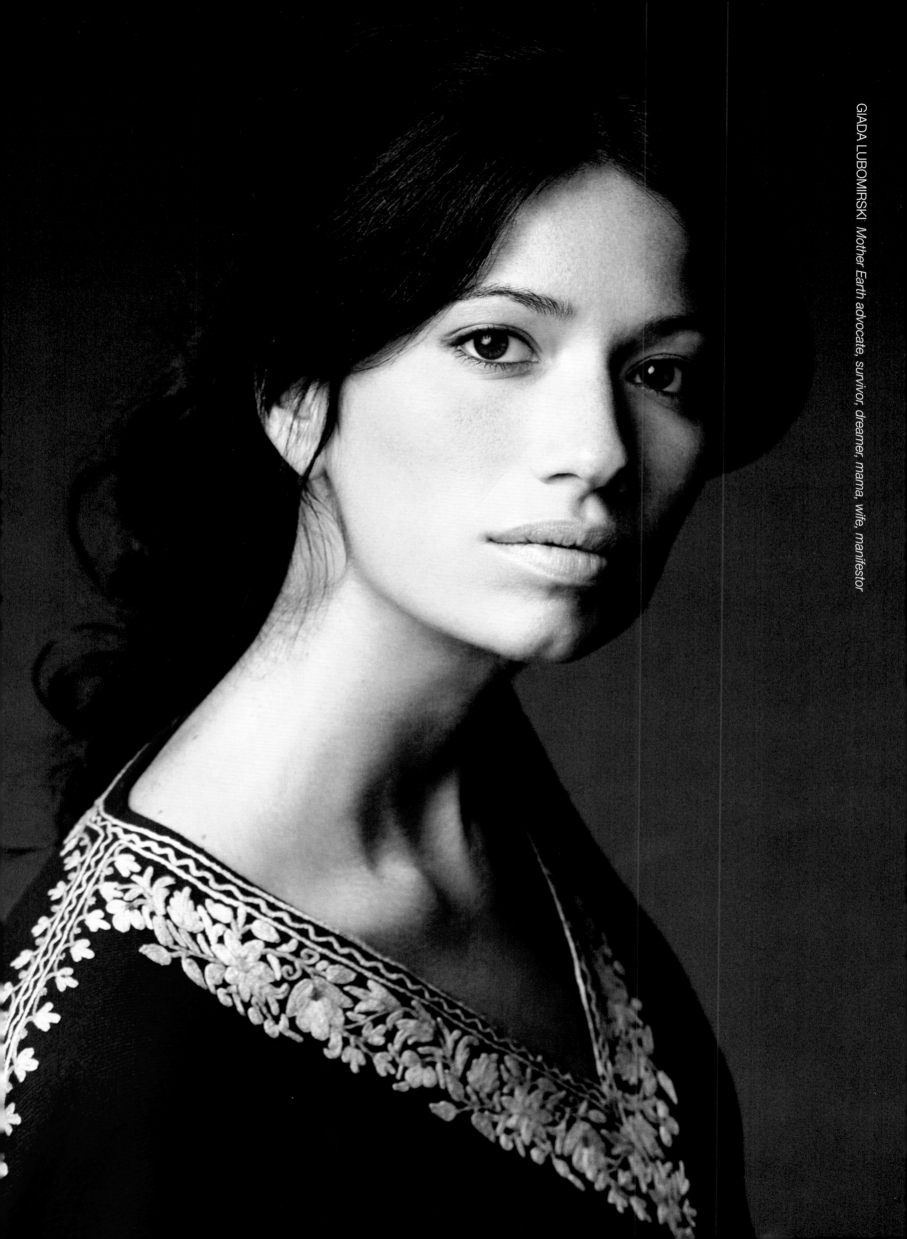

GIADA LUBOMIRSKI *Mother Earth advocate, survivor, dreamer, mama, wife, manifestor*

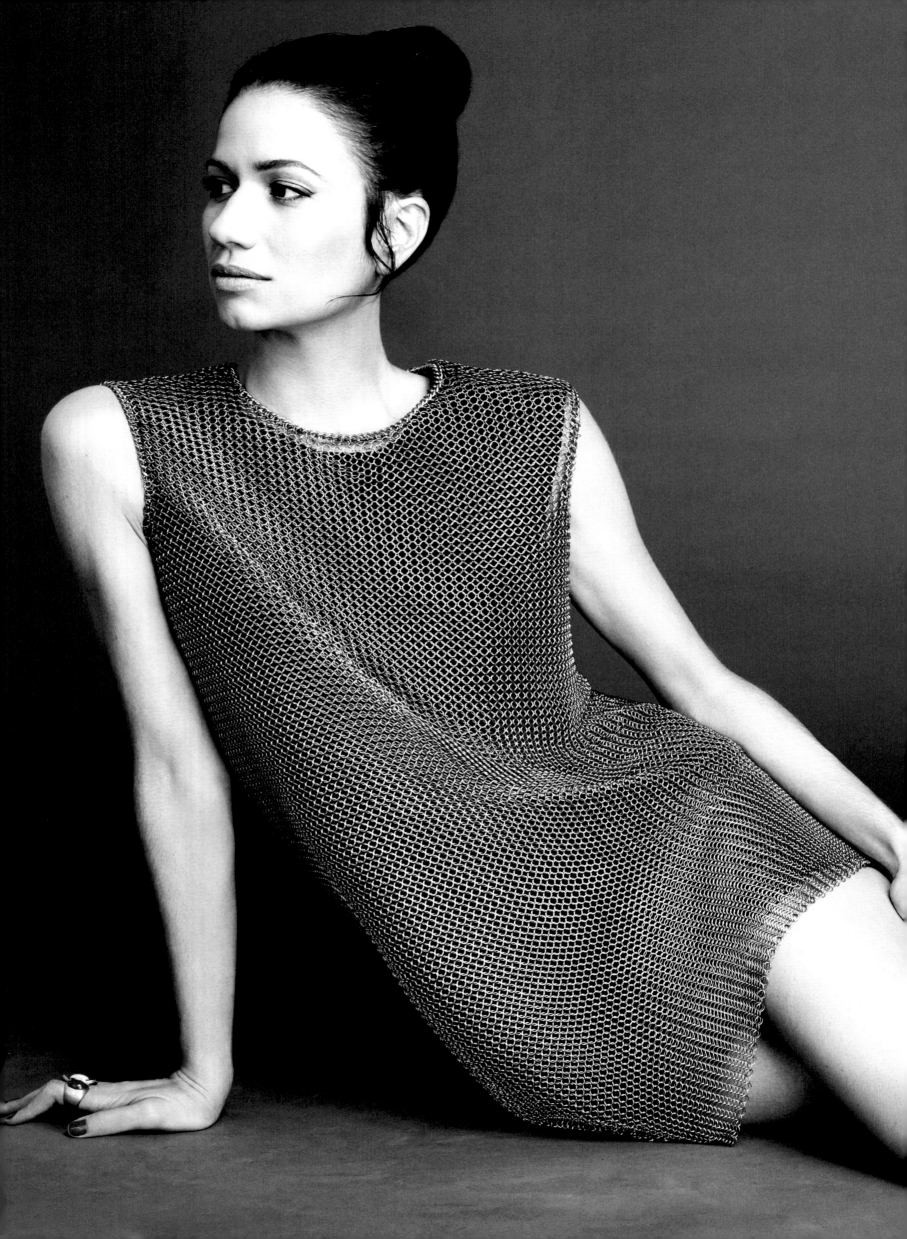

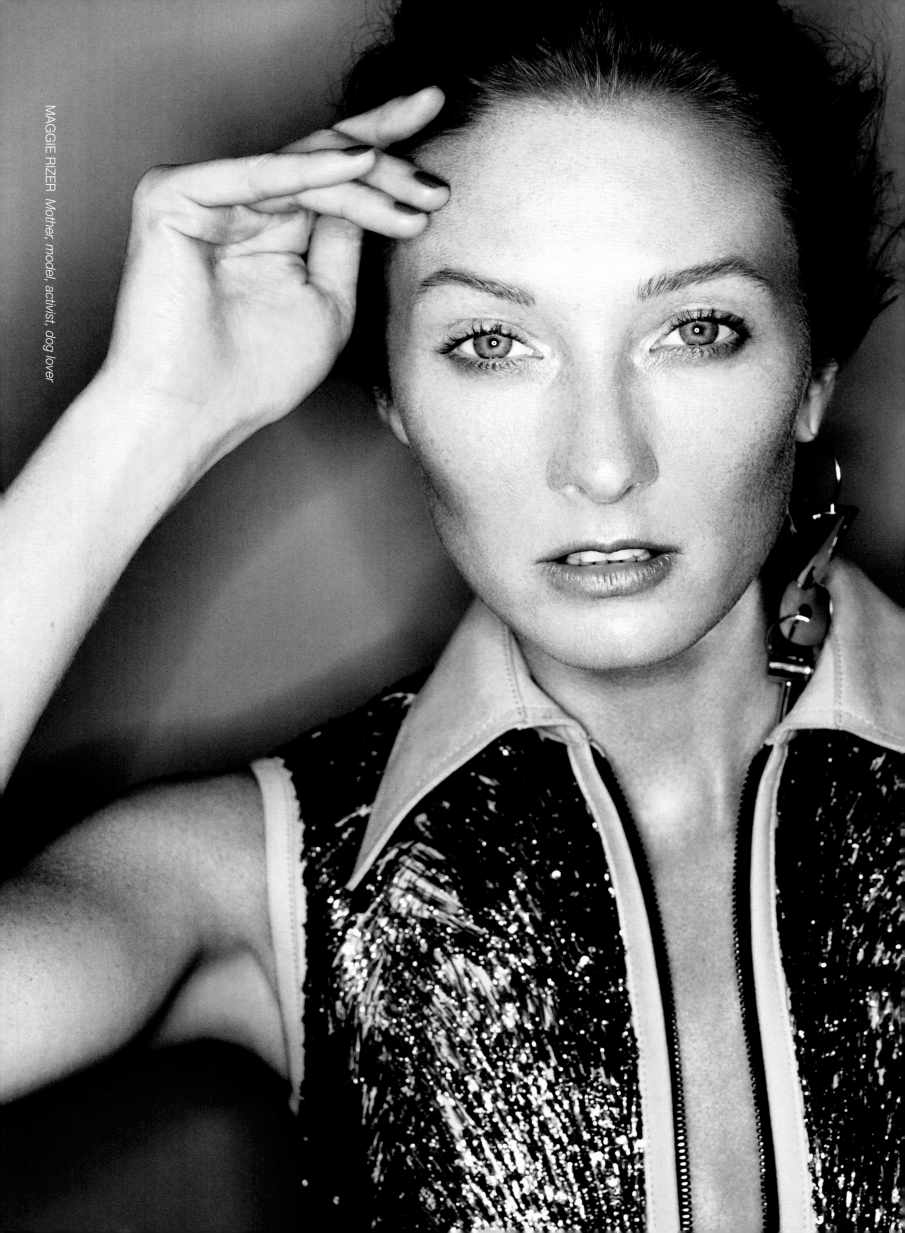

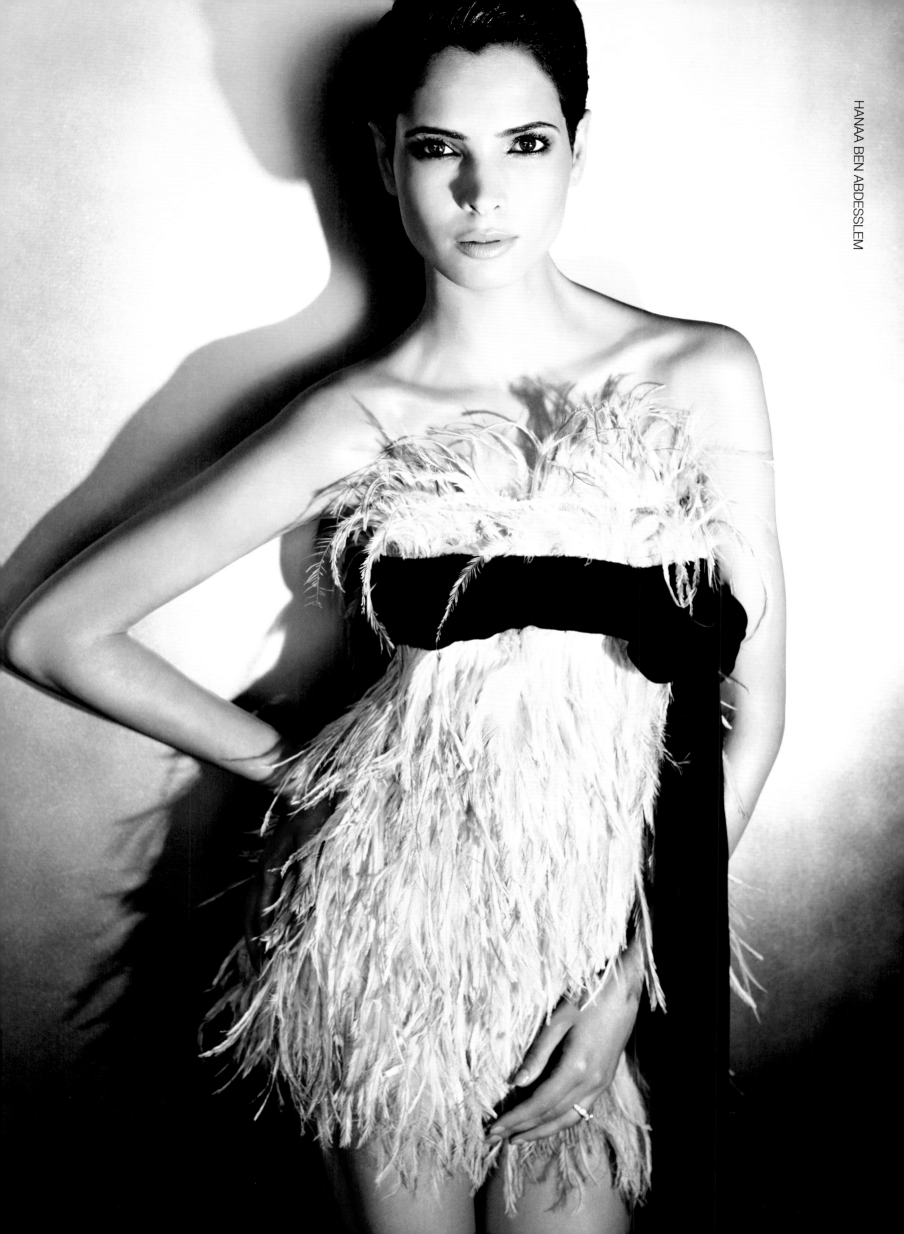

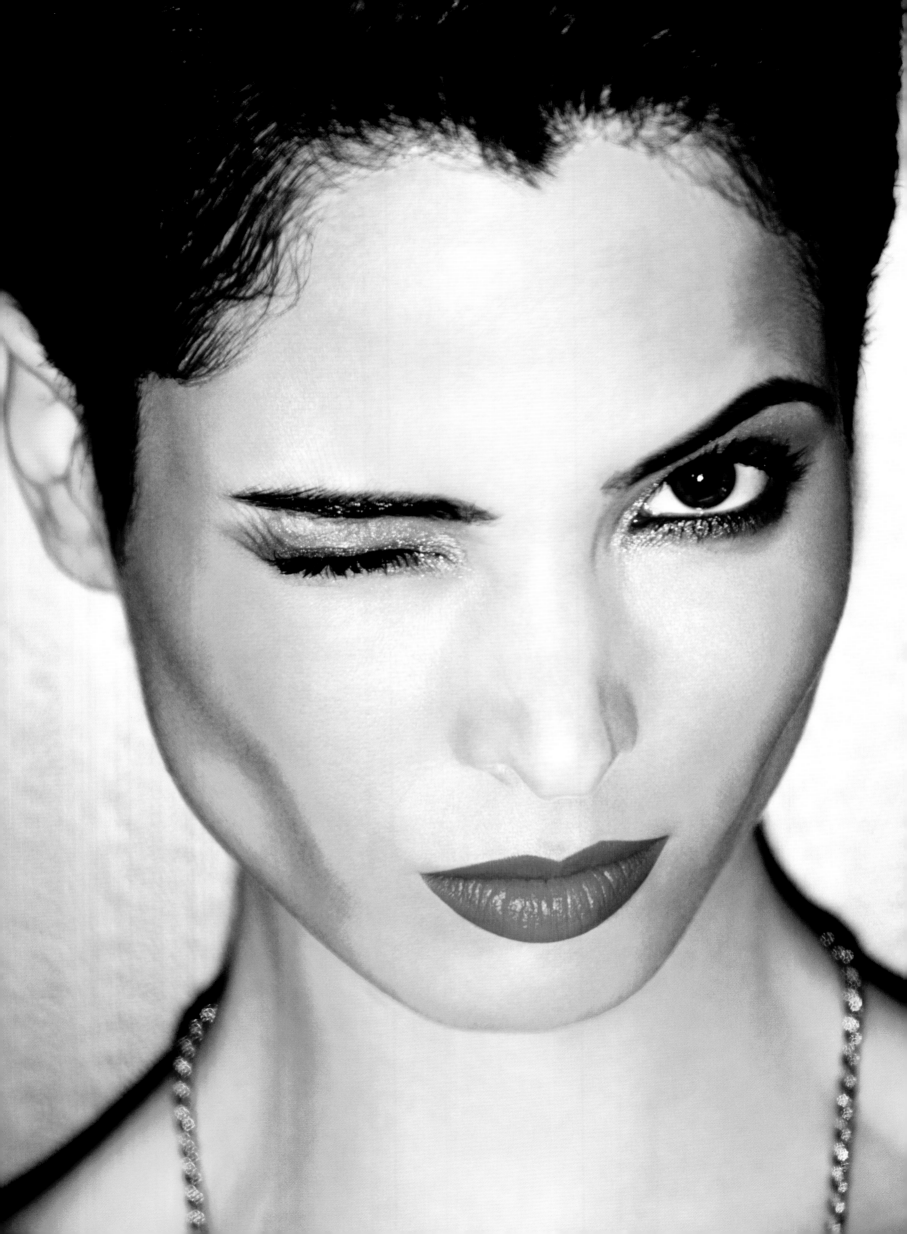

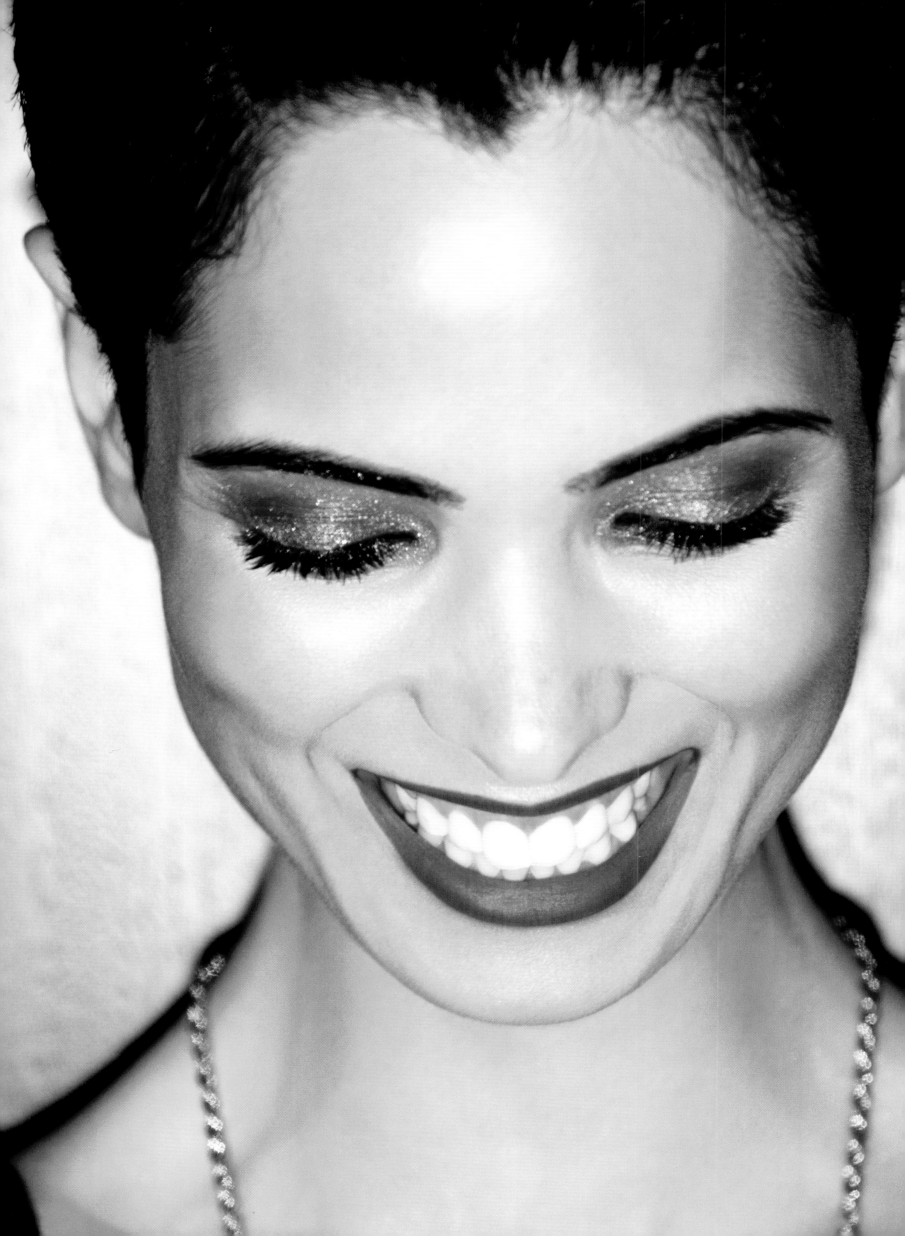

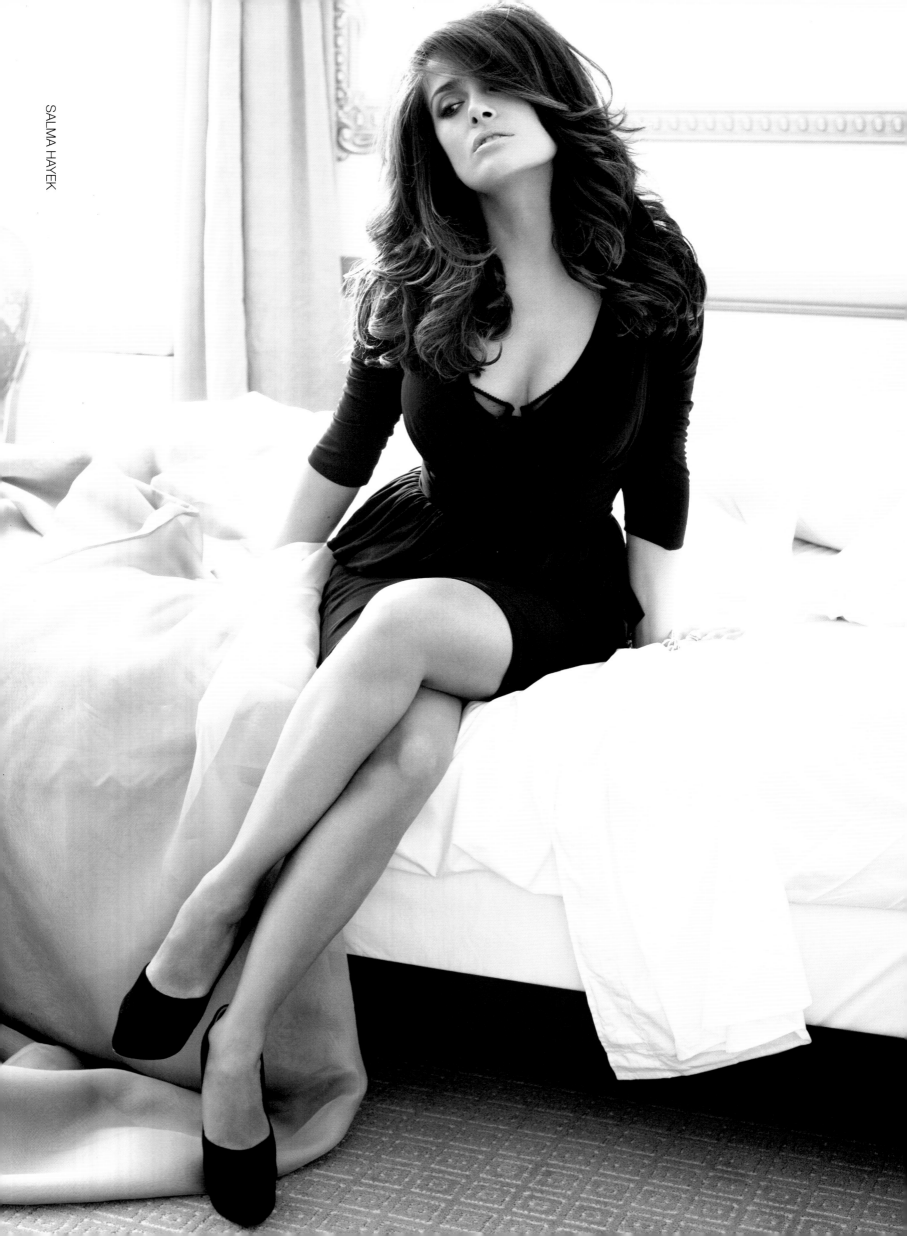

SALMA HAYEK

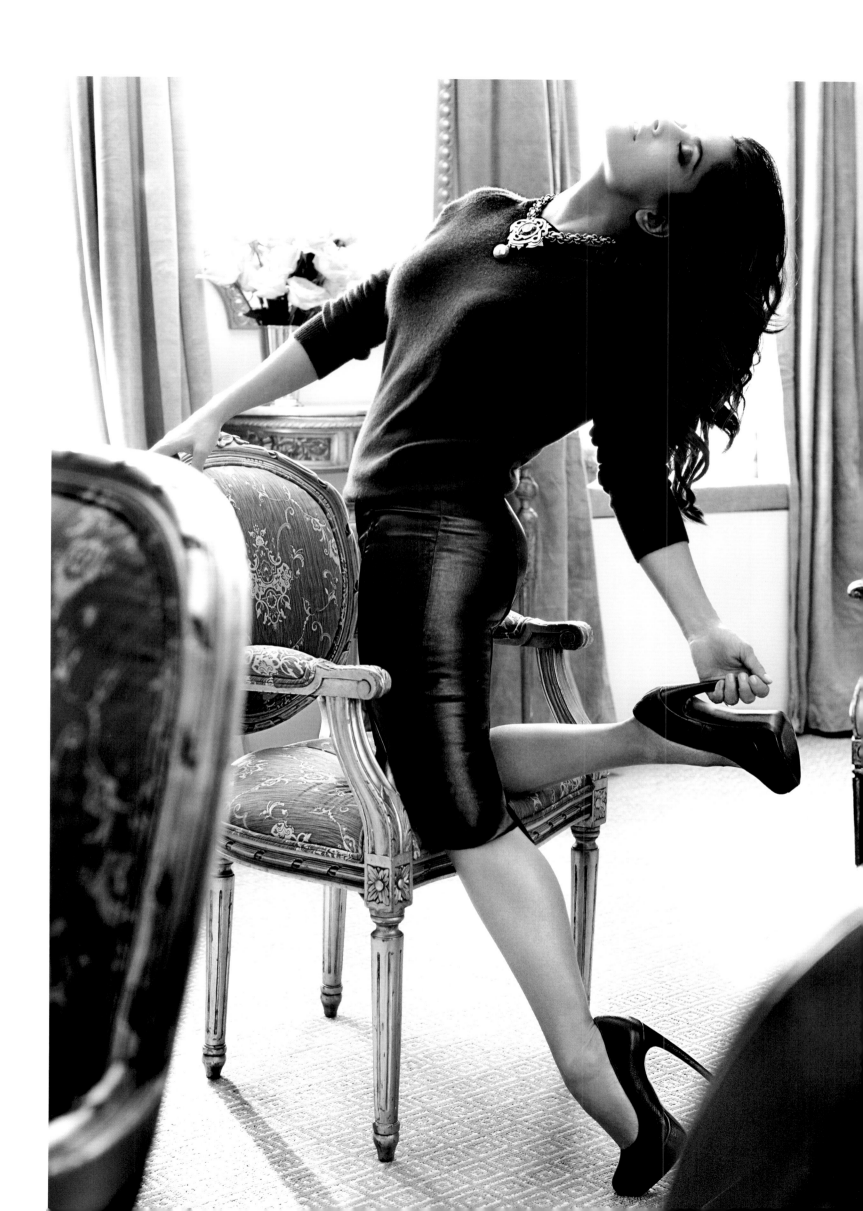

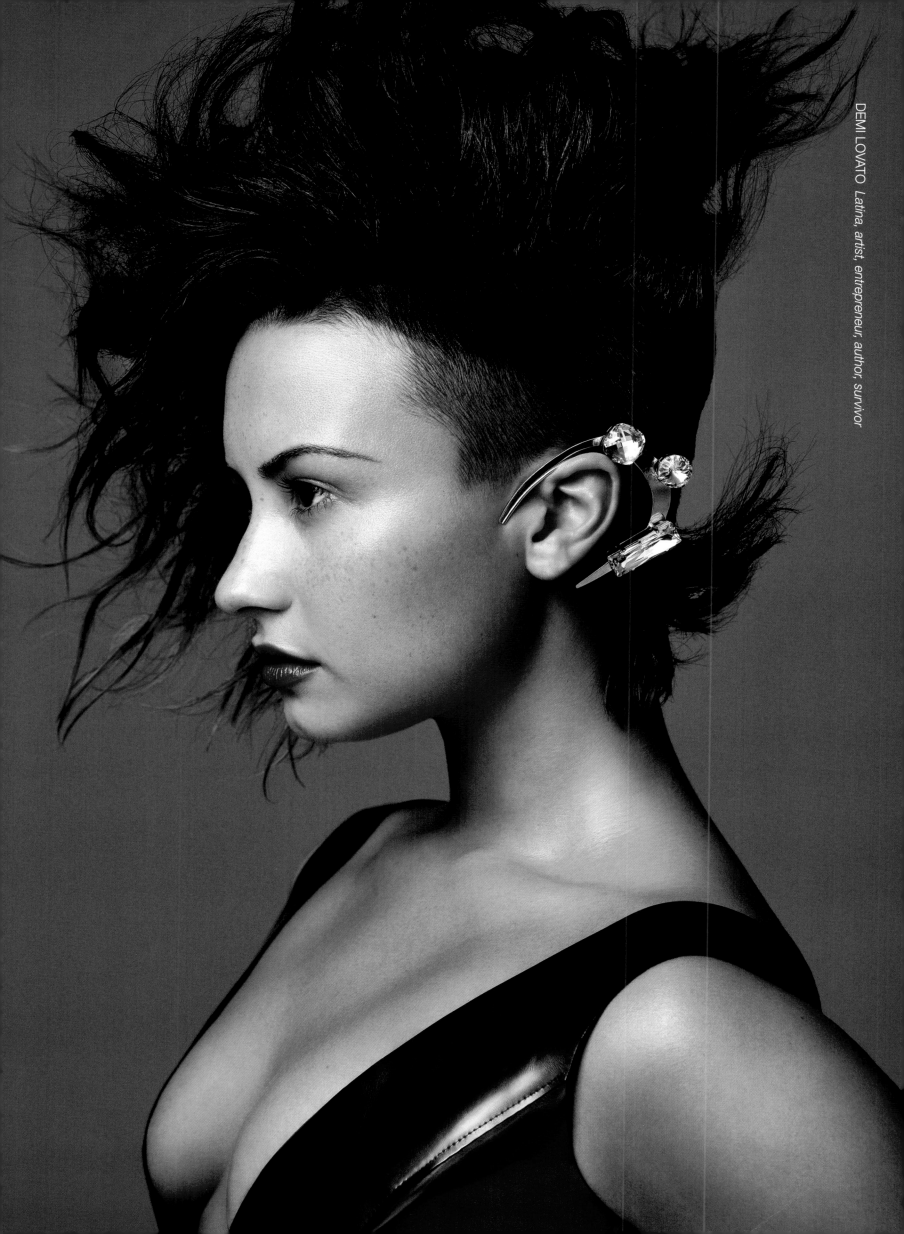

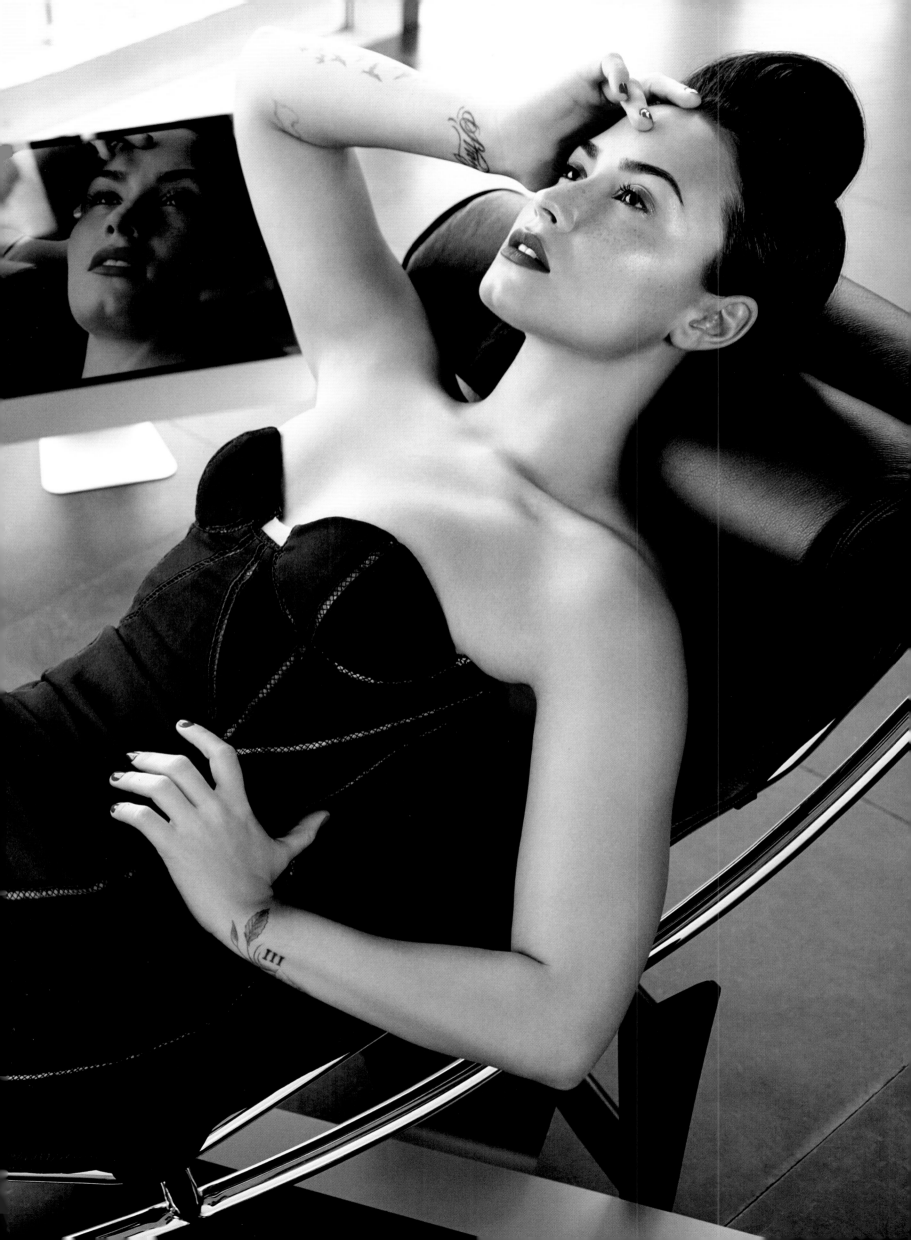

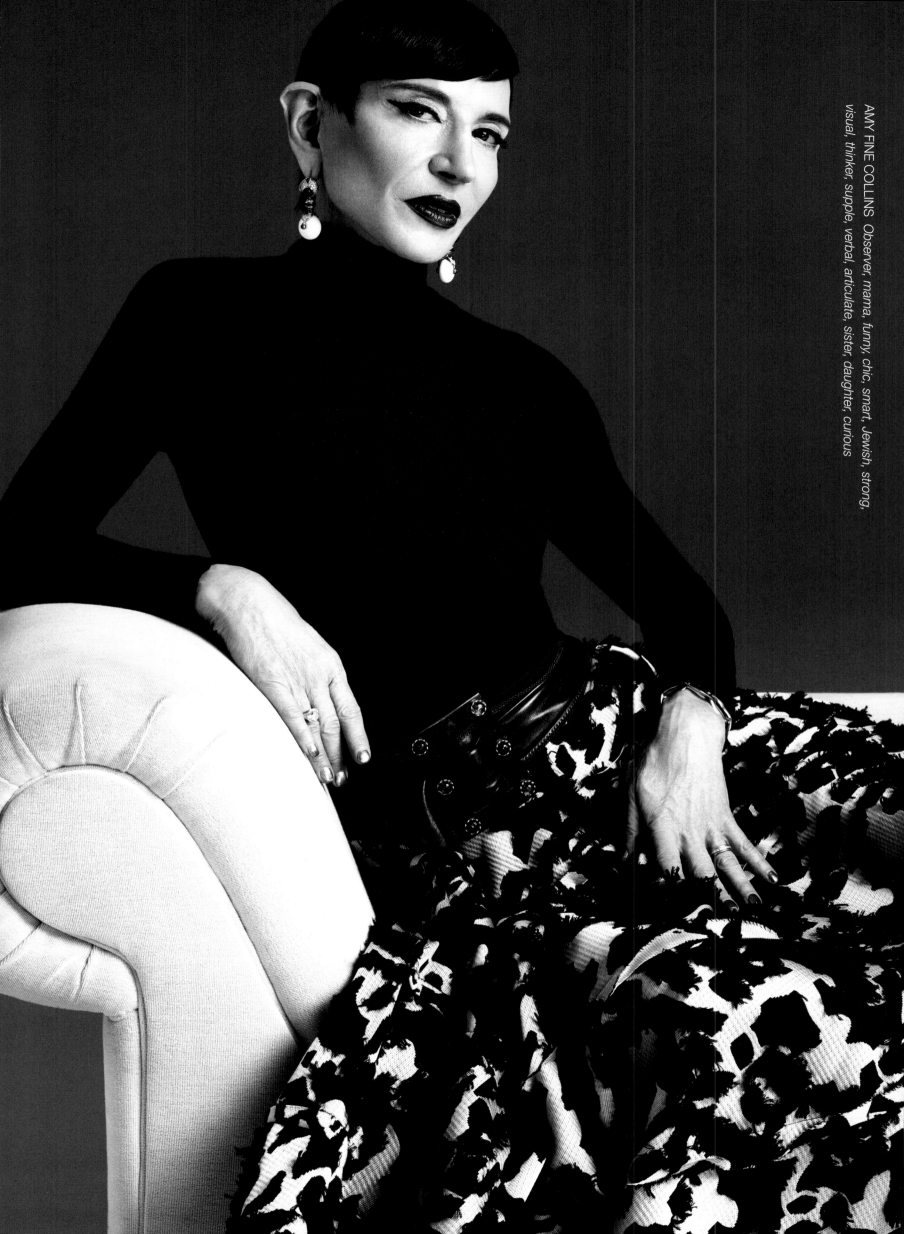

AMY FINE COLLINS *Observer, mama, funny, chic, smart, Jewish, strong, visual, thinker, supple, verbal, articulate, sister, daughter, curious*

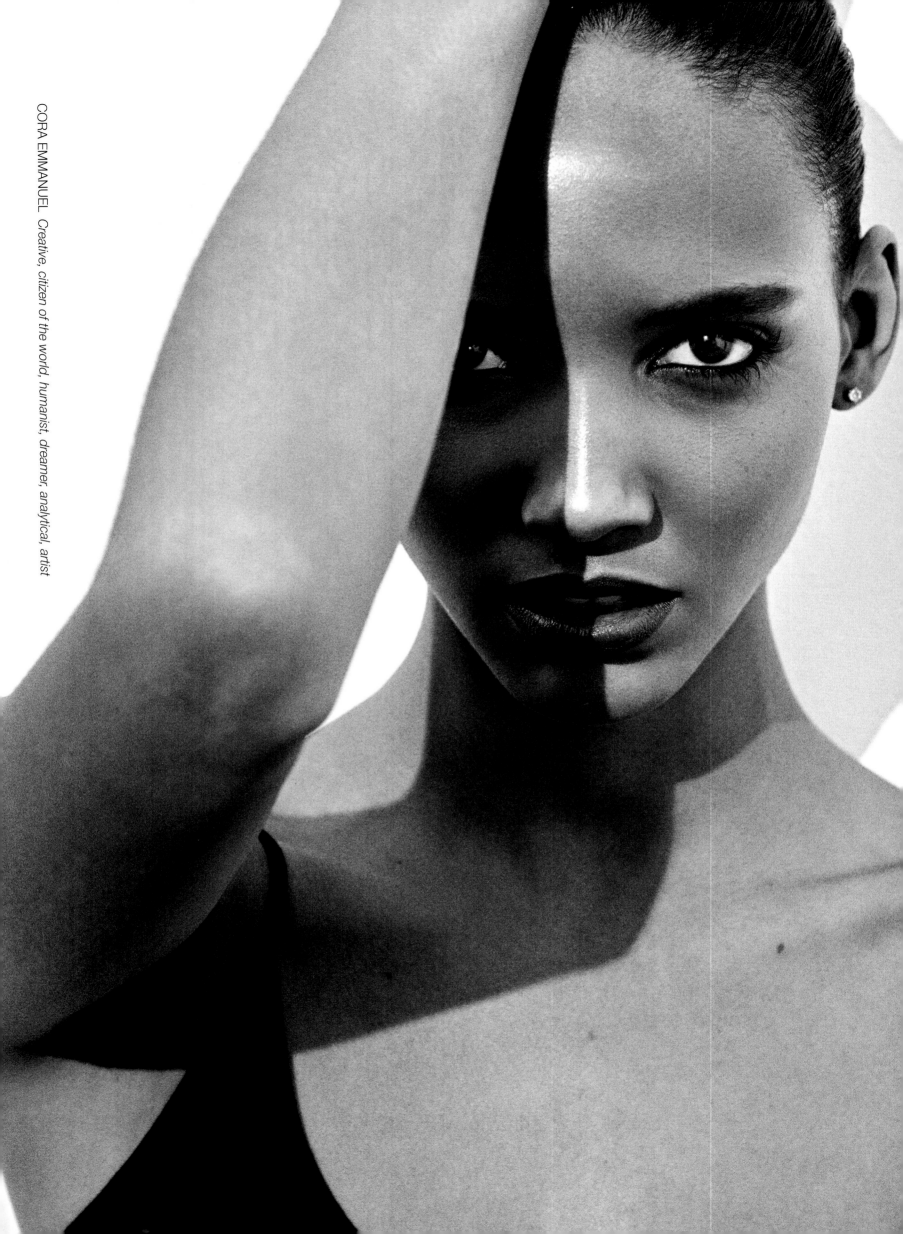

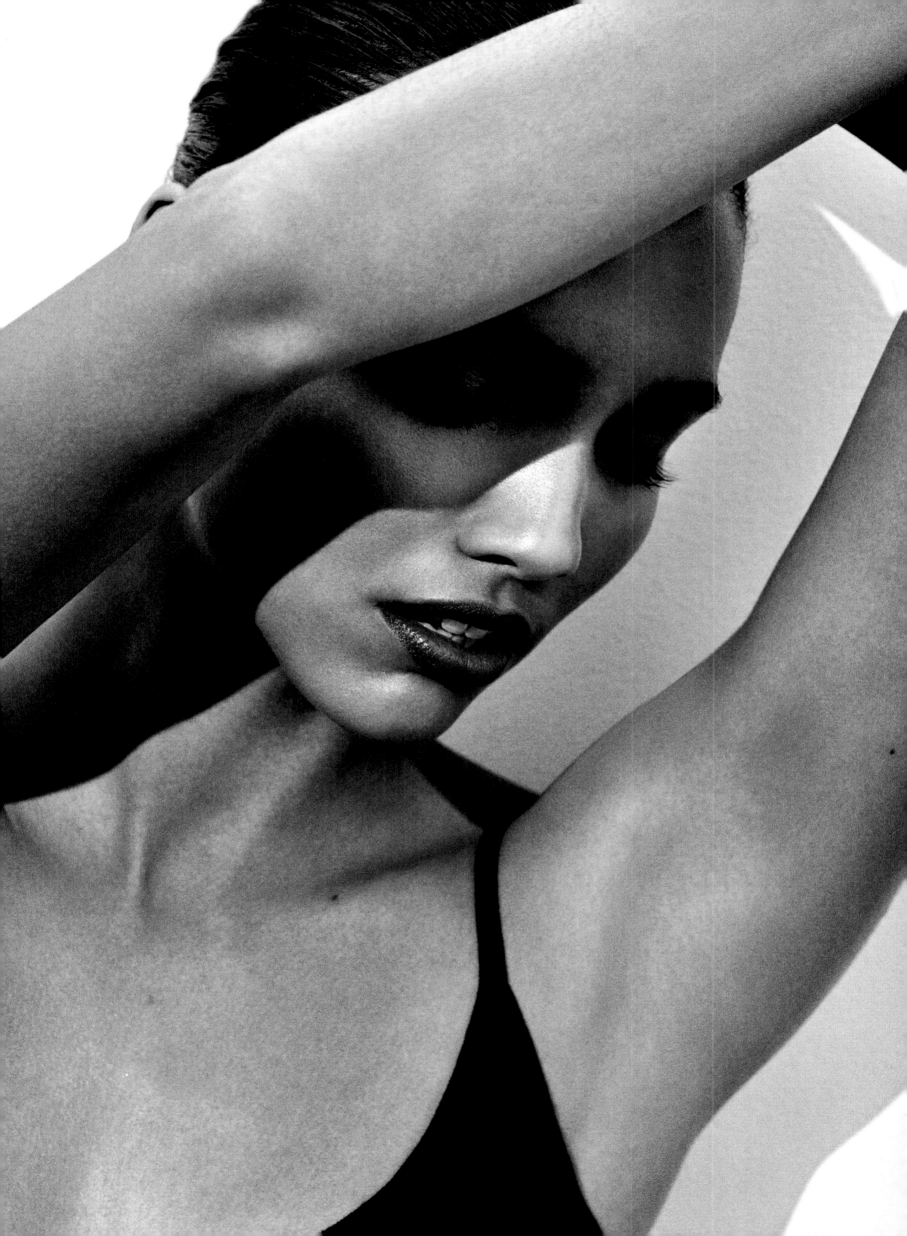

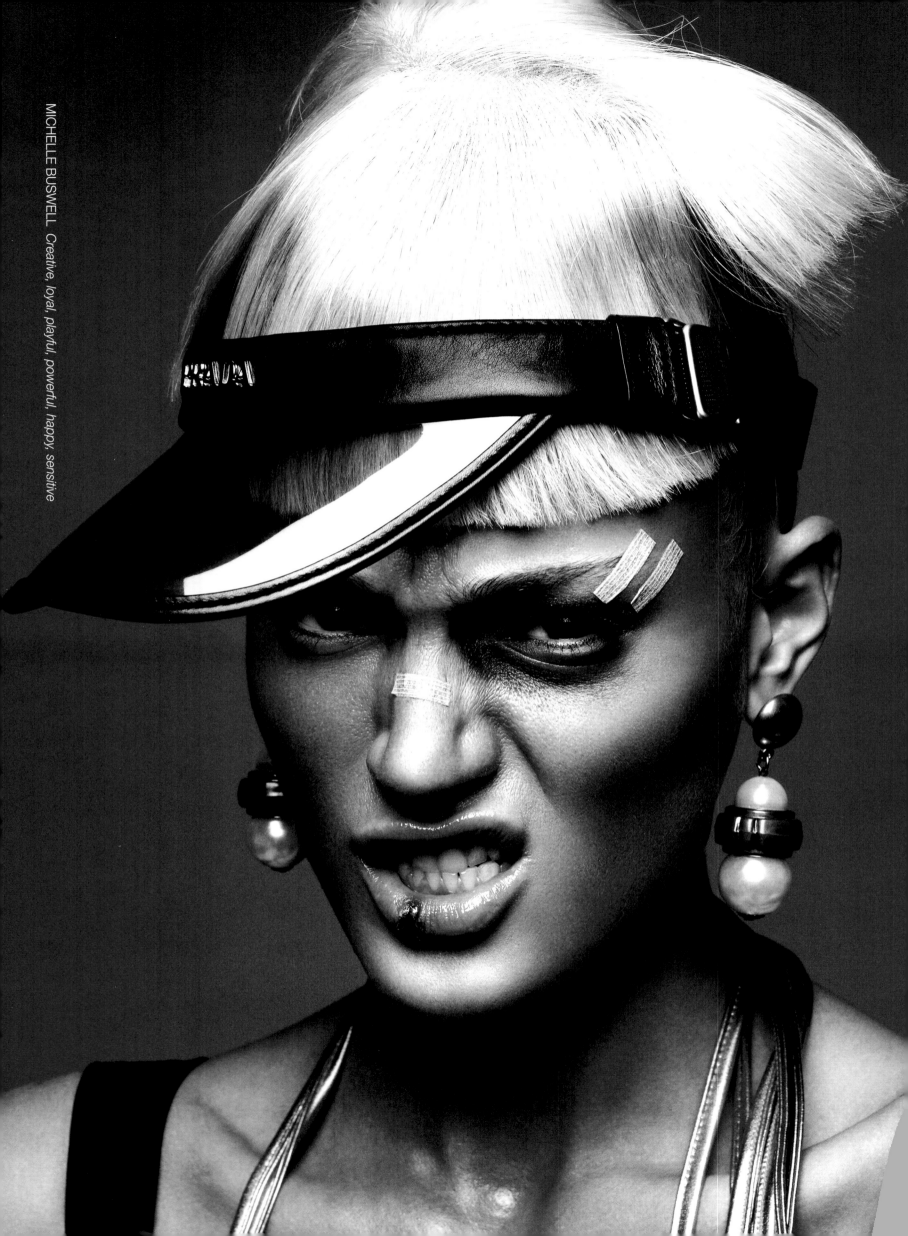

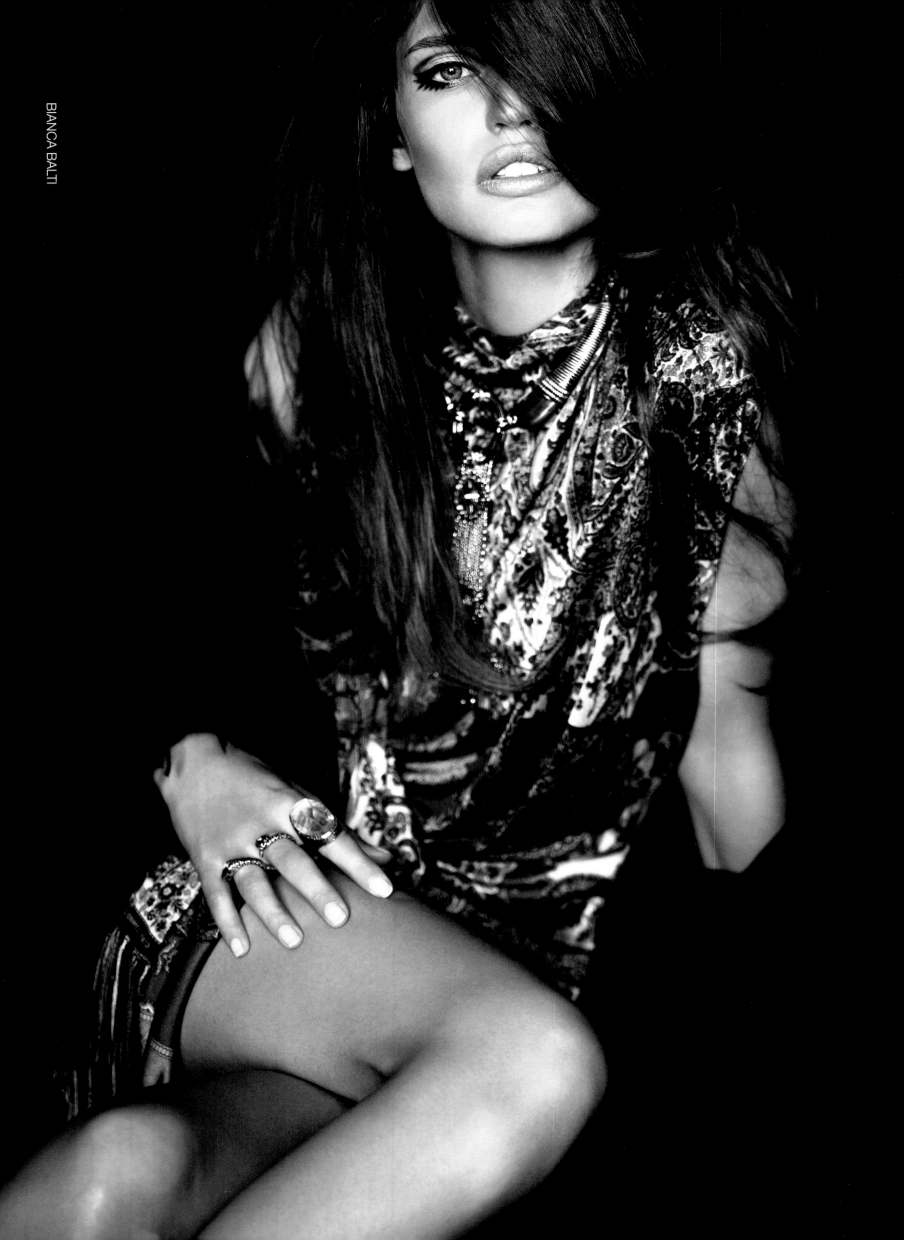

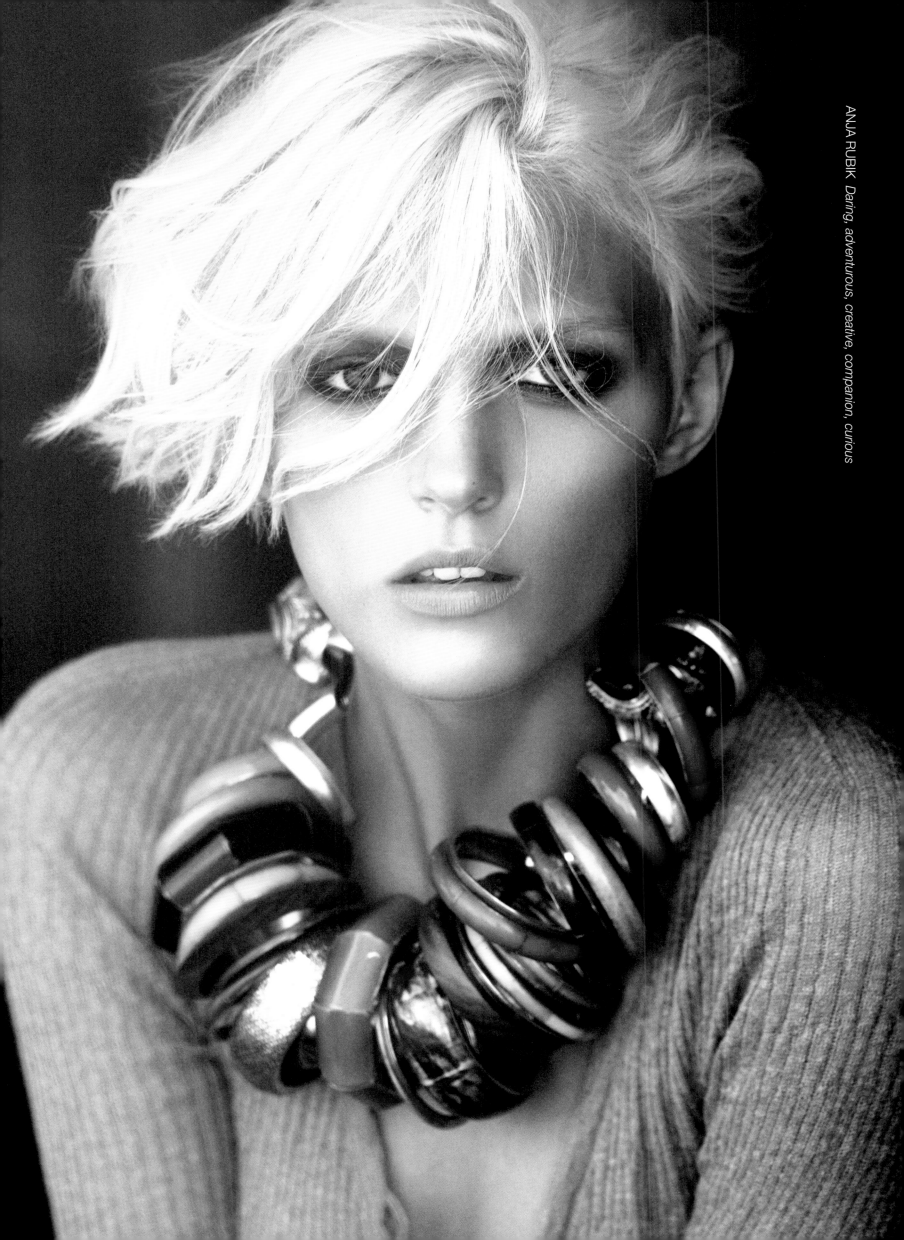

ANJA RUBIK *Daring, adventurous, creative, companion, curious*

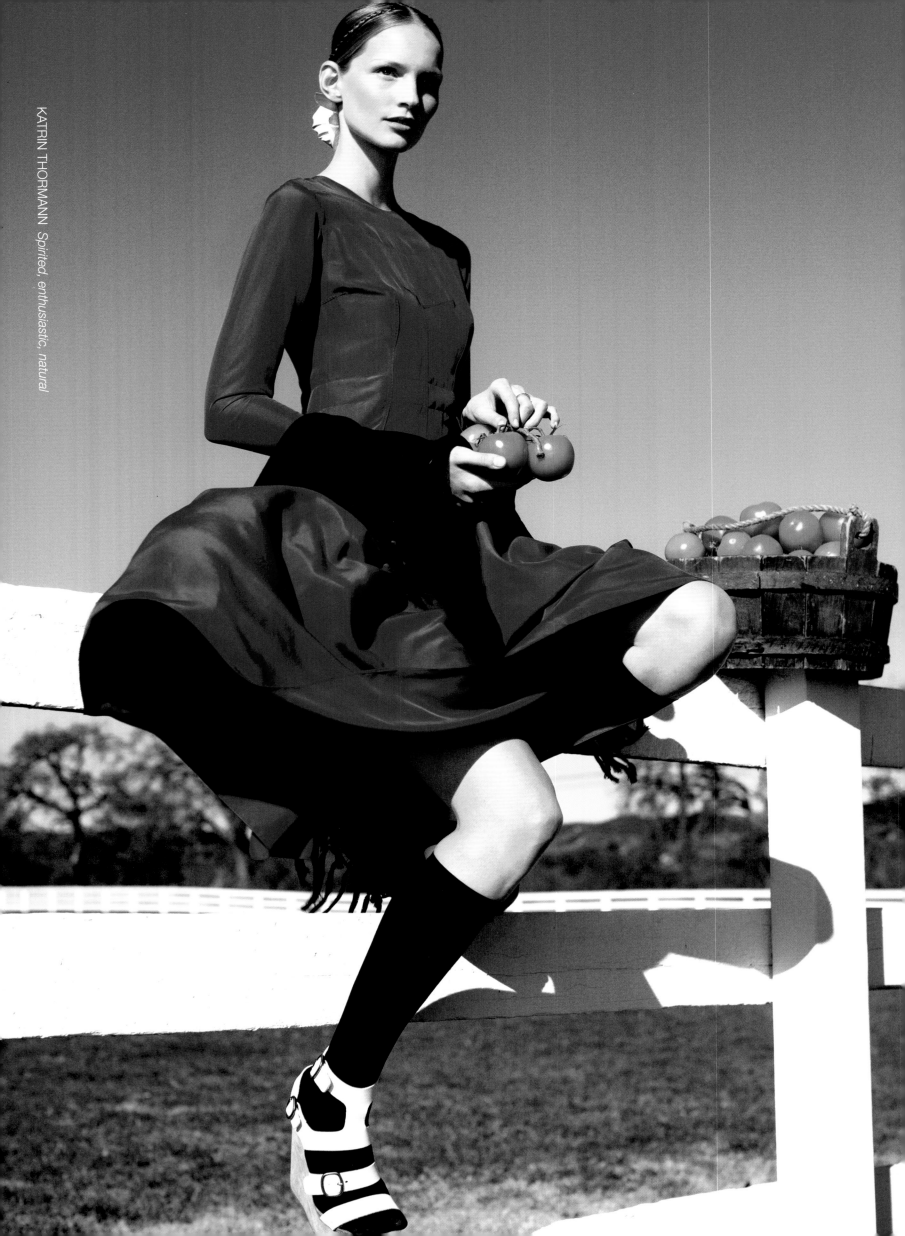

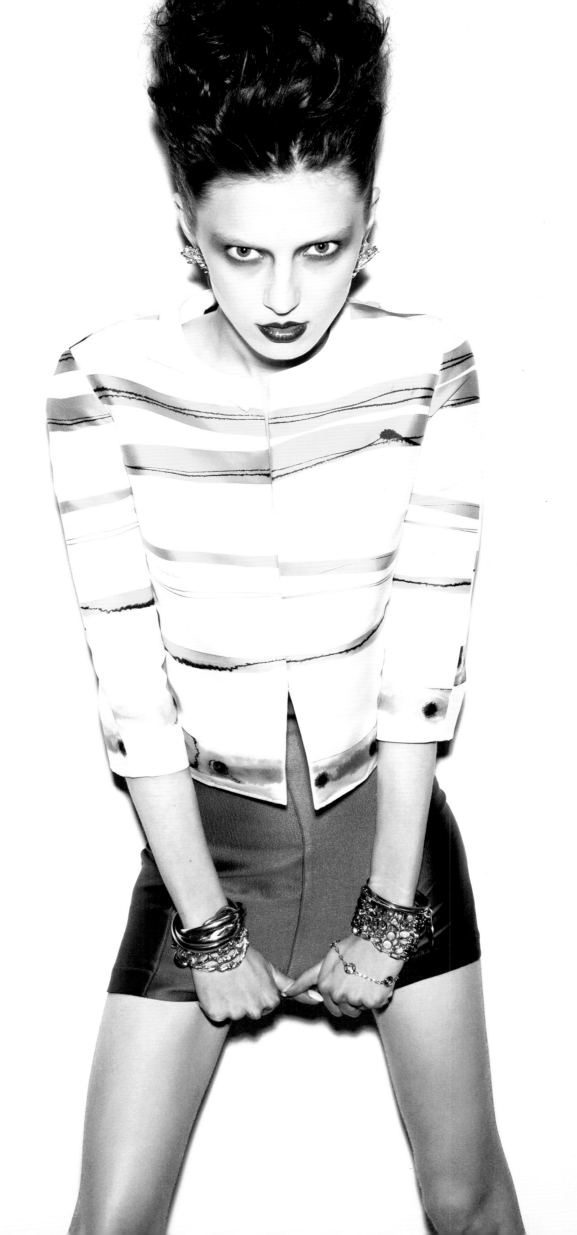

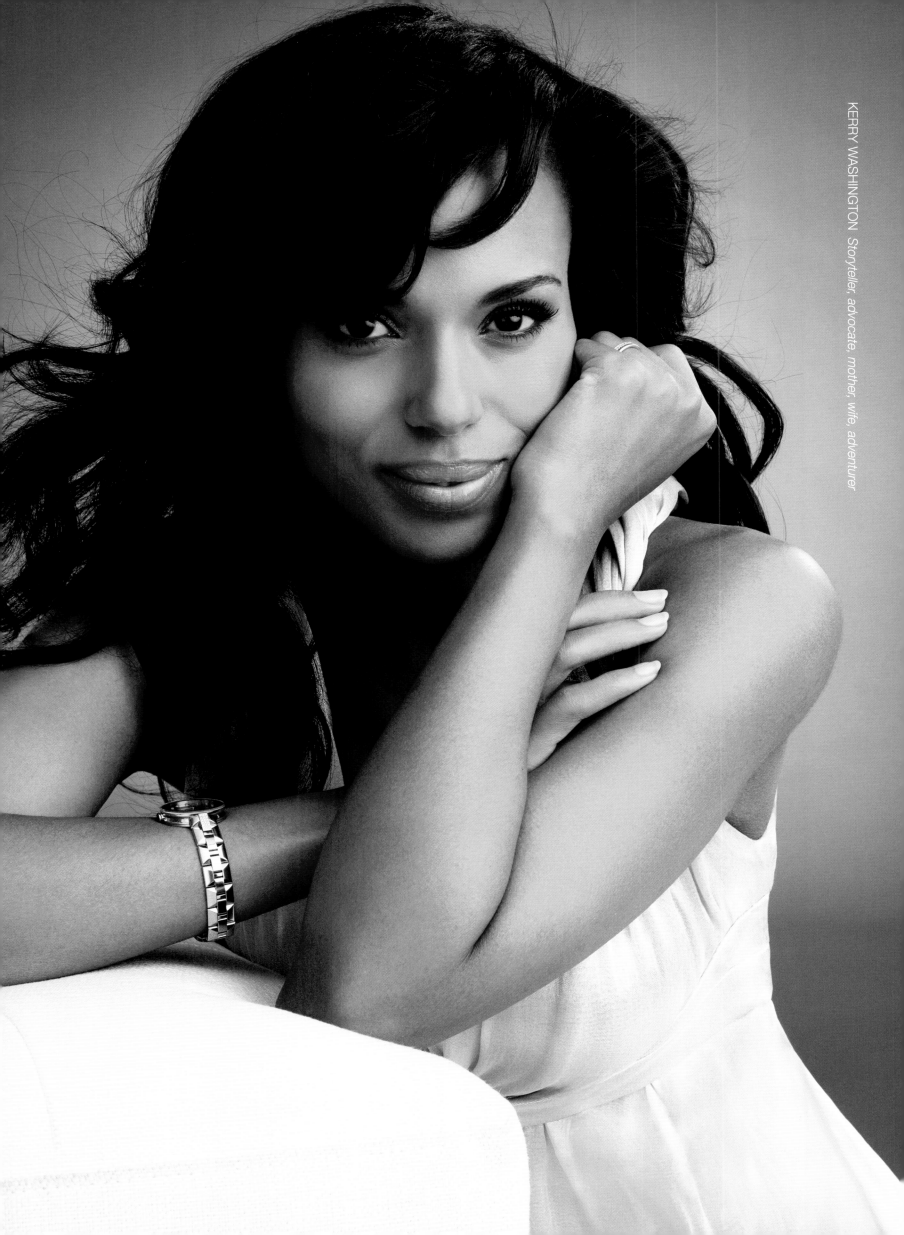

KERRY WASHINGTON *Storyteller, advocate, mother, wife, adventurer*

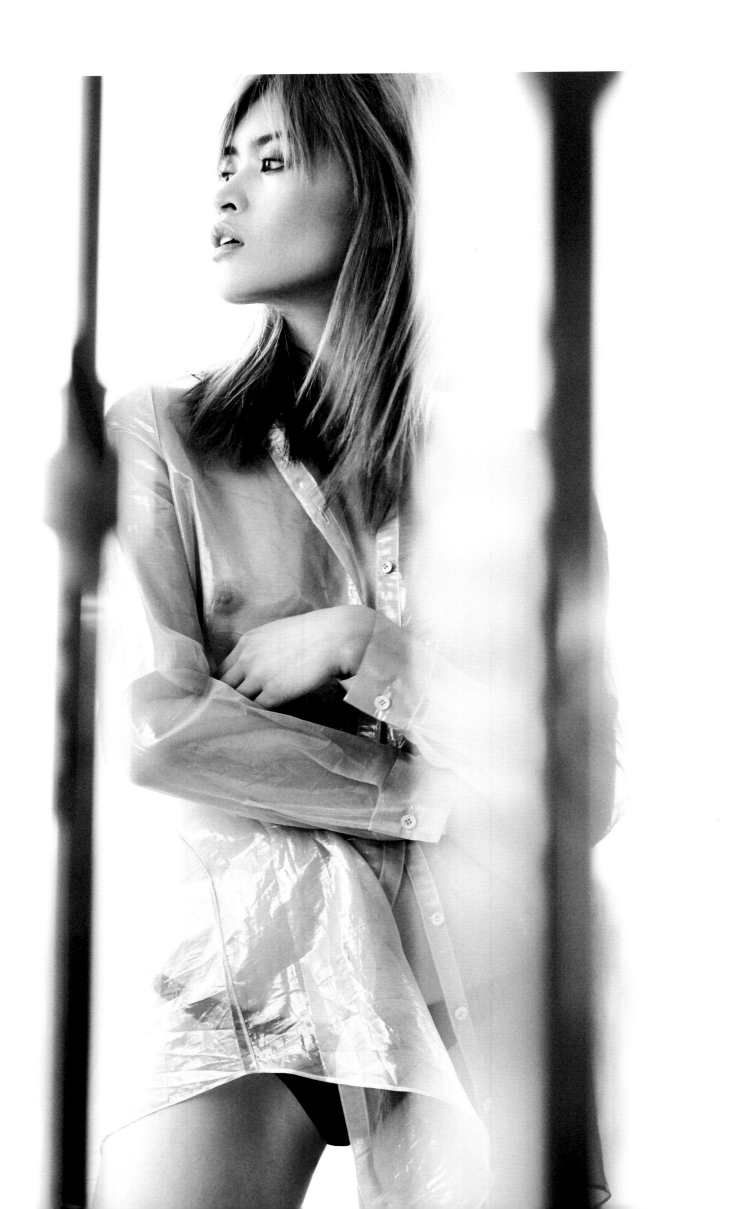

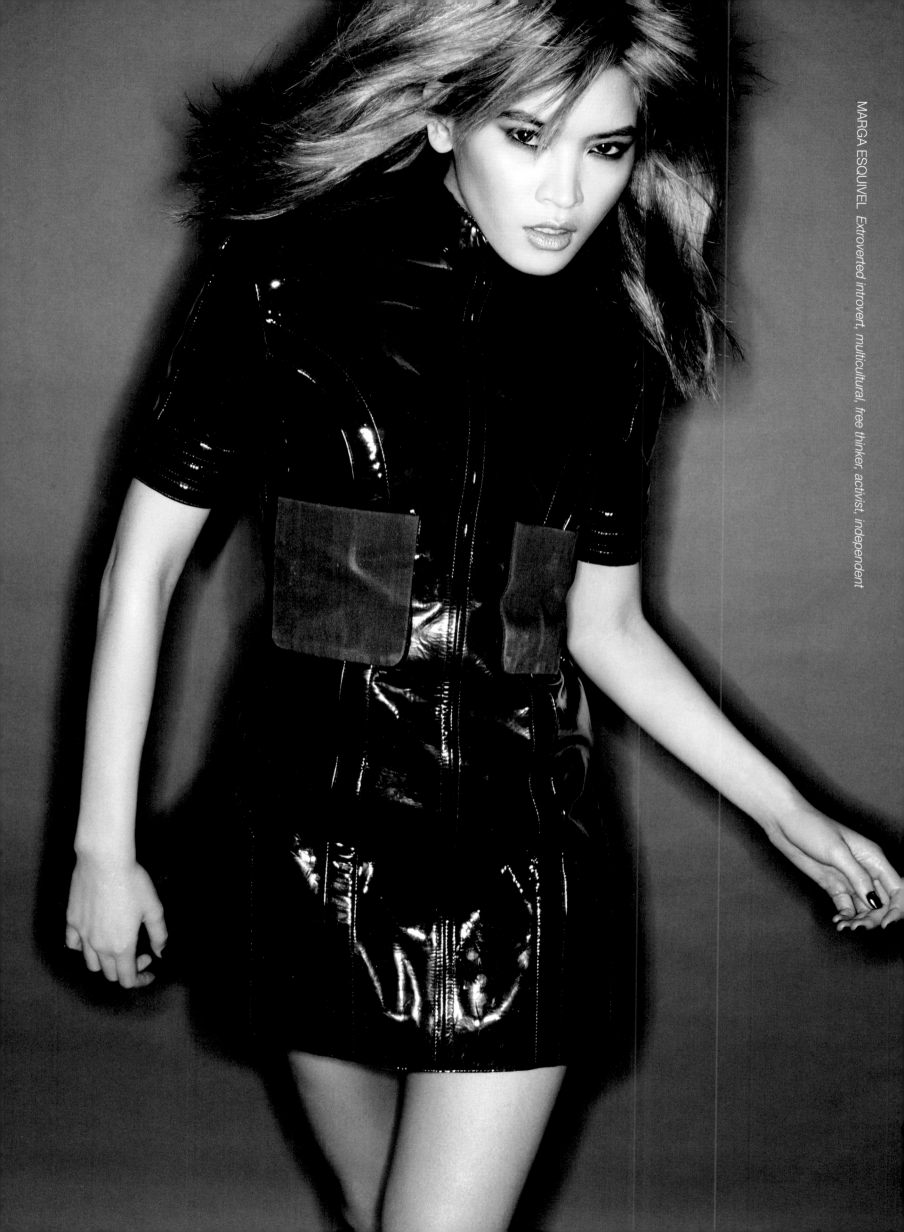

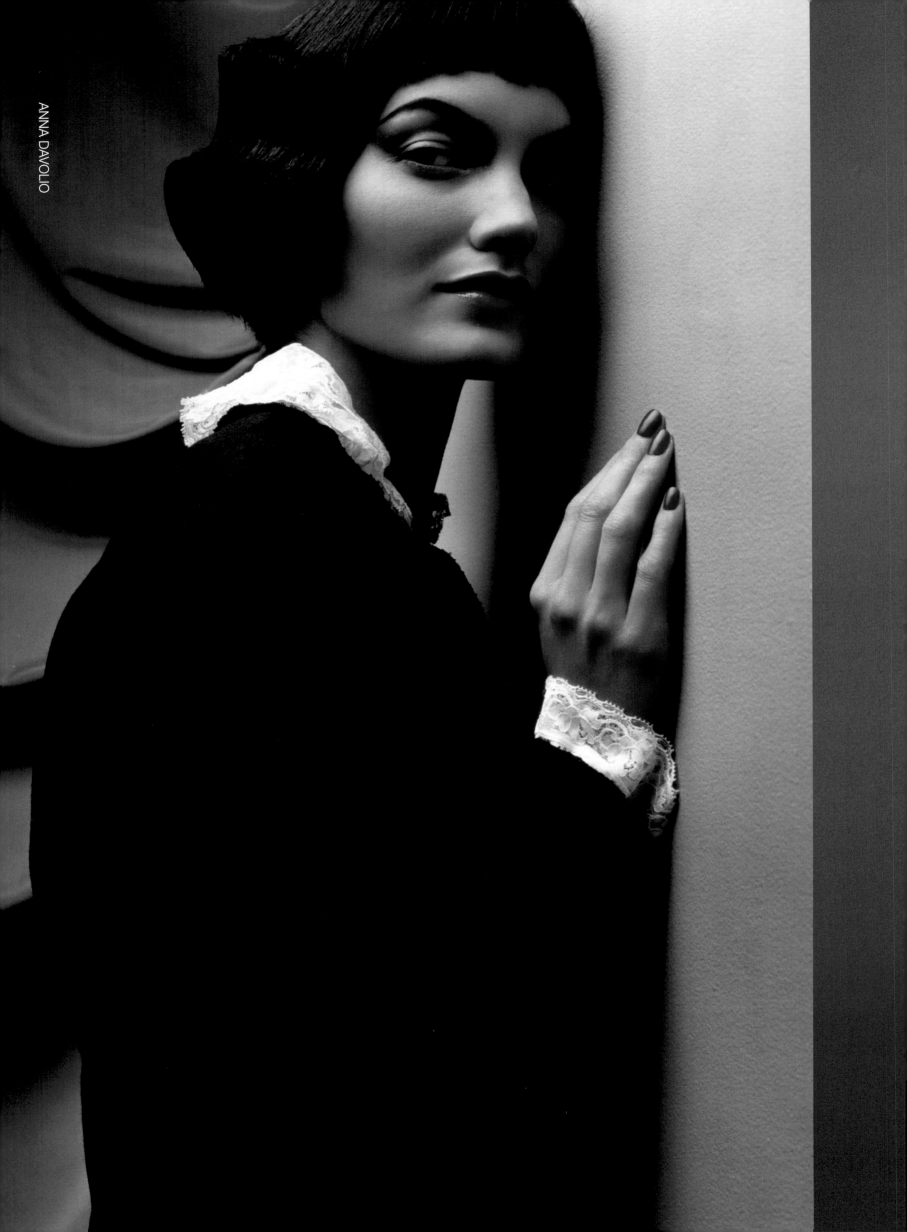

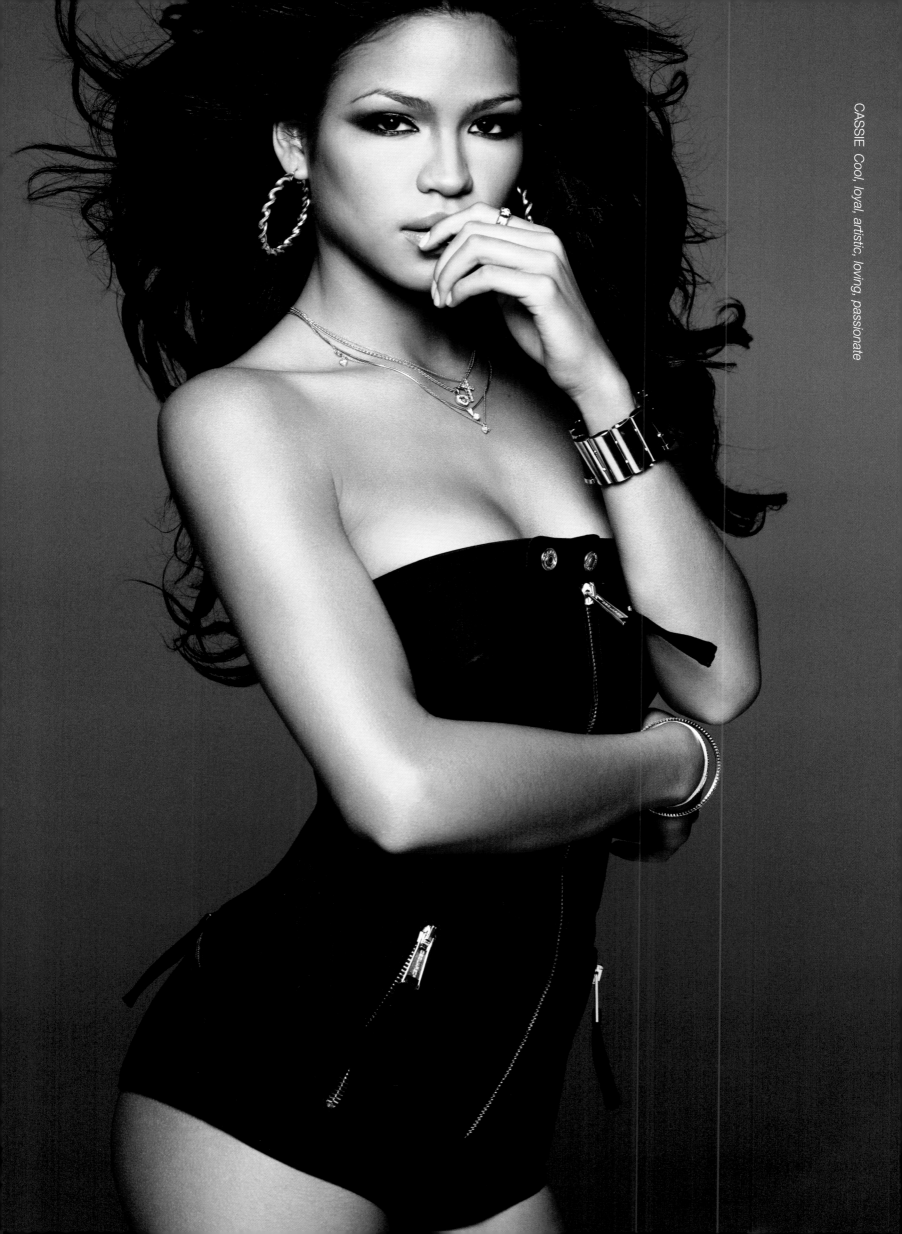

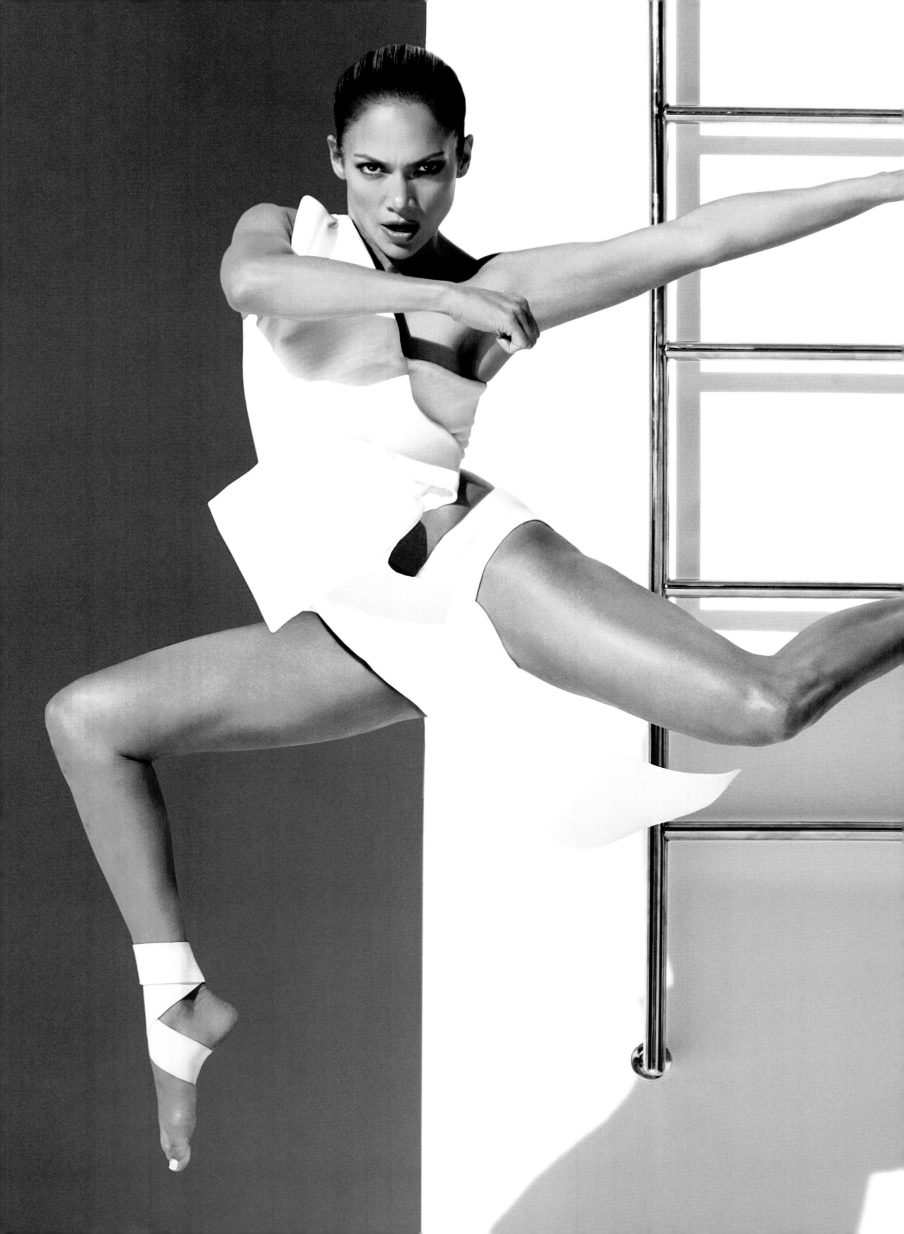

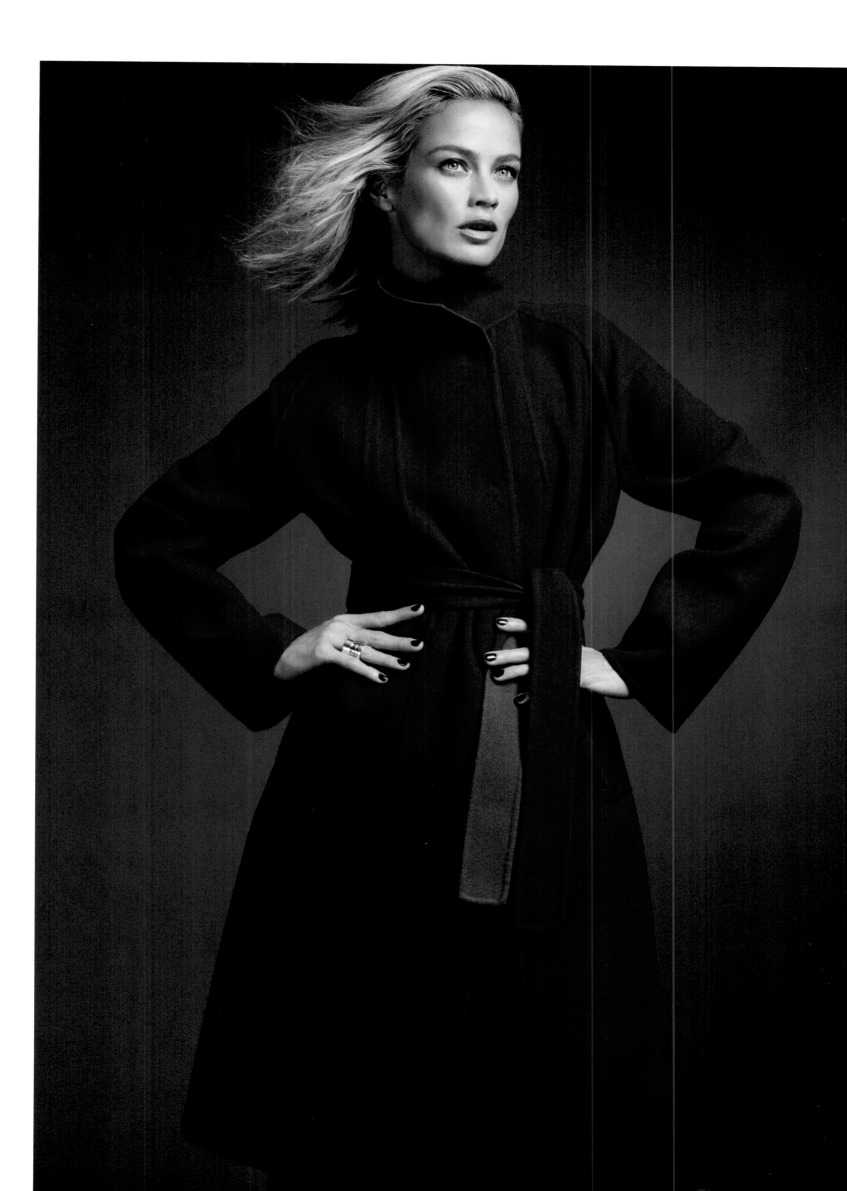

CHANEL IMAN

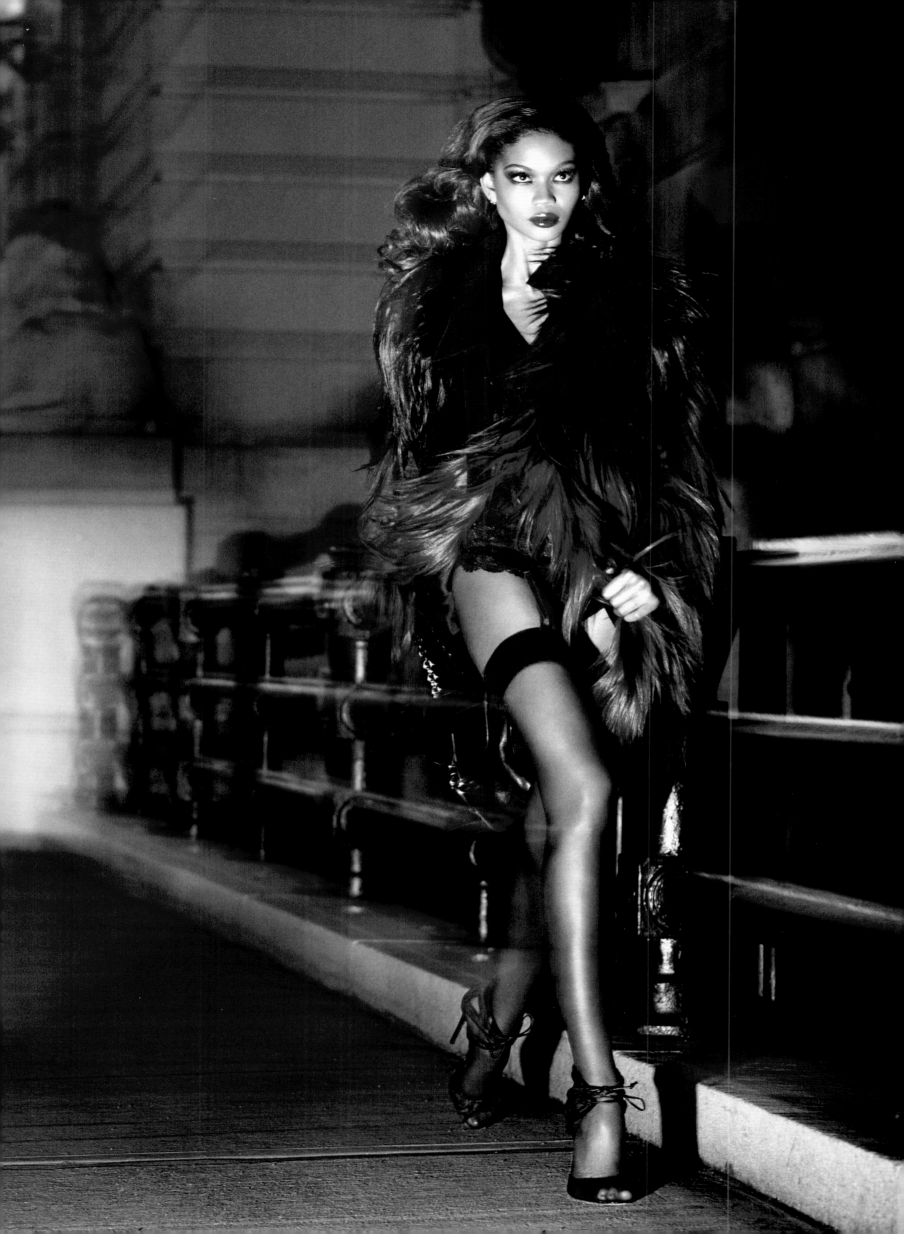

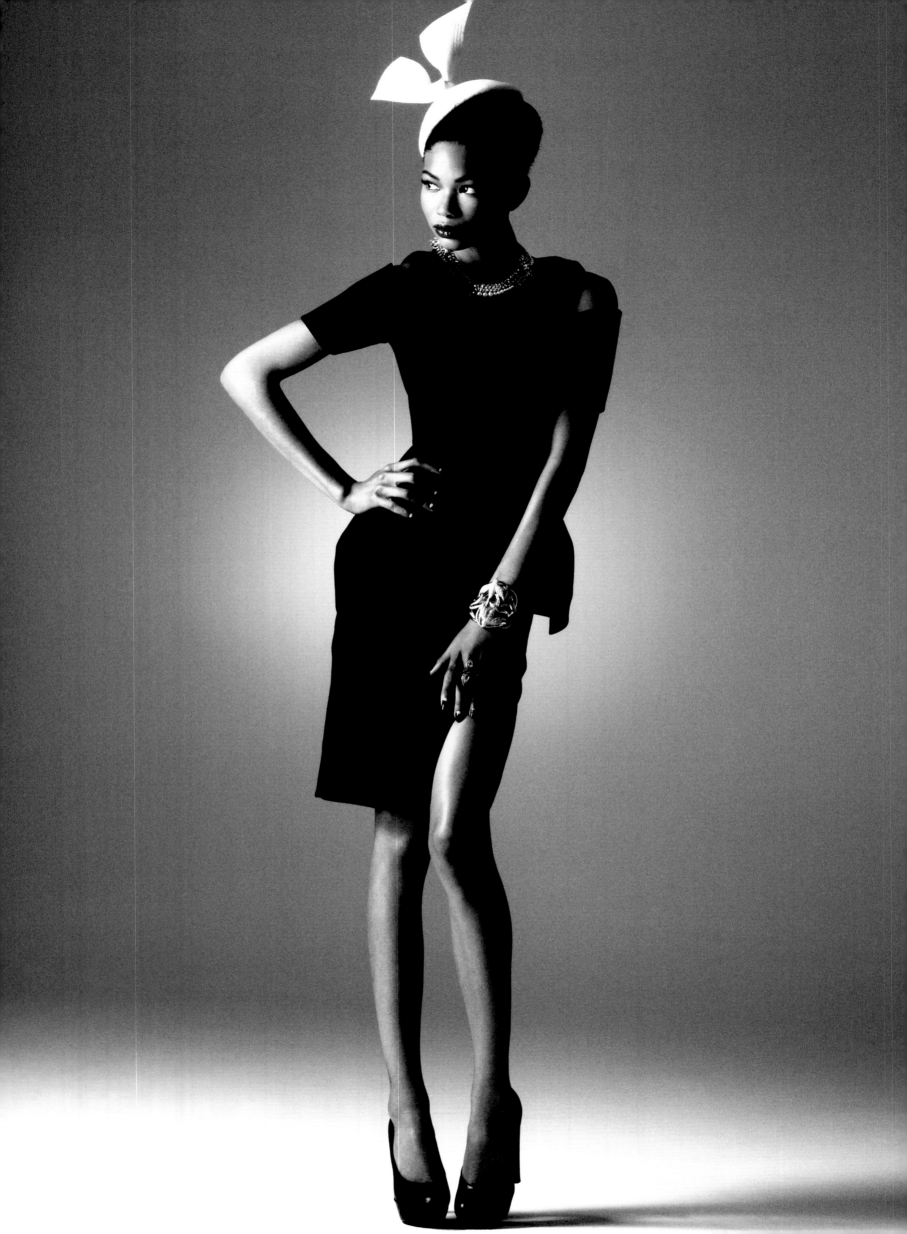

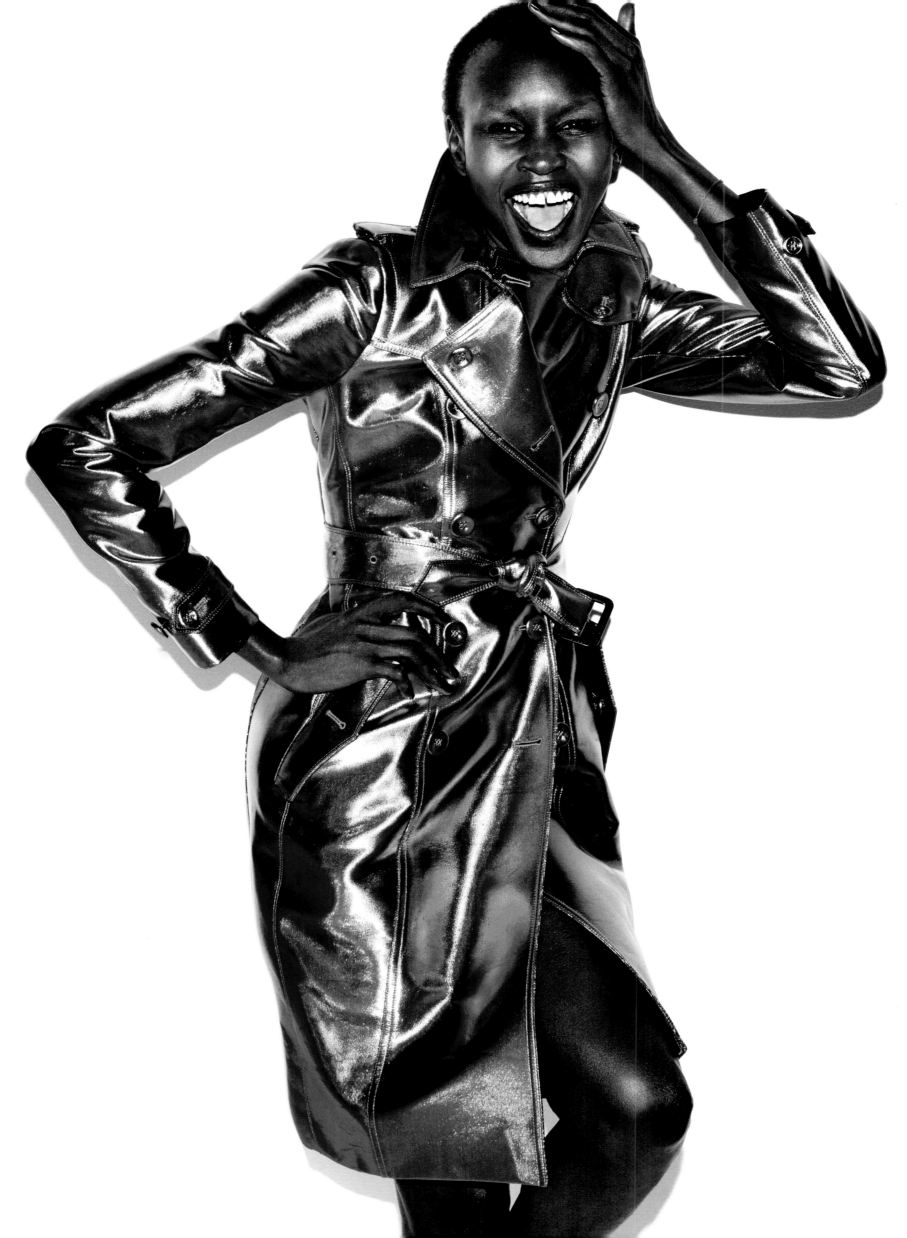

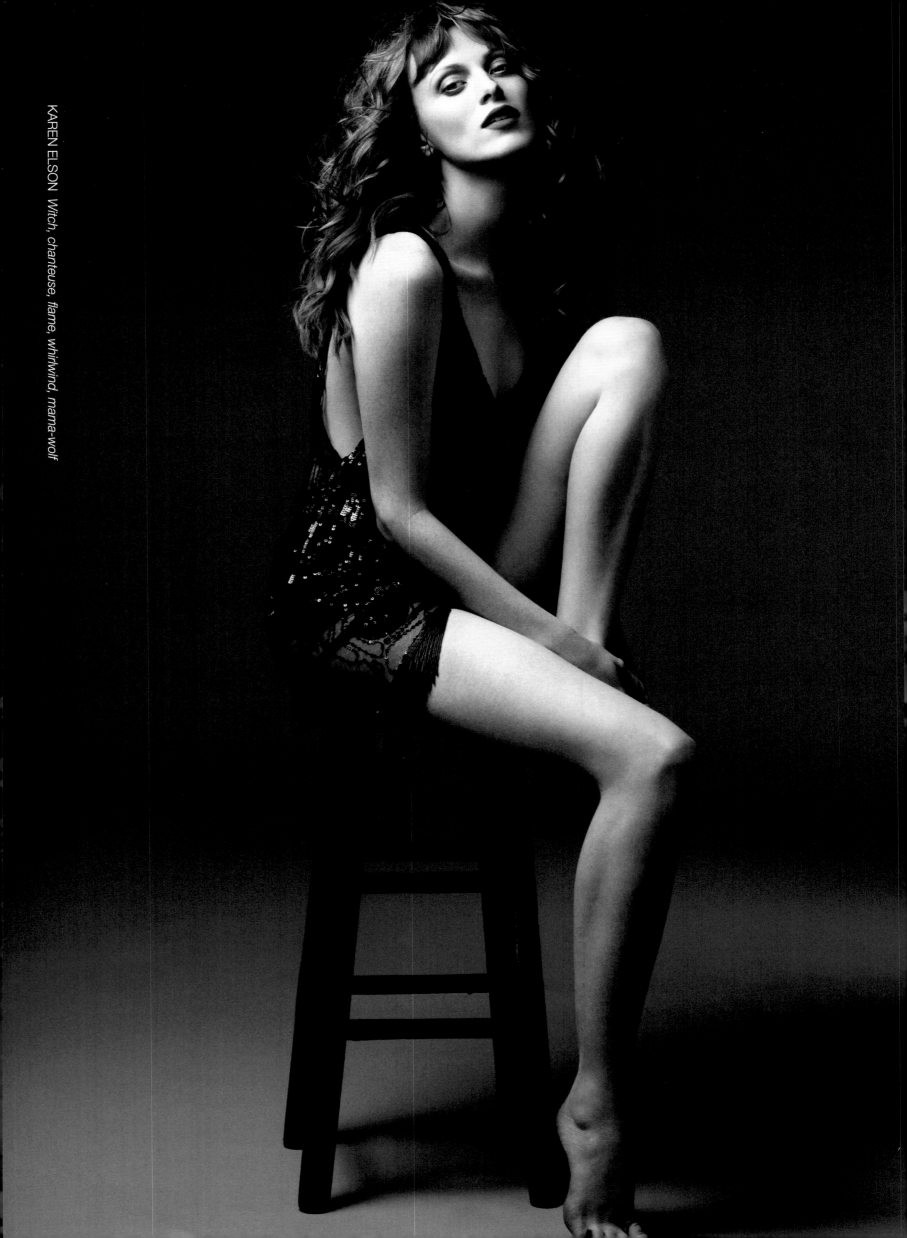

KAREN ELSON *Witch, chanteuse, flame, whirlwind, mama-wolf*

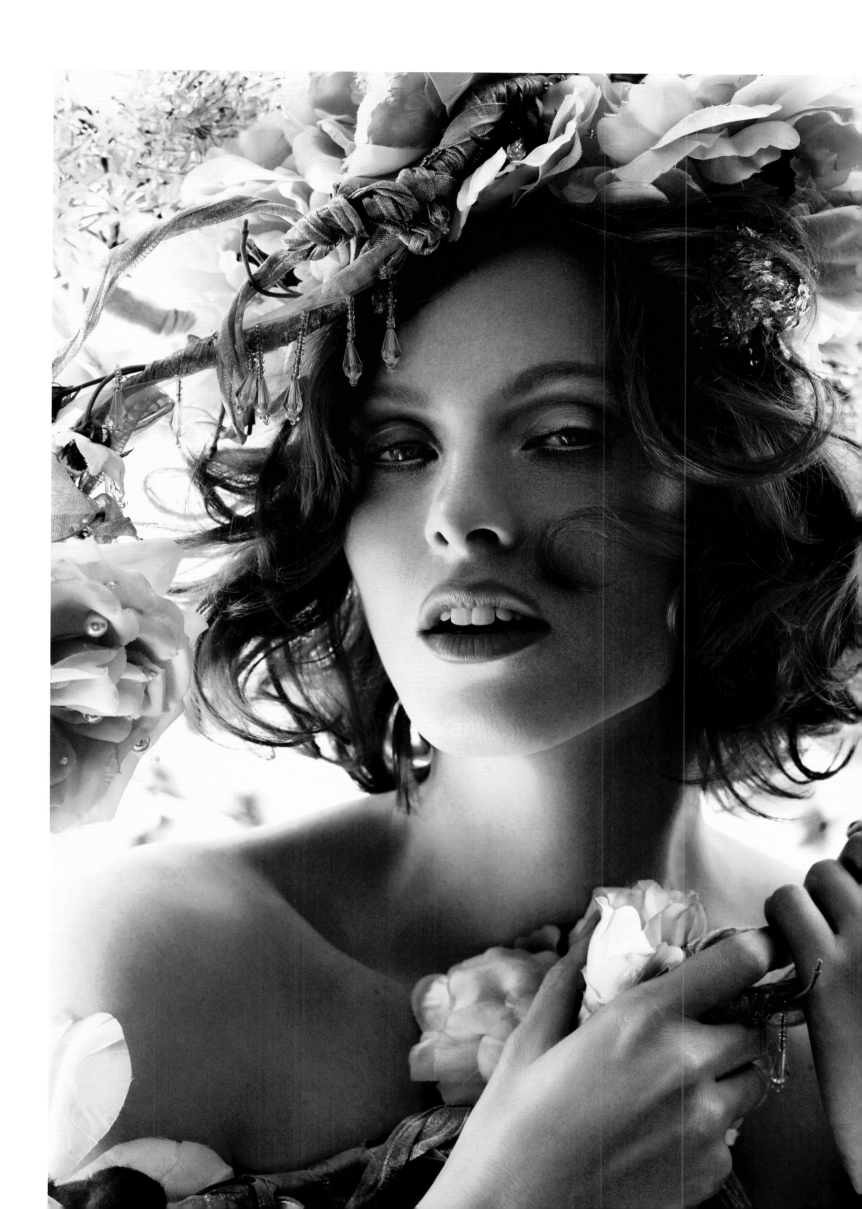

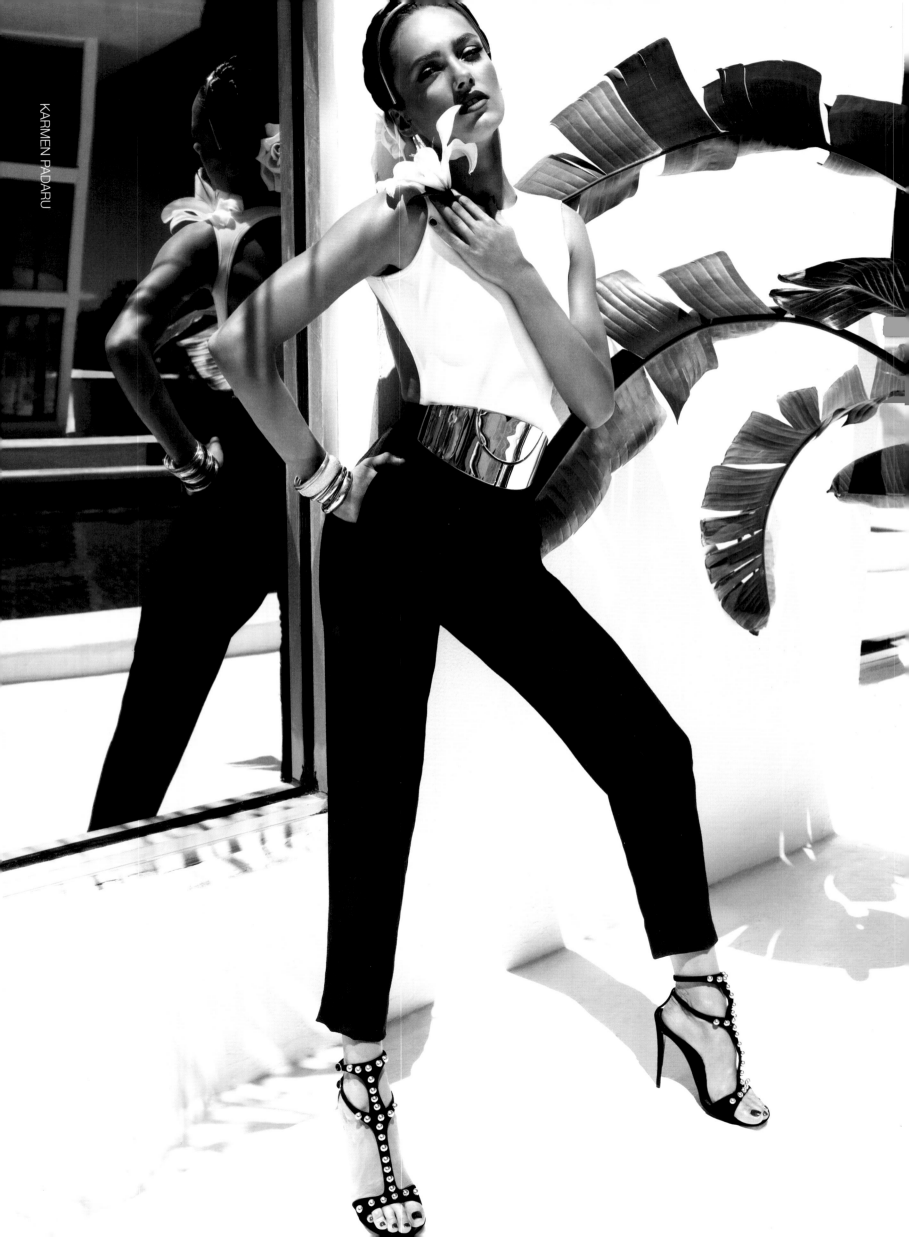

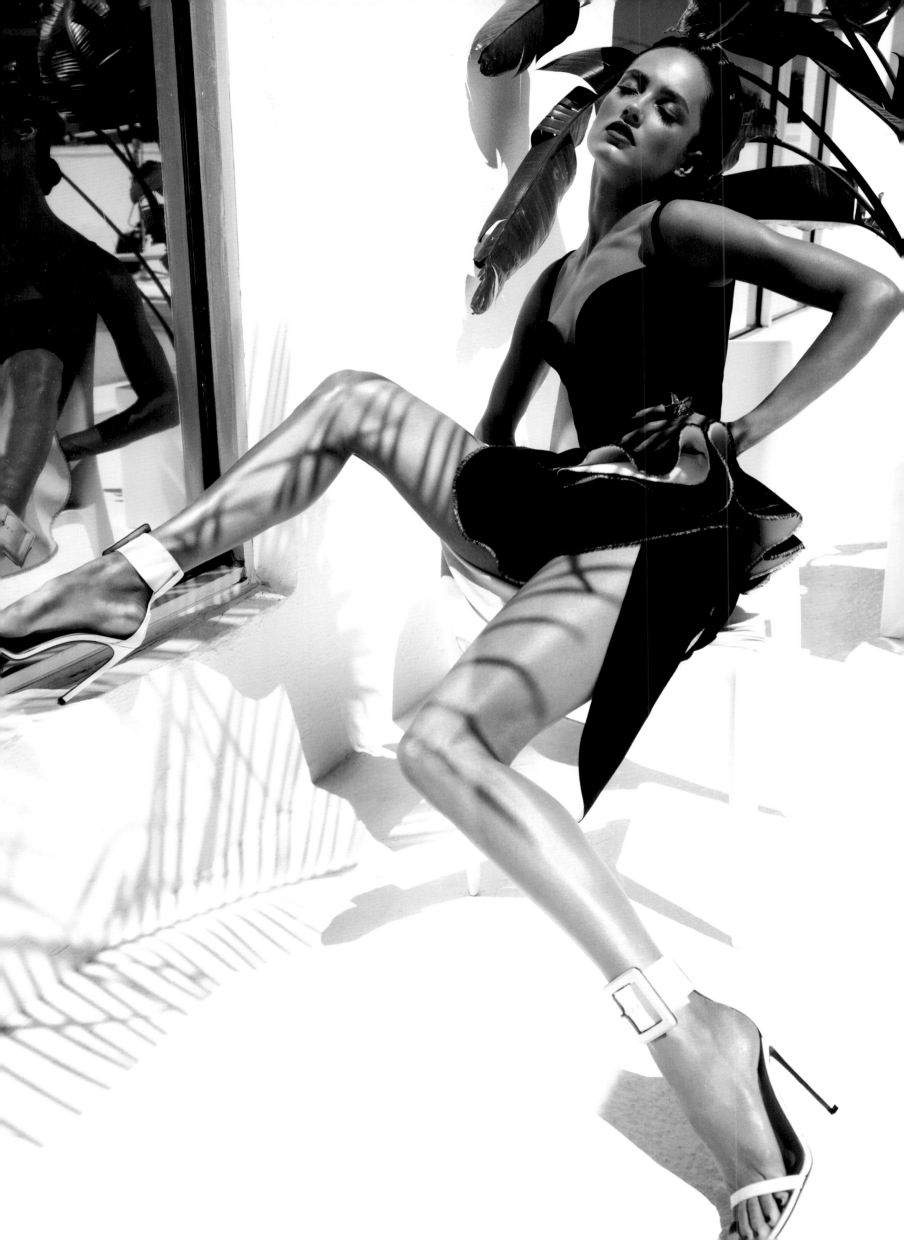

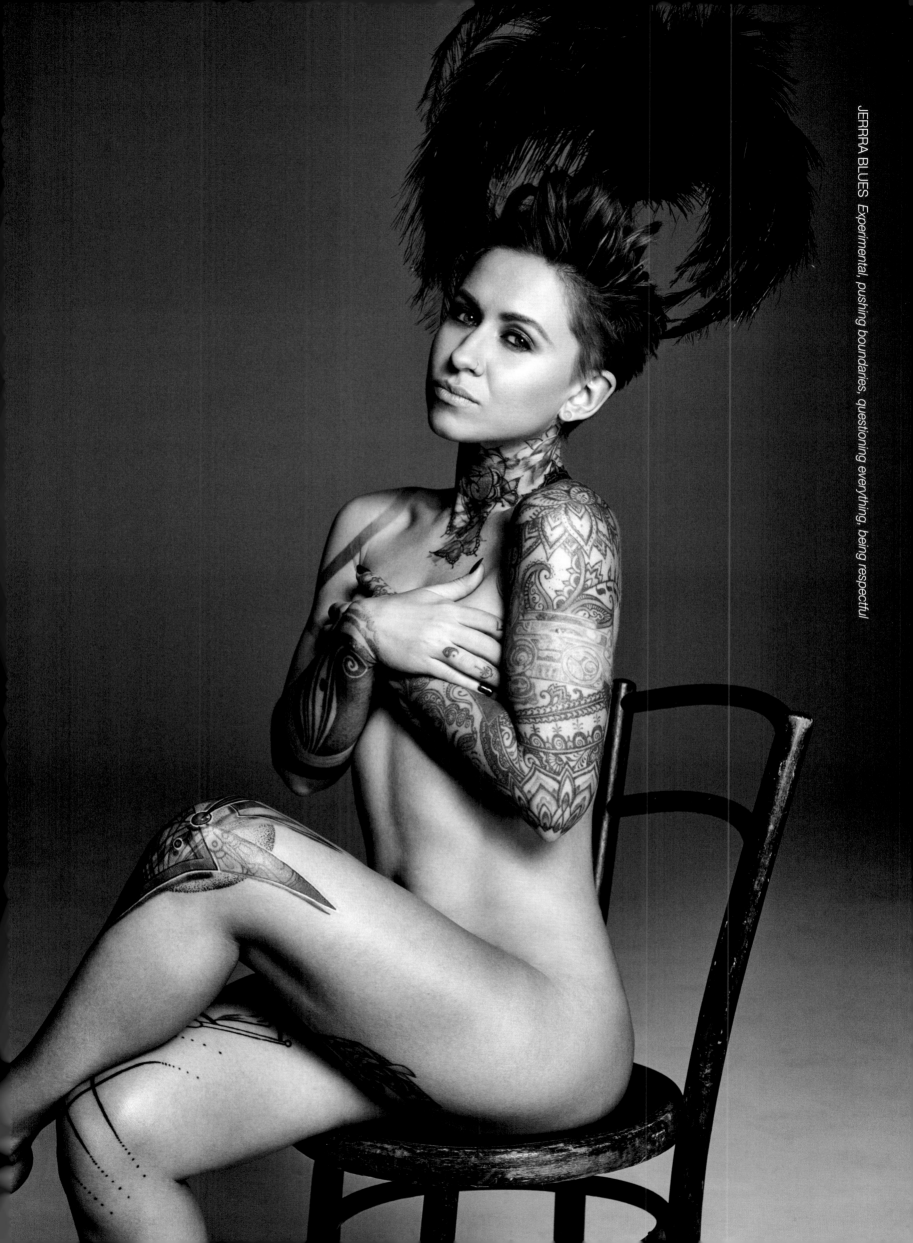

JERRRA BLUES *Experimental, pushing boundaries, questioning everything, being respectful*

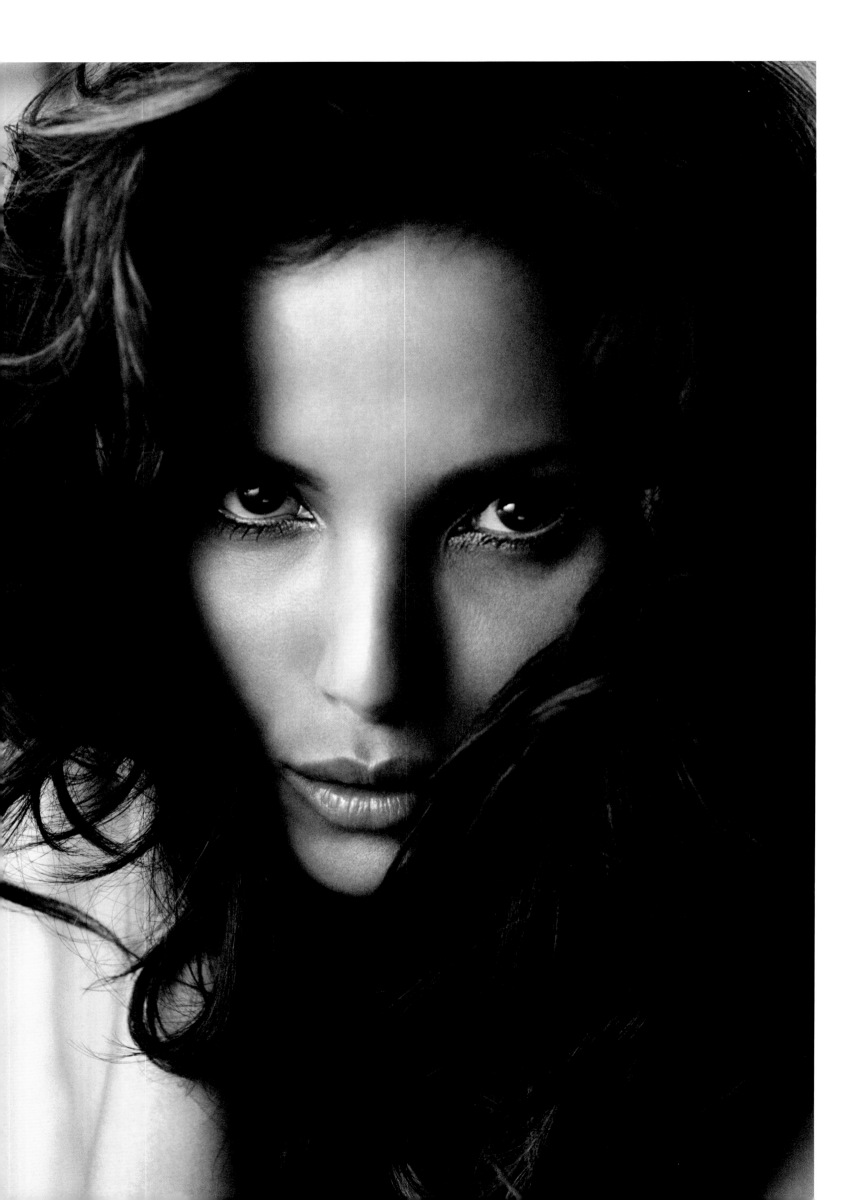

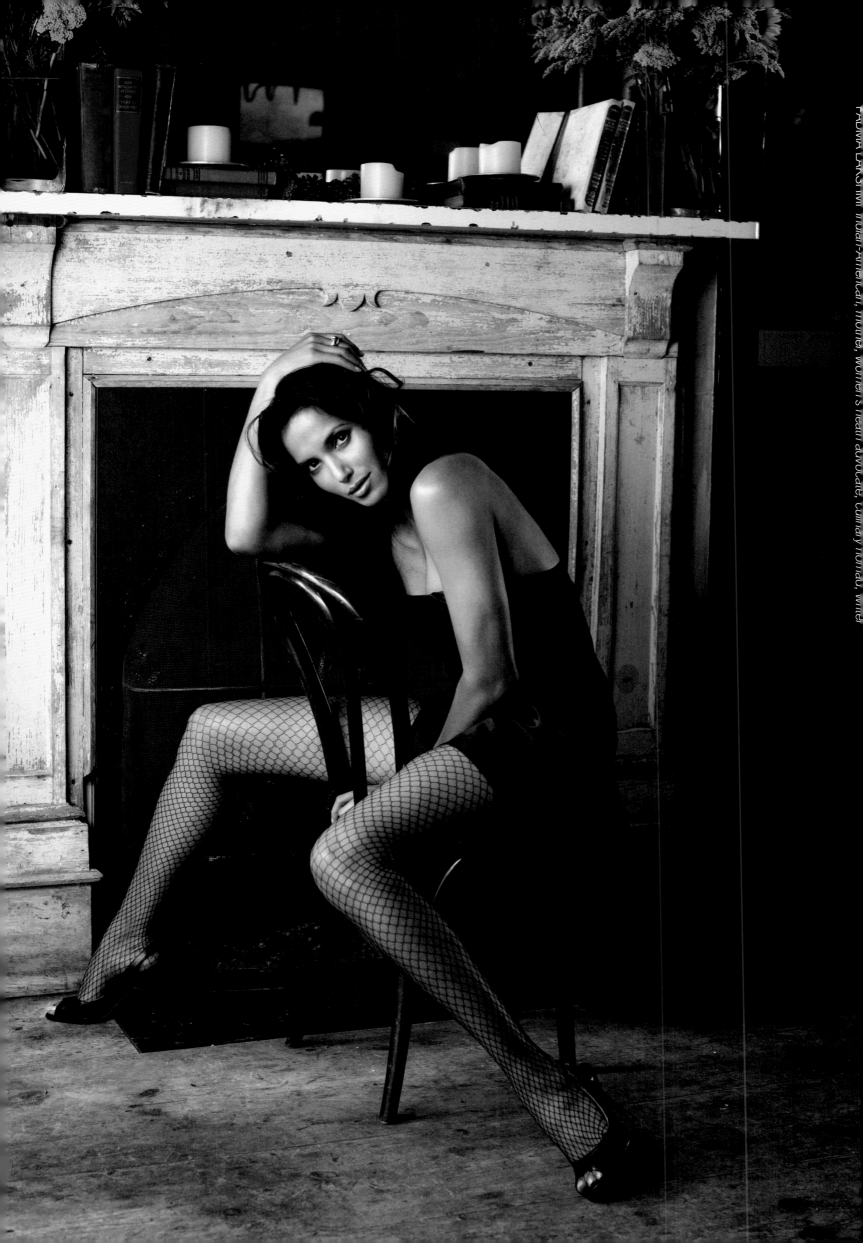

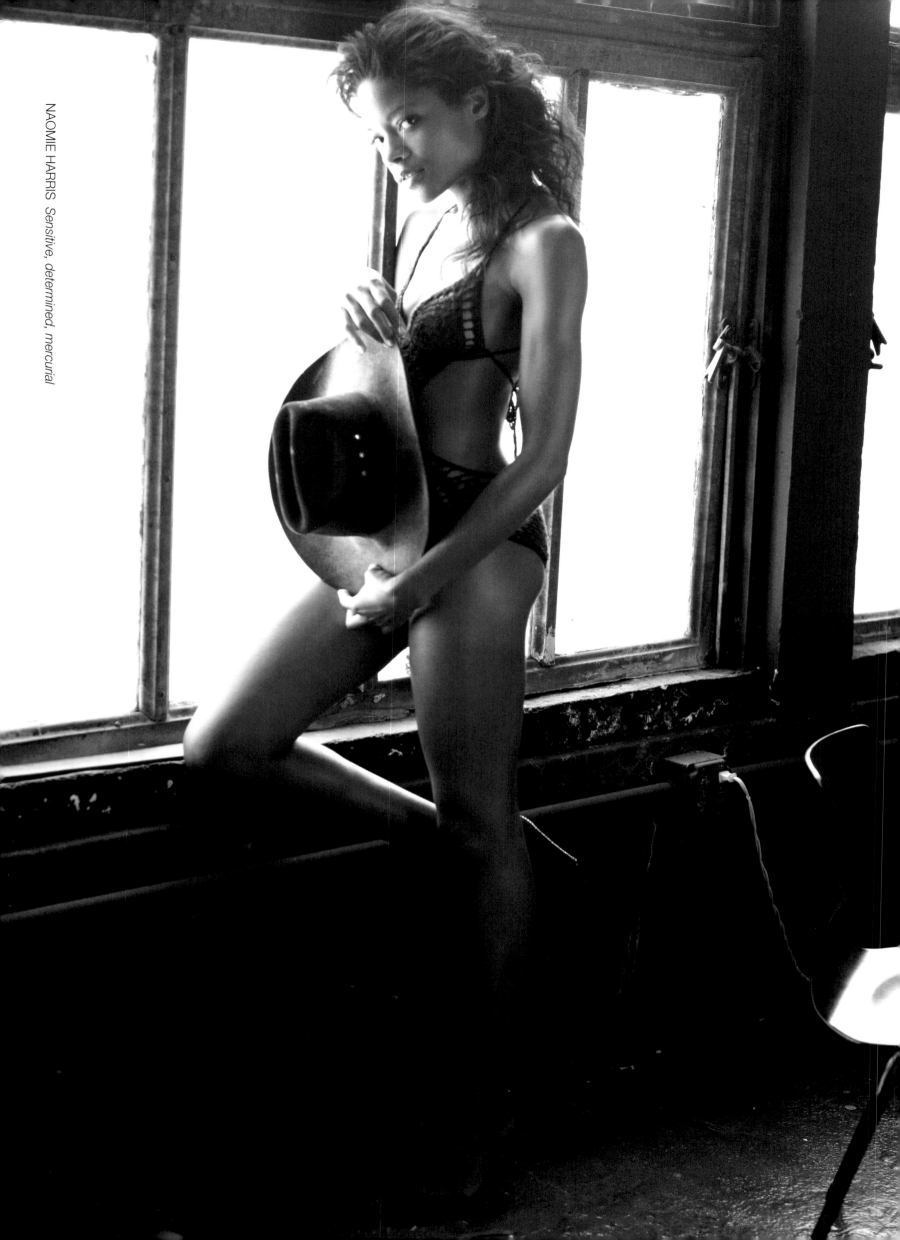

NAOMIE HARRIS *Sensitive, determined, mercurial*

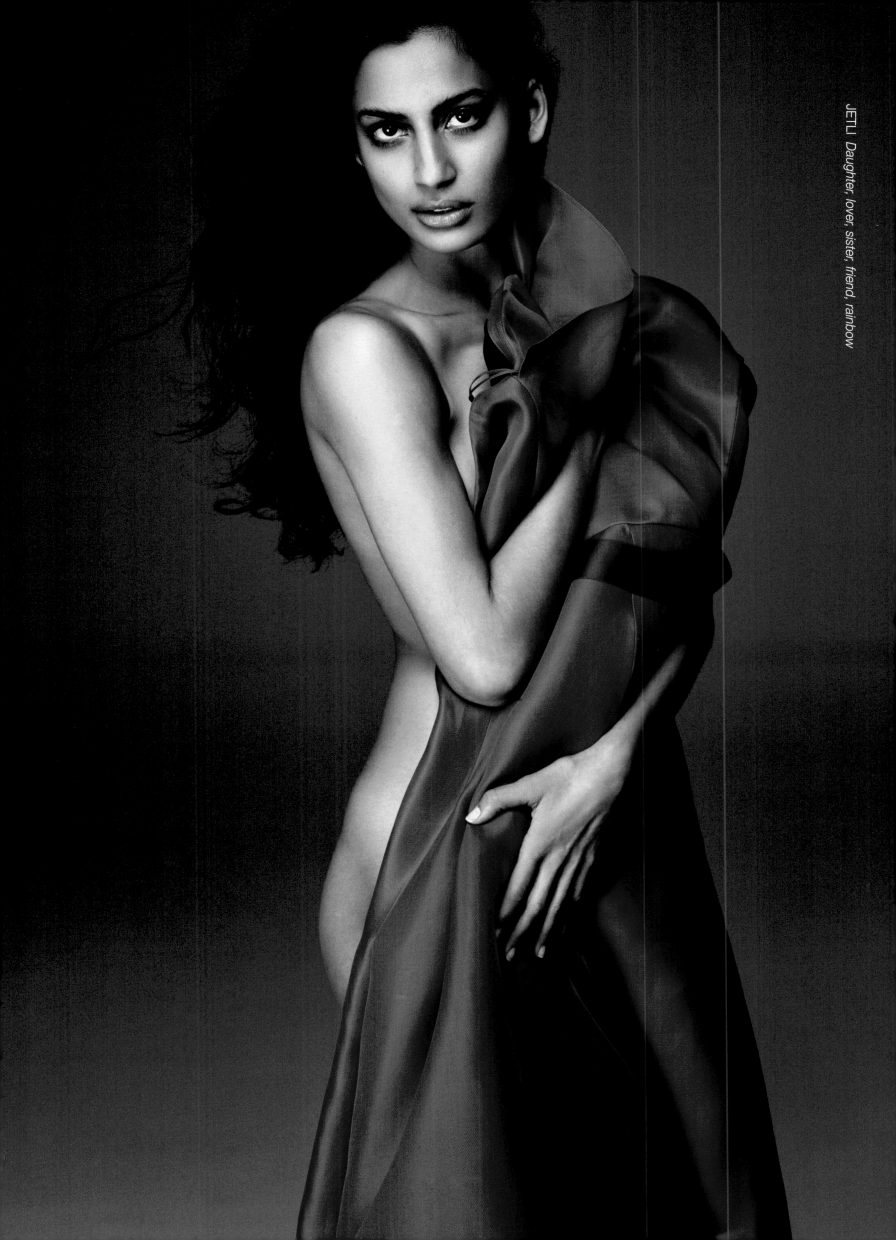

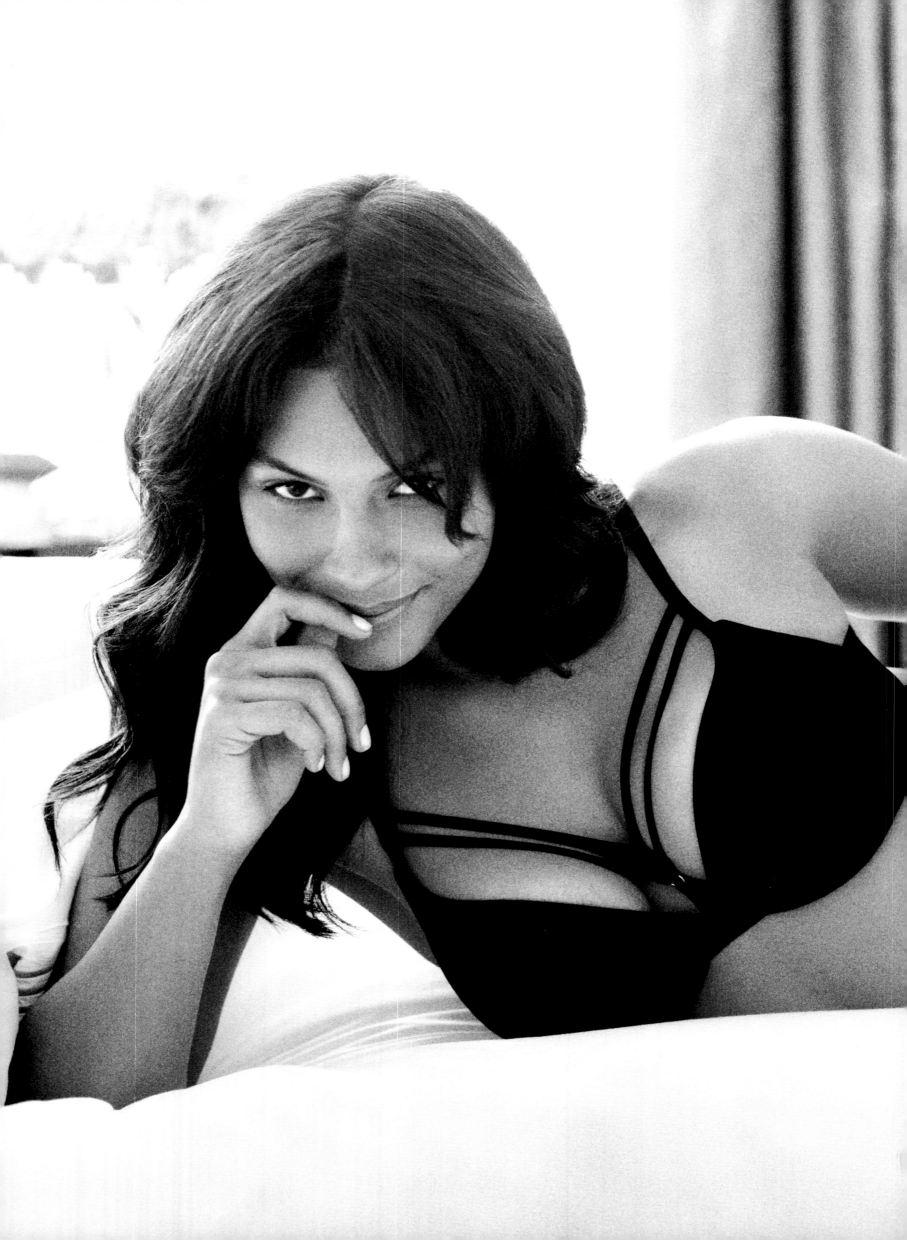

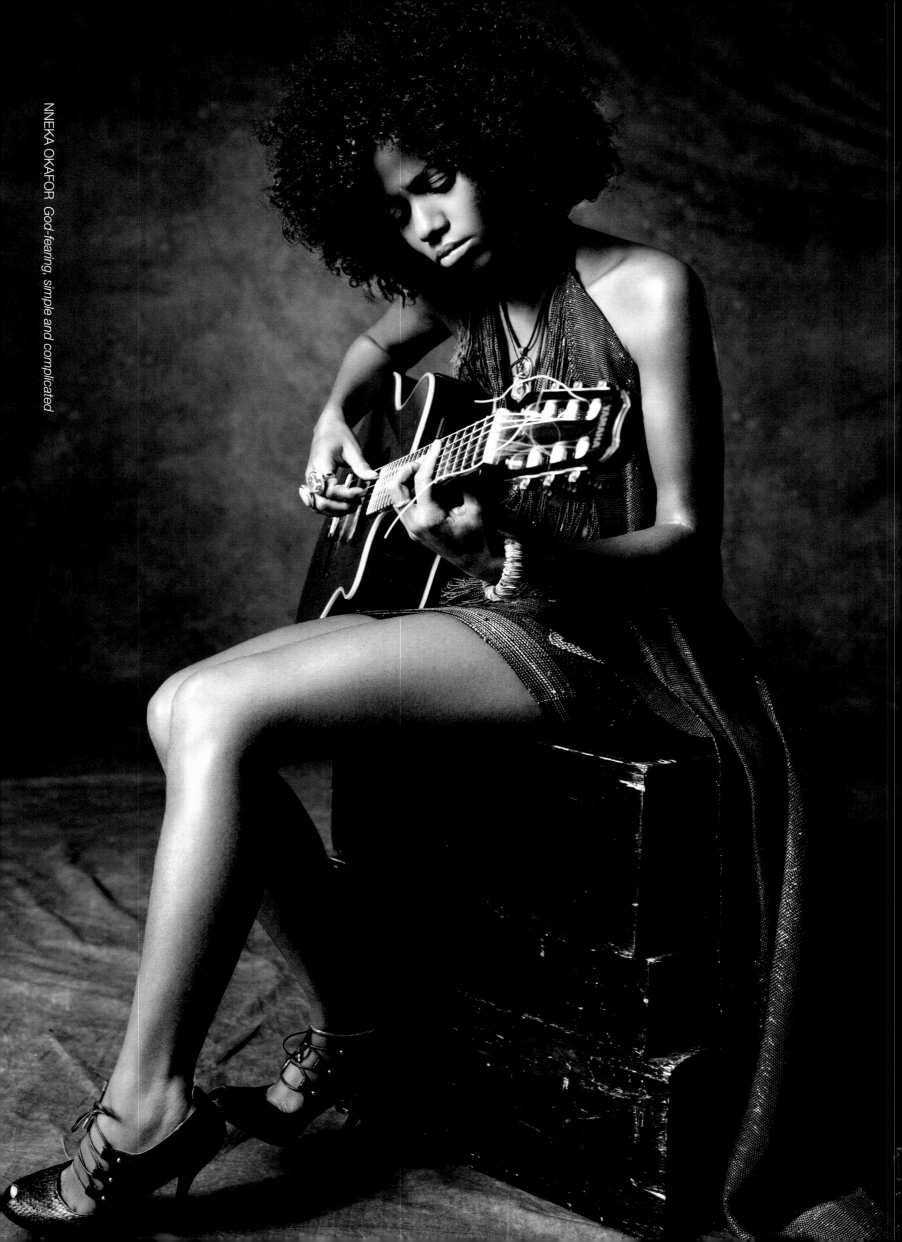

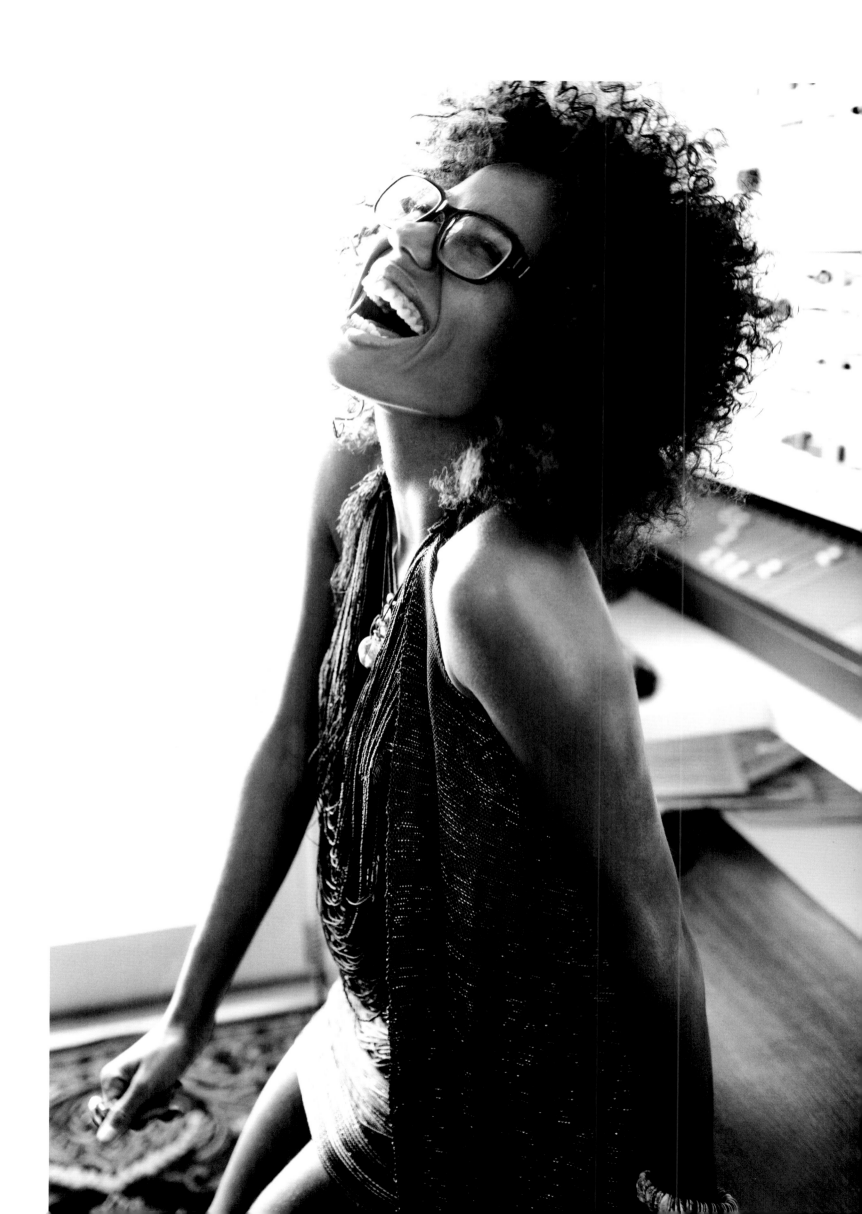

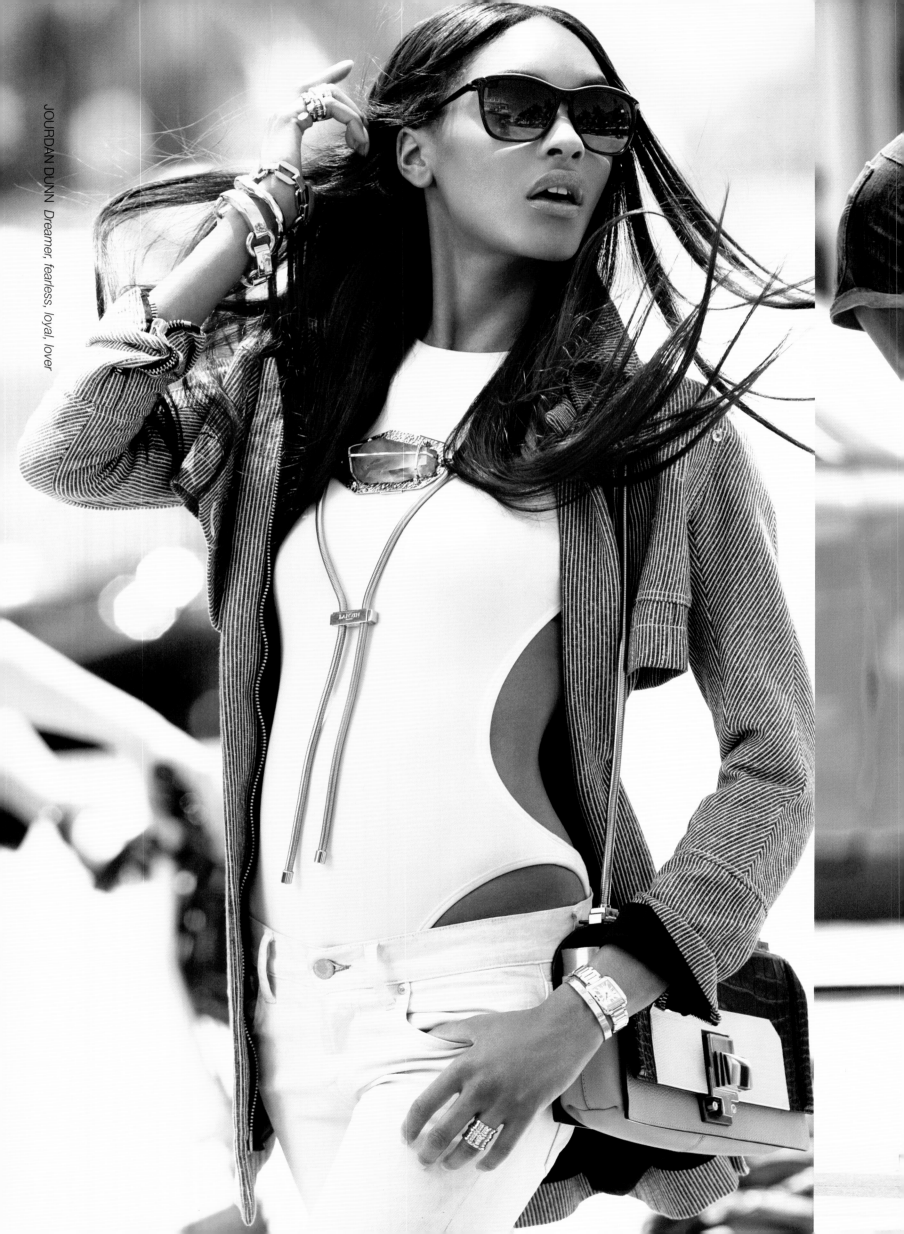

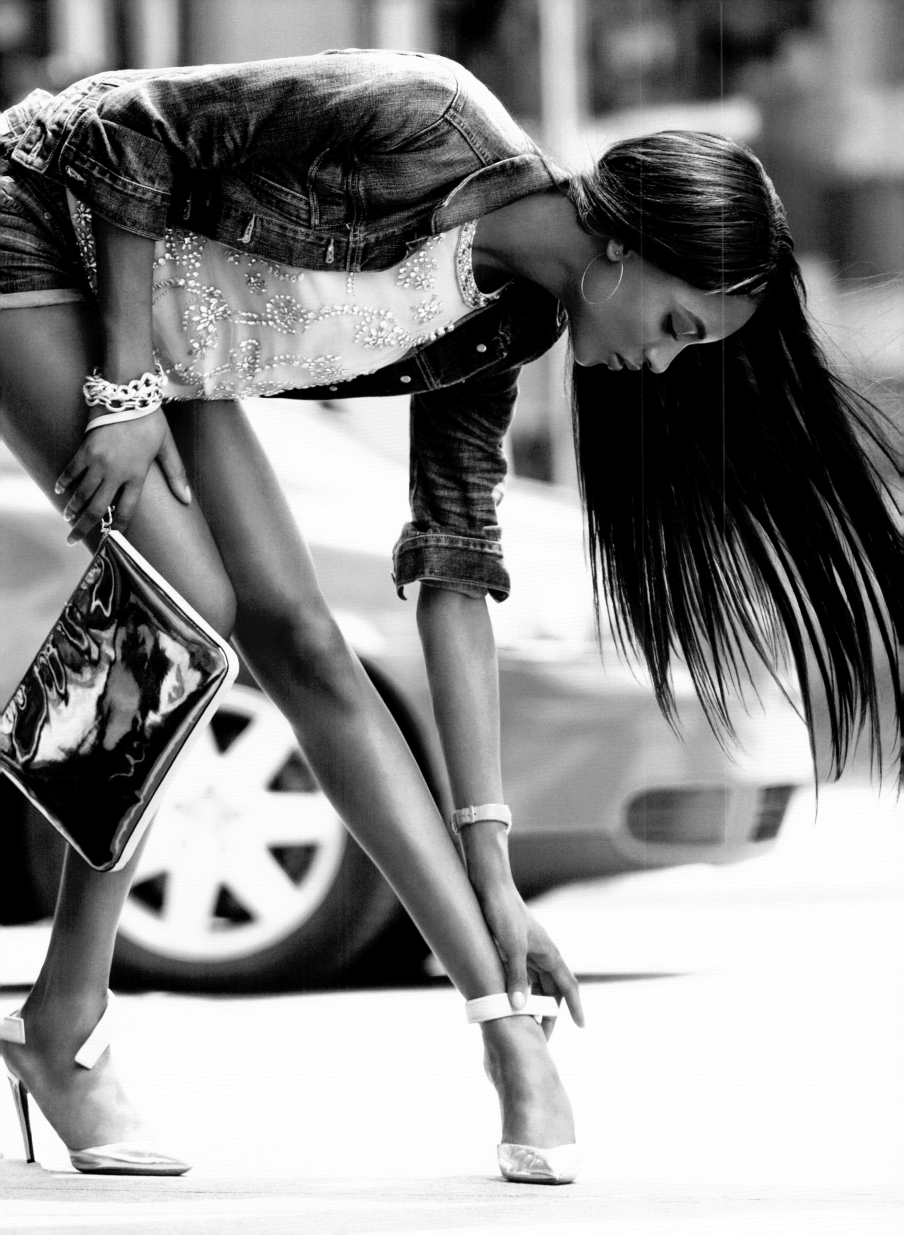

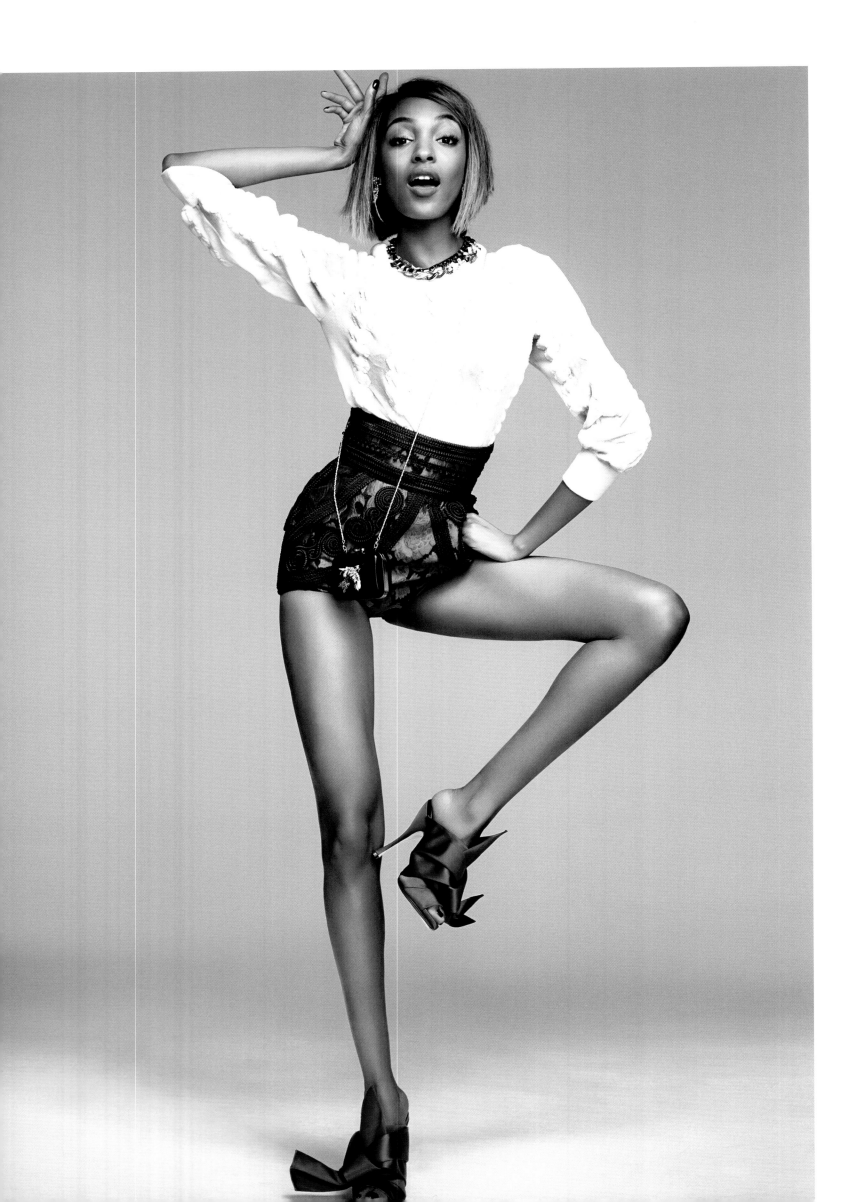

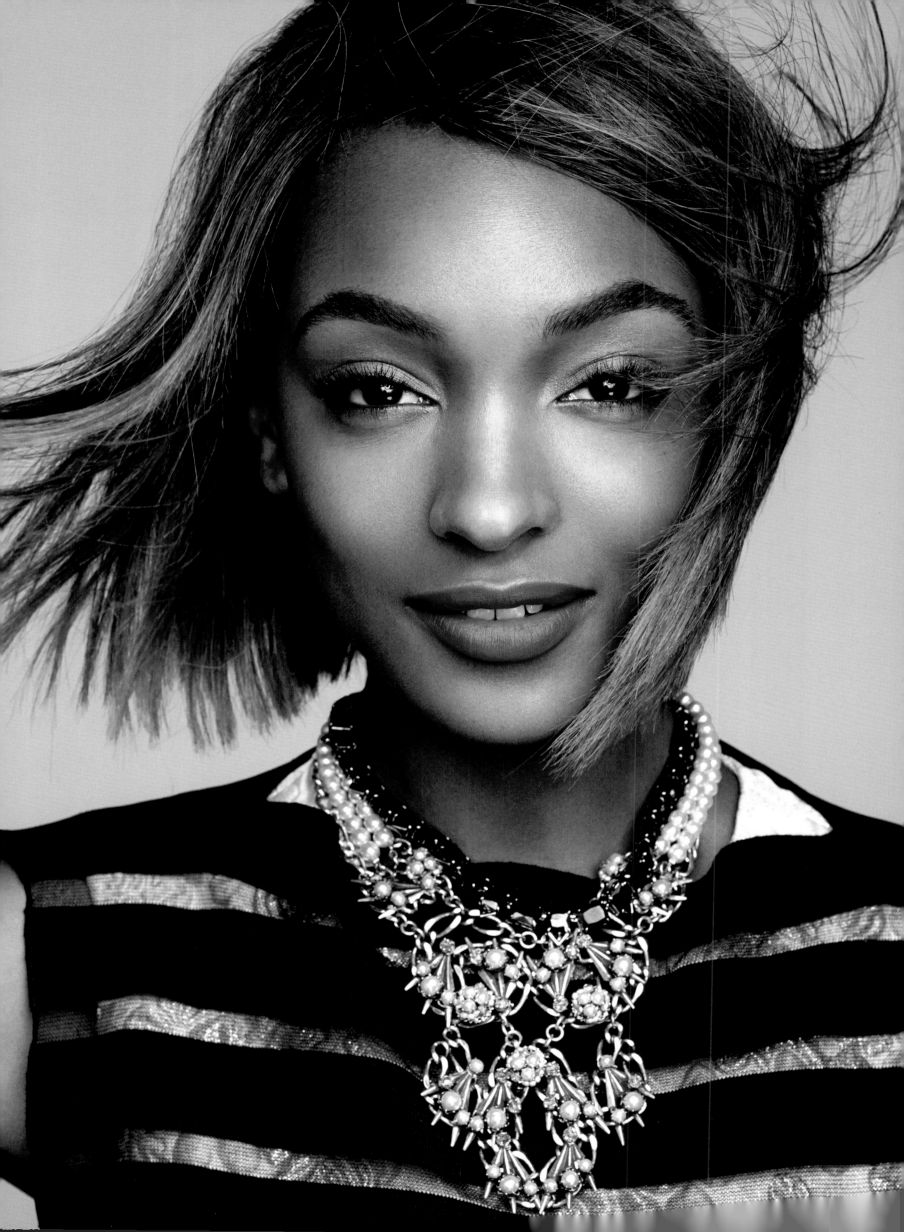

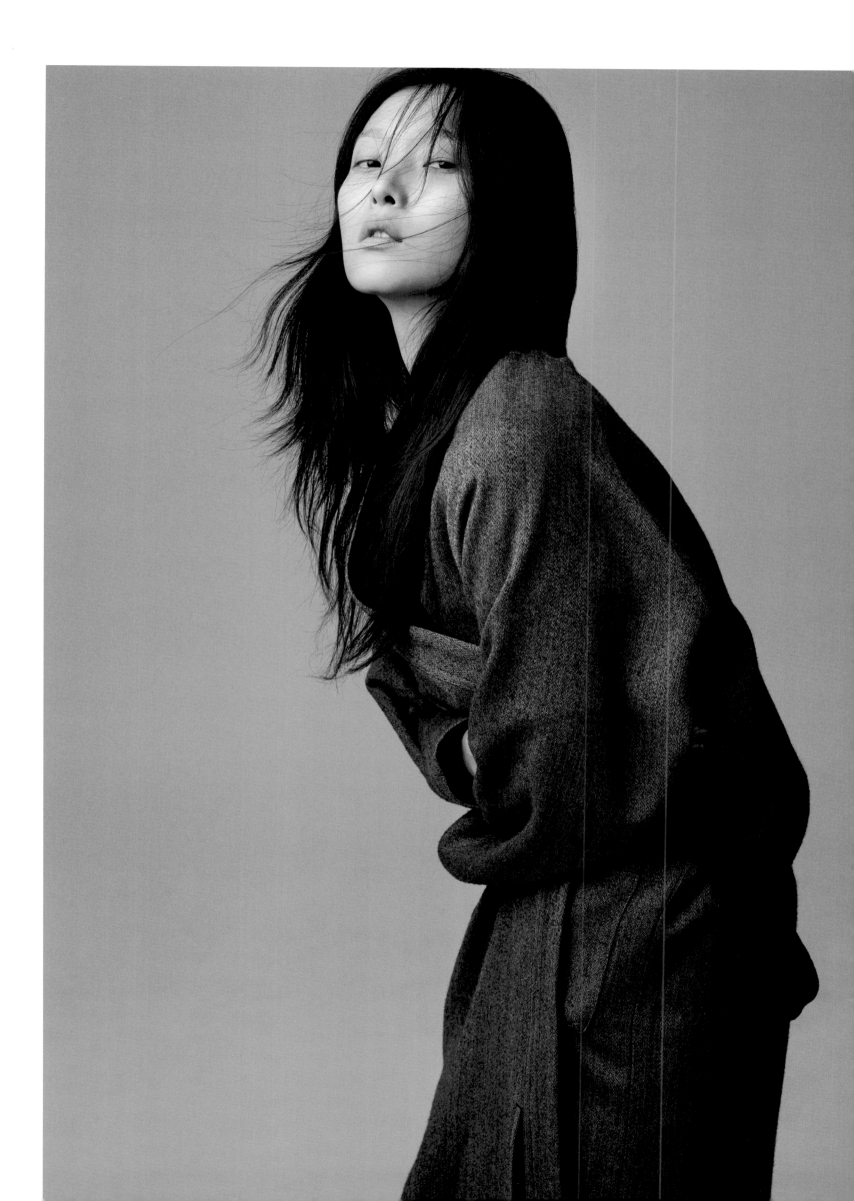

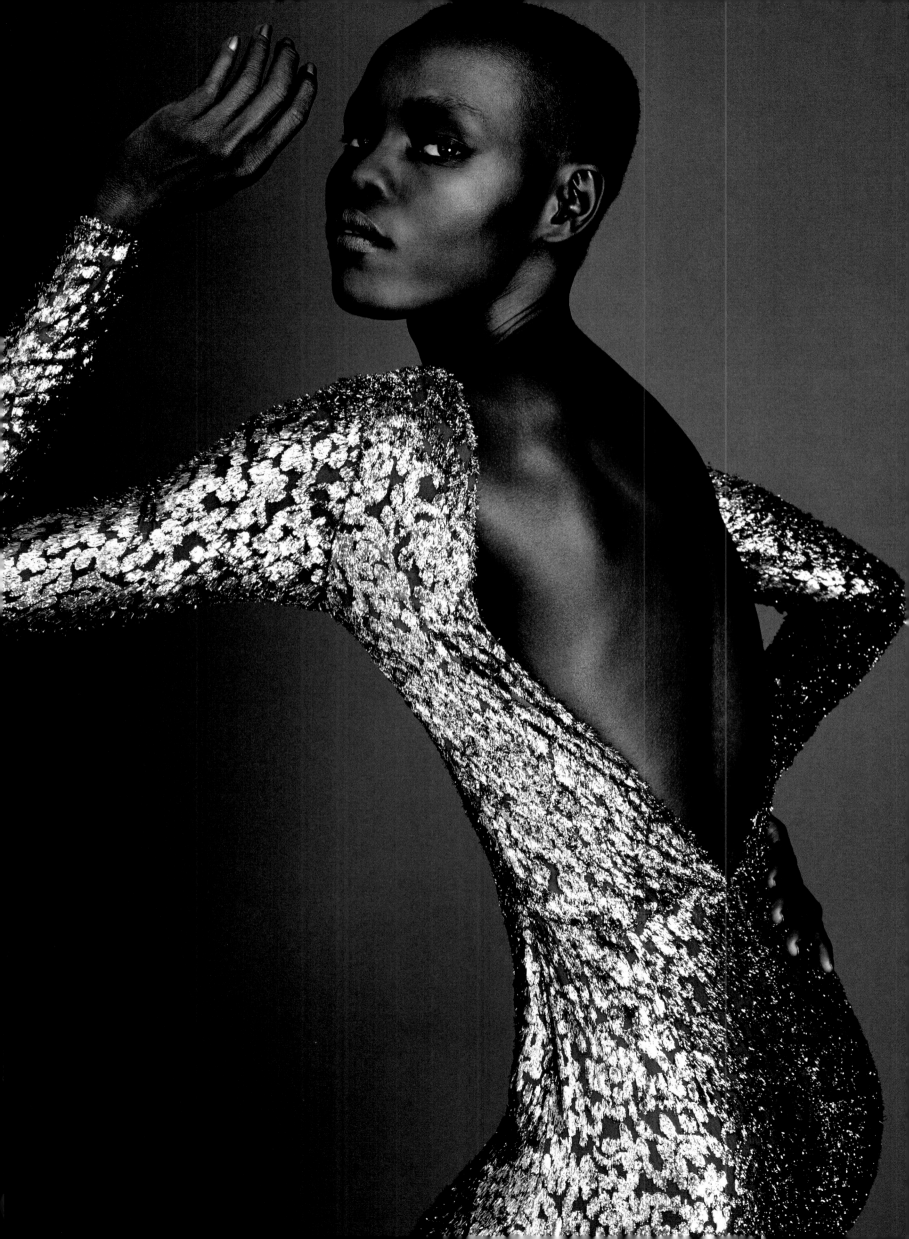

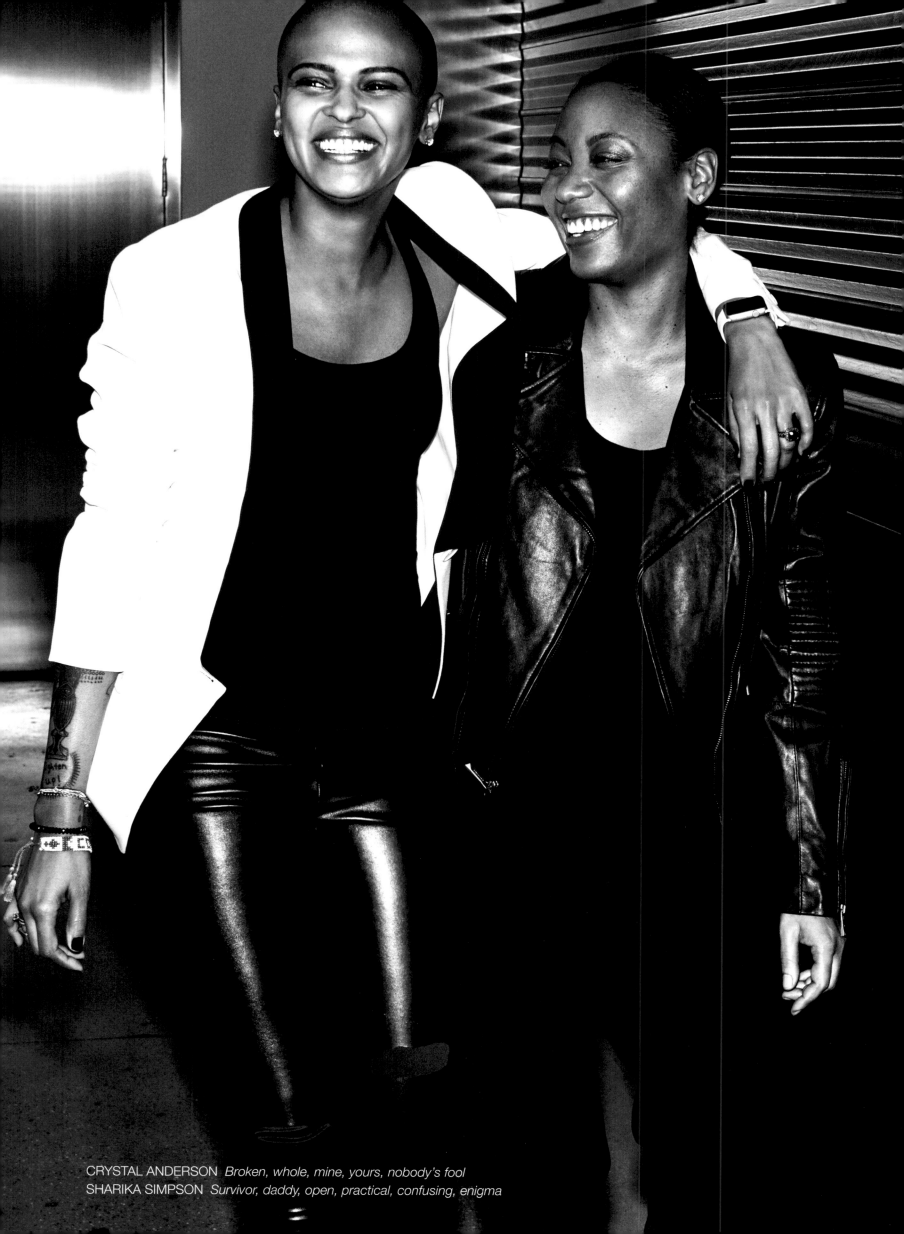

CRYSTAL ANDERSON *Broken, whole, mine, yours, nobody's fool*
SHARIKA SIMPSON *Survivor, daddy, open, practical, confusing, enigma*

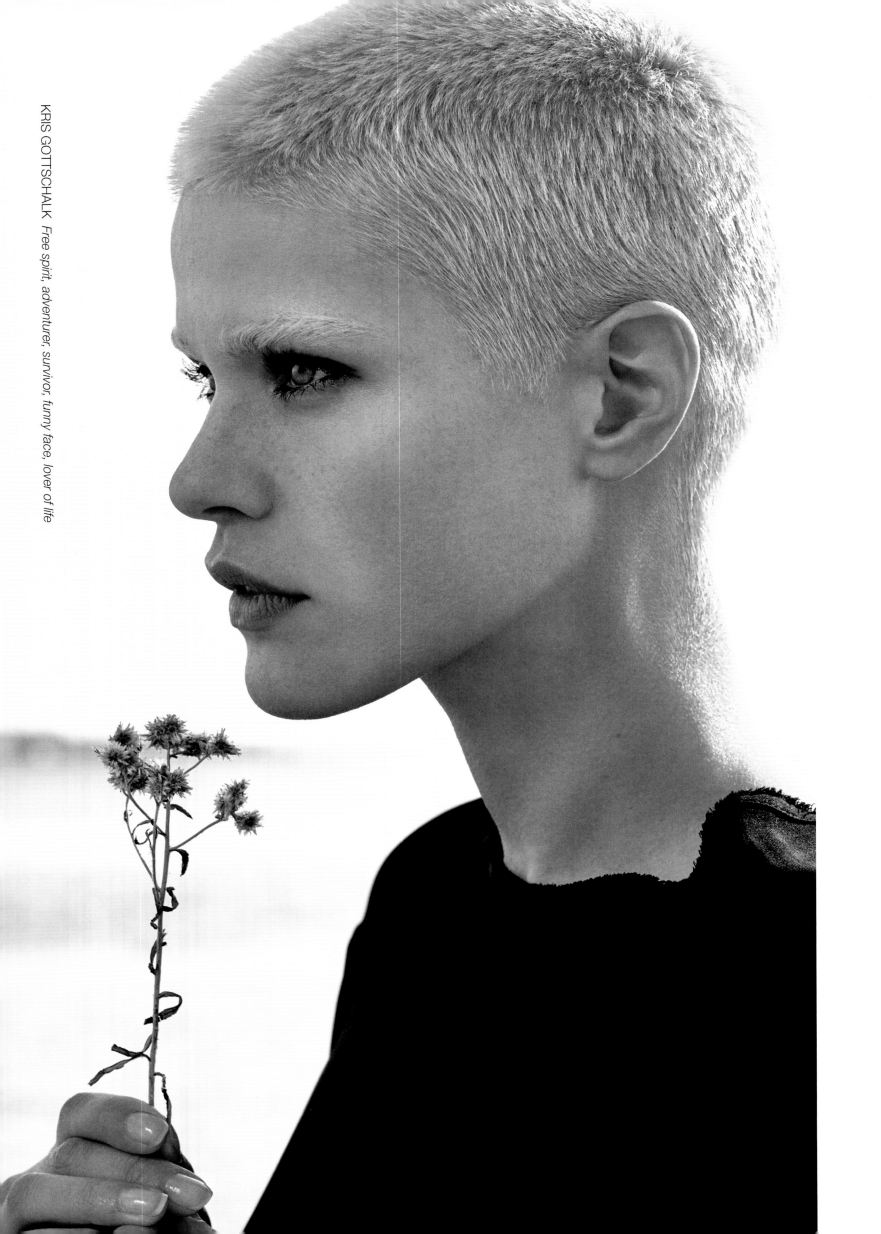

KRIS GOTTSCHALK *Free spirit, adventurer, survivor, funny face, lover of life*

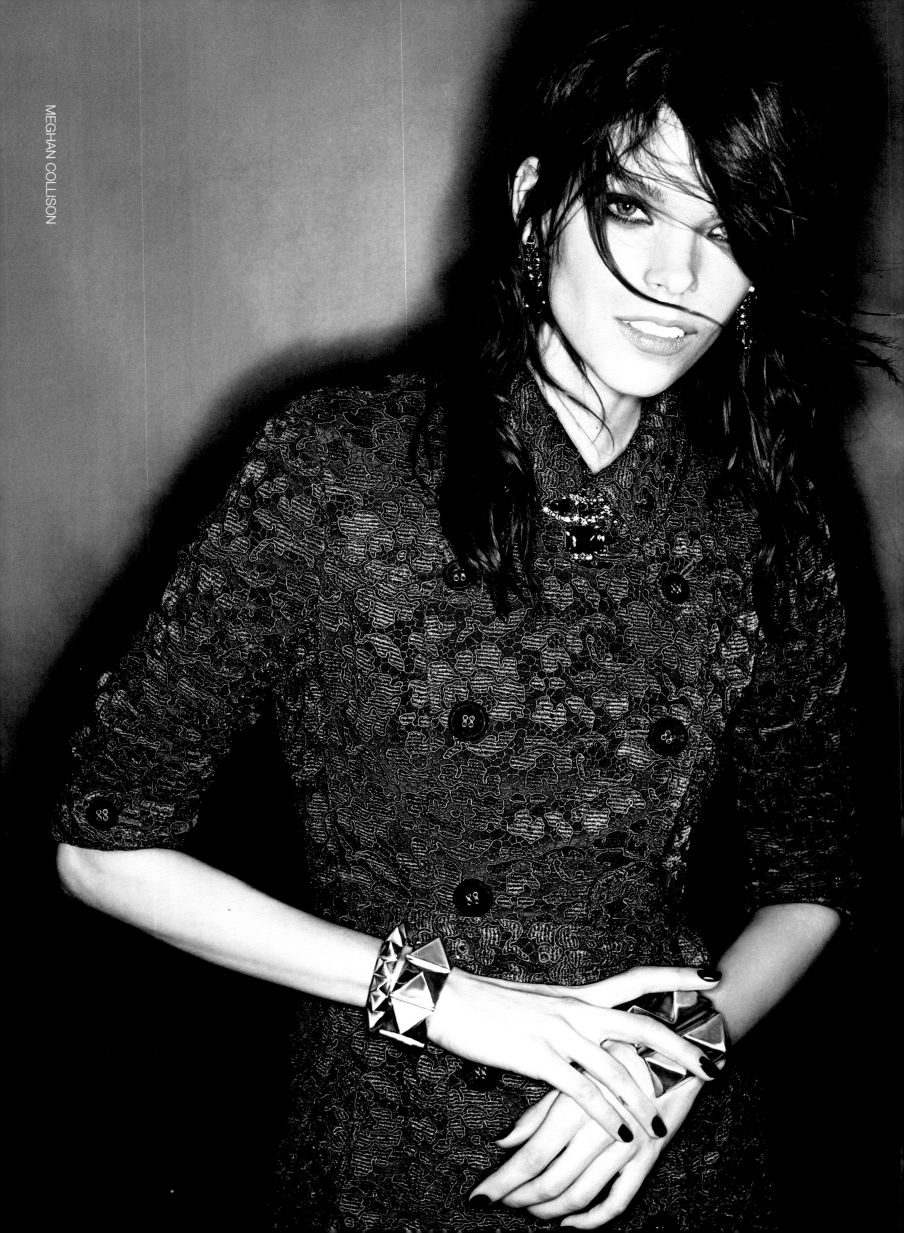

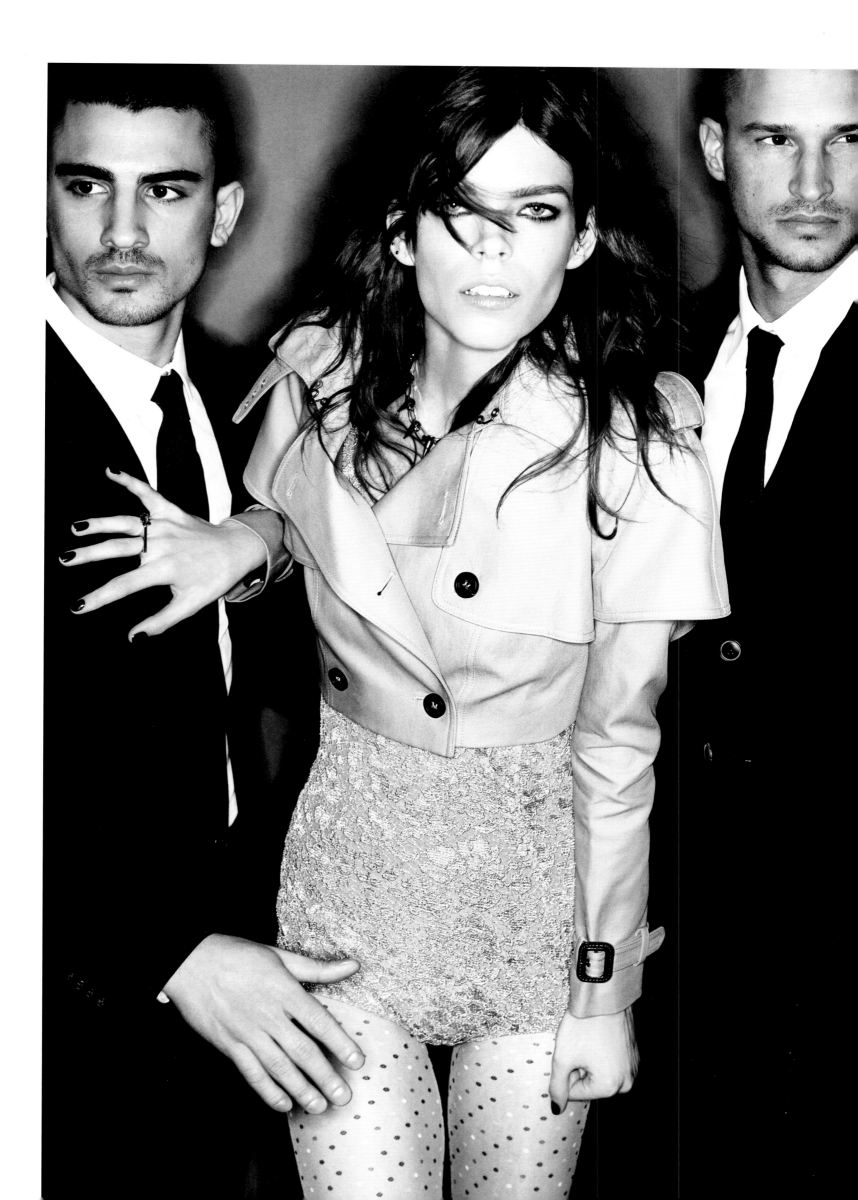

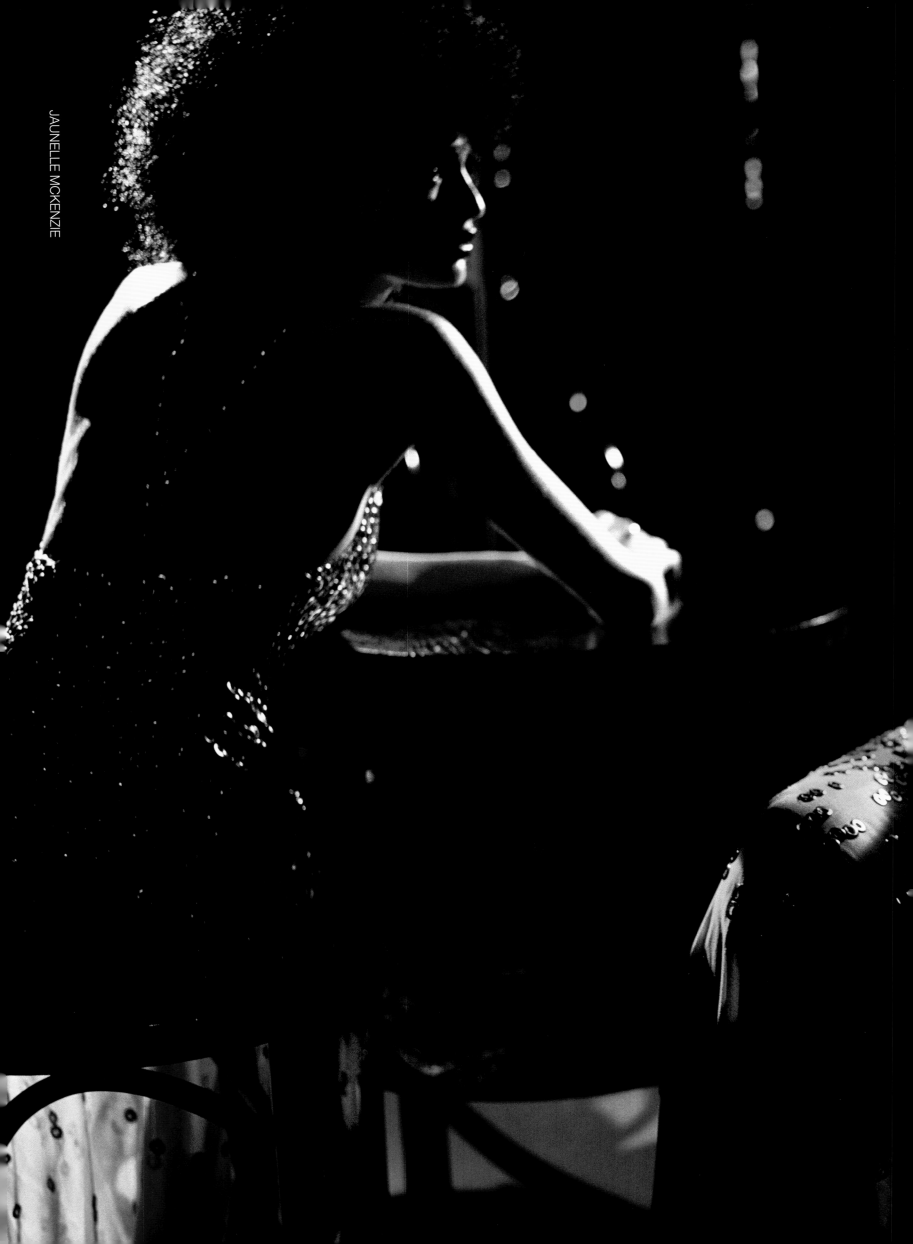

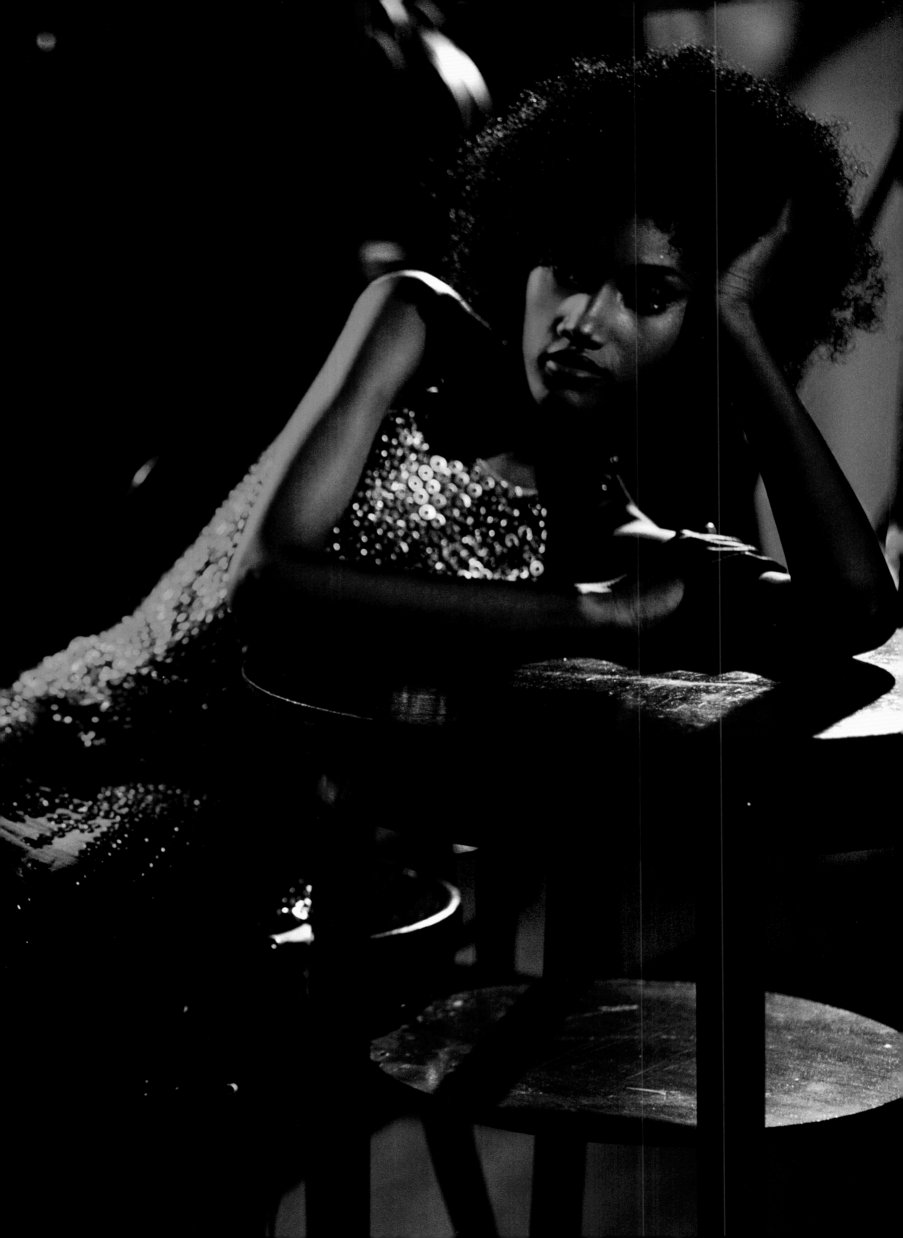

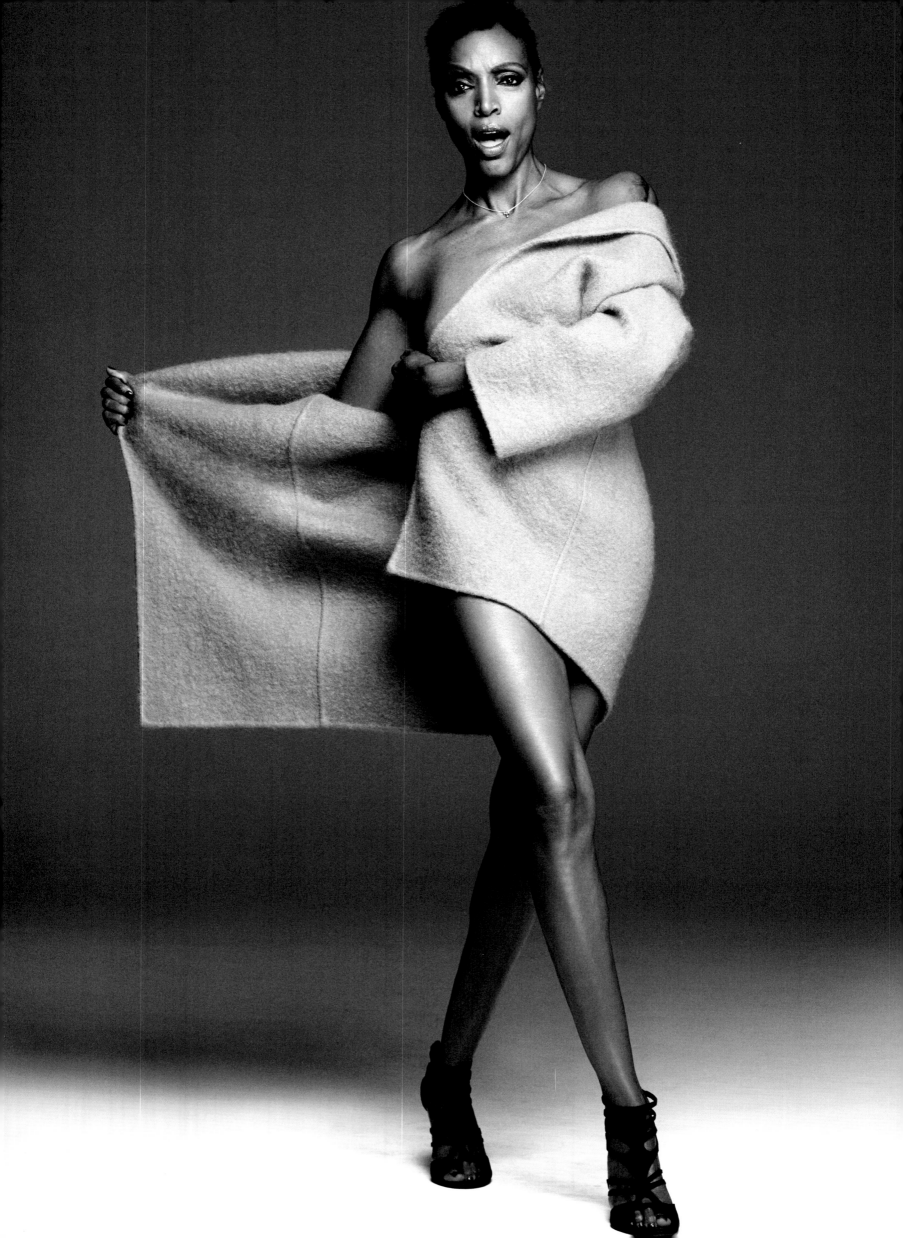

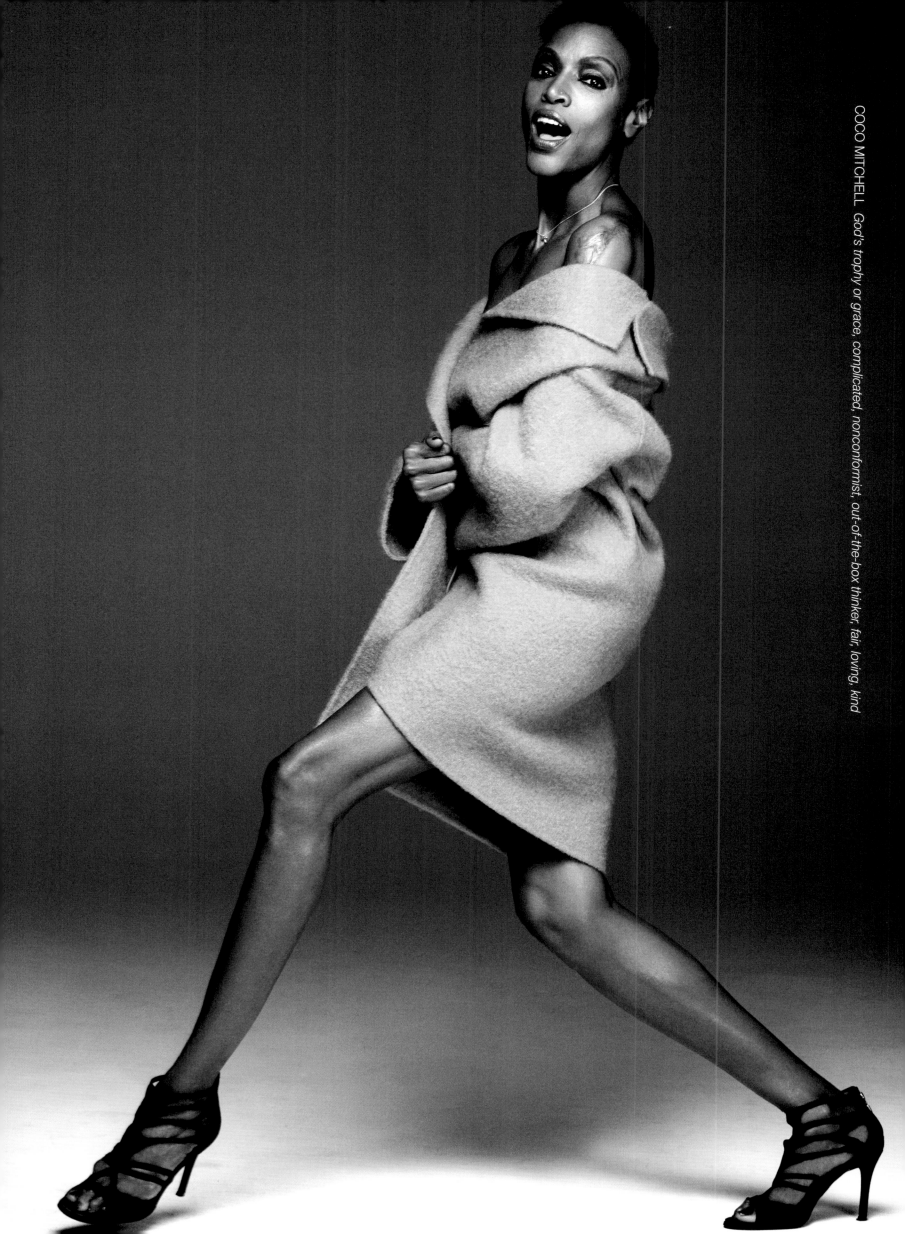

COCO MITCHELL *God's trophy or grace, complicated, nonconformist, out-of-the-box thinker, fair, loving, kind*

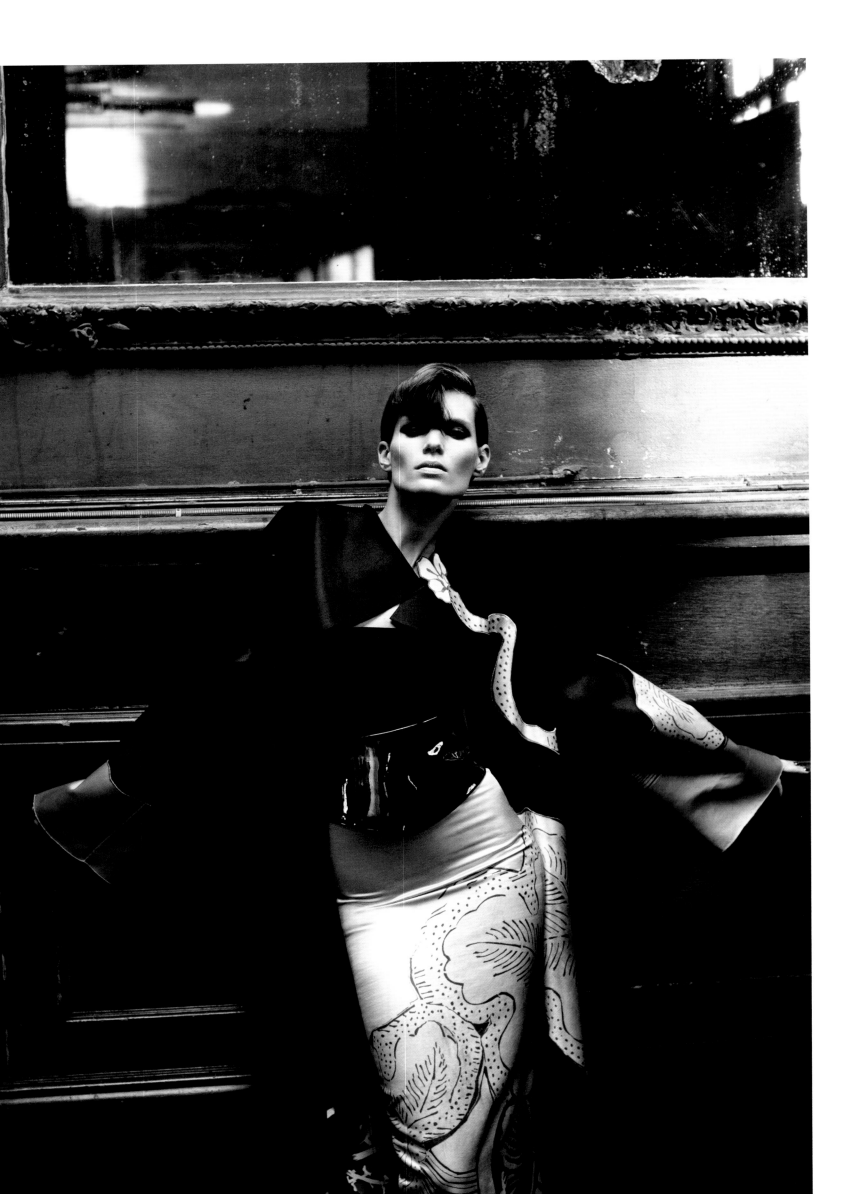

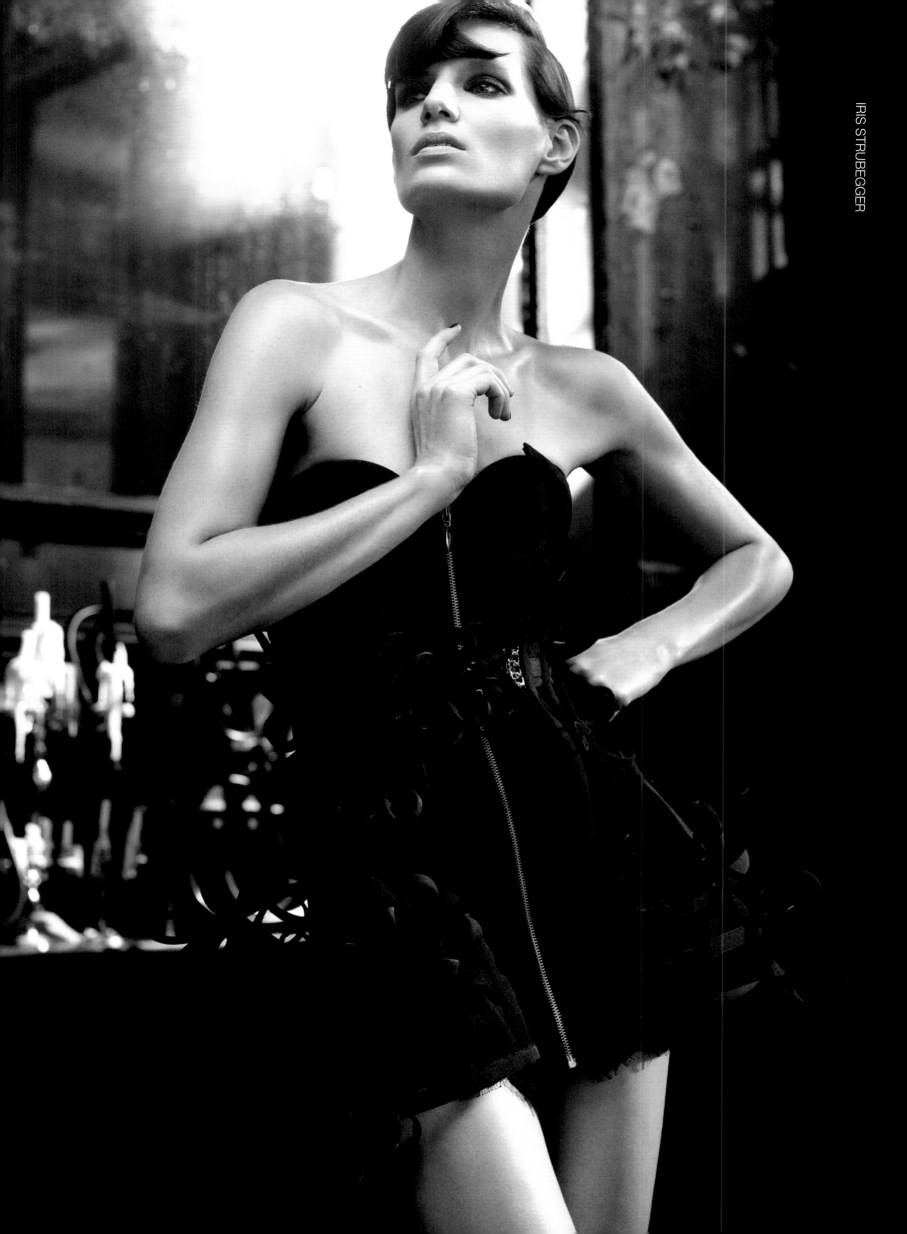

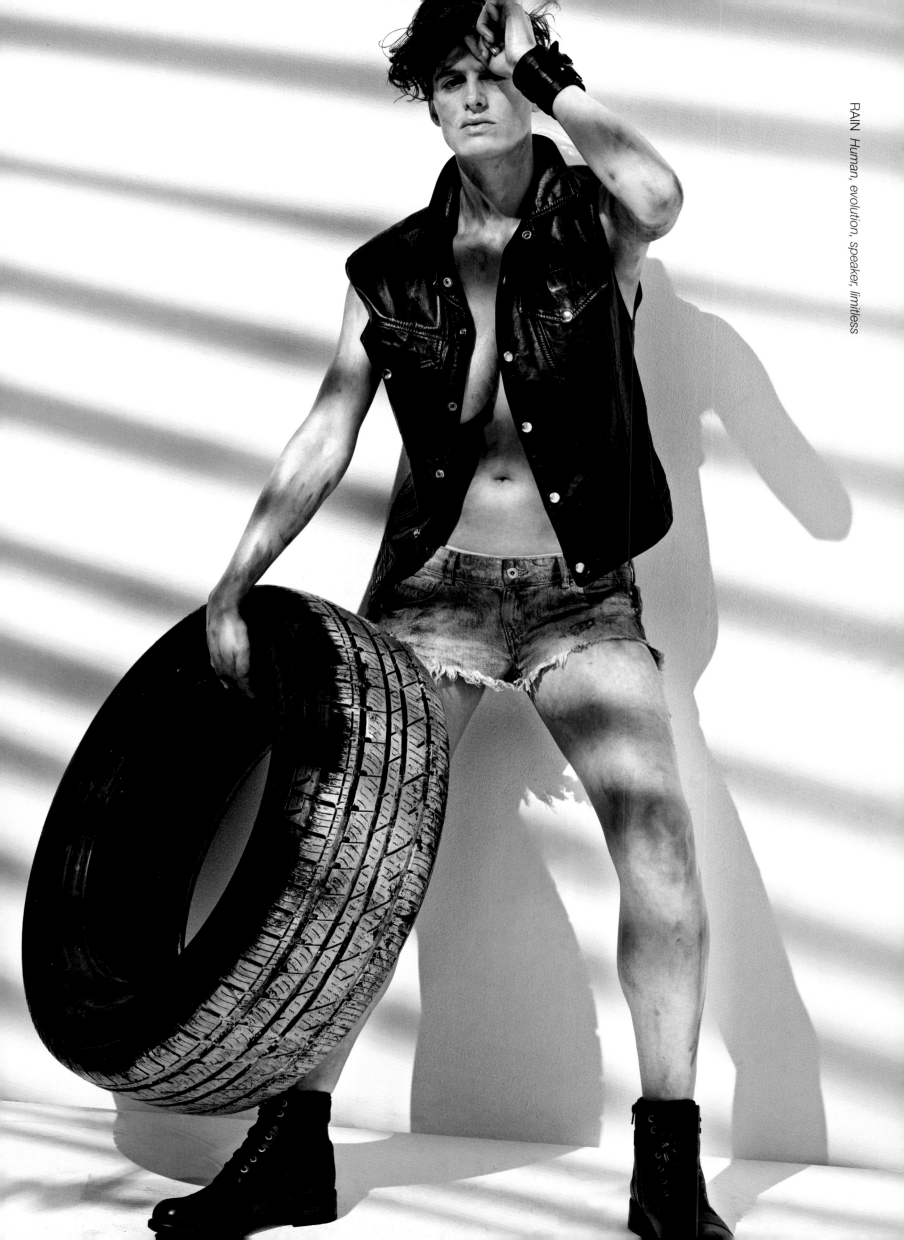

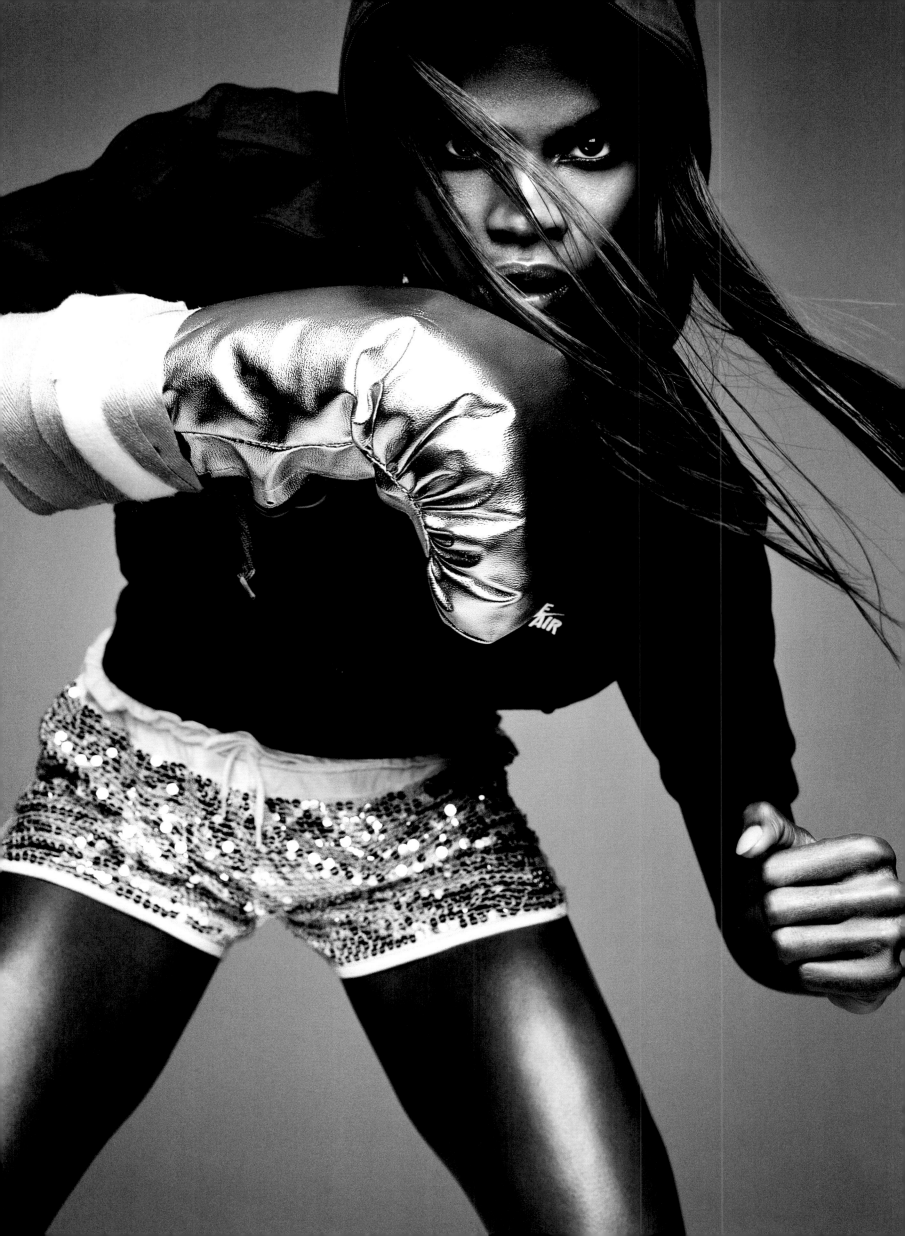

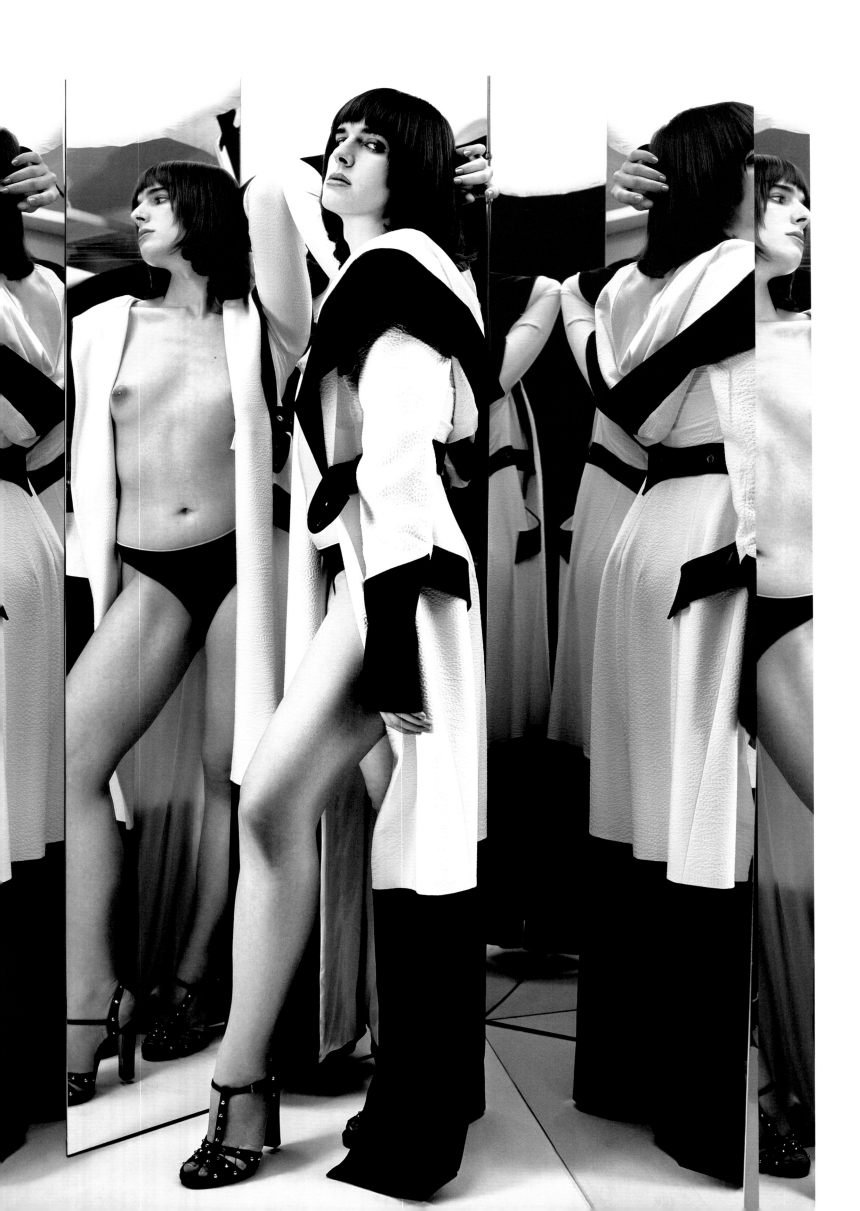

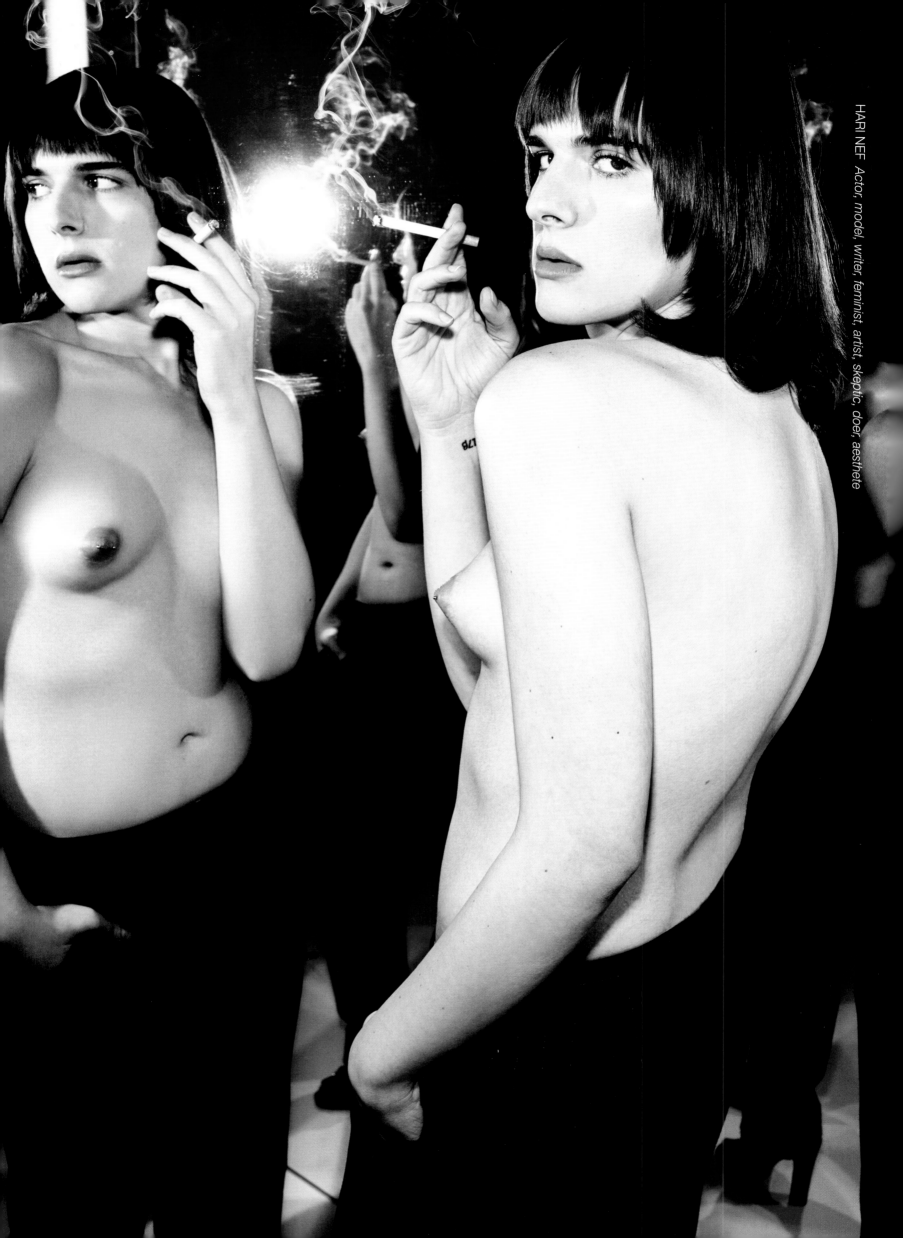

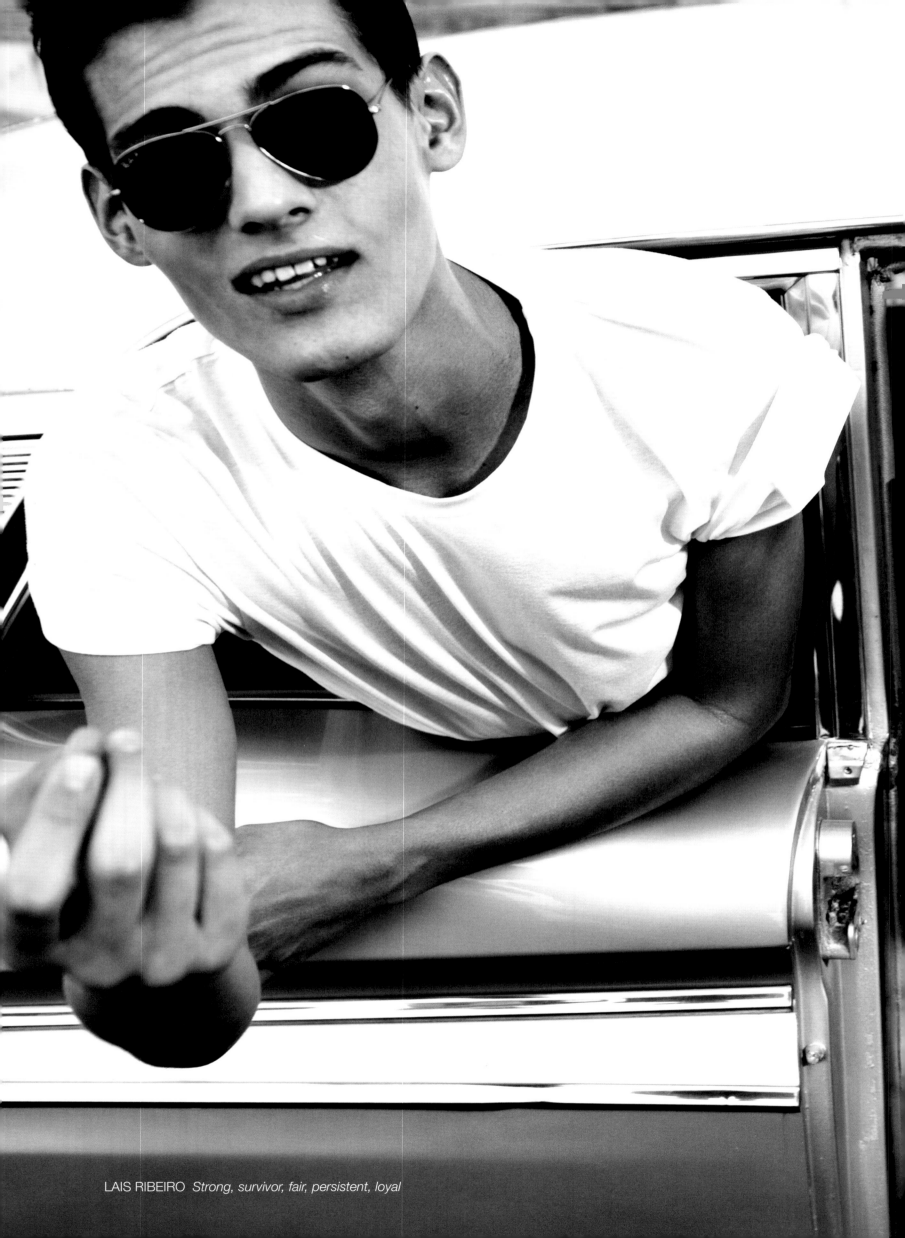

LAIS RIBEIRO *Strong, survivor, fair, persistent, loyal*

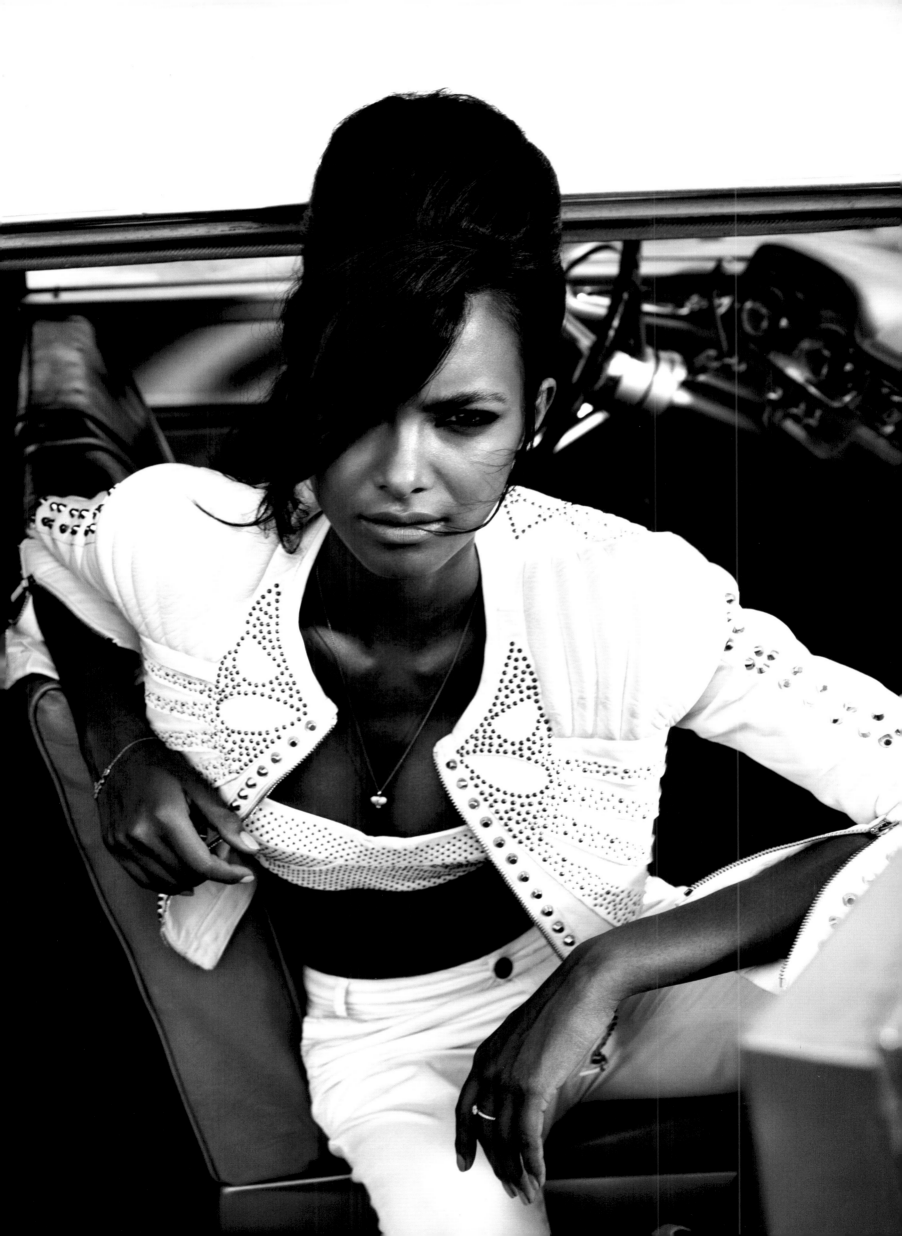

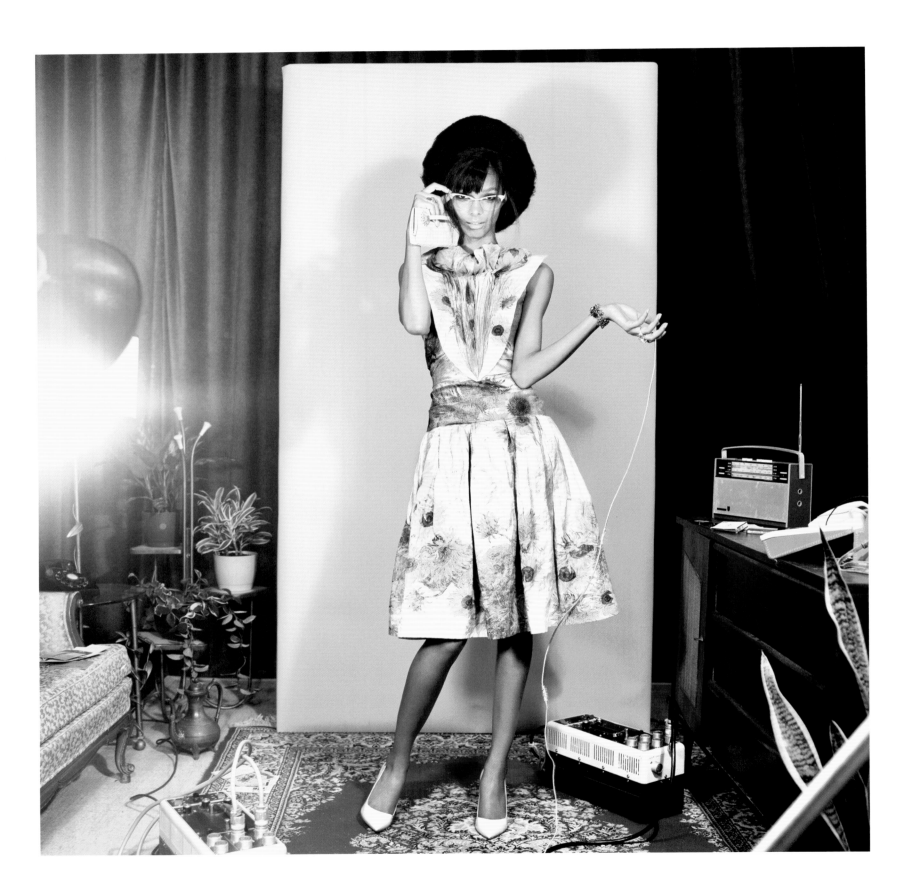

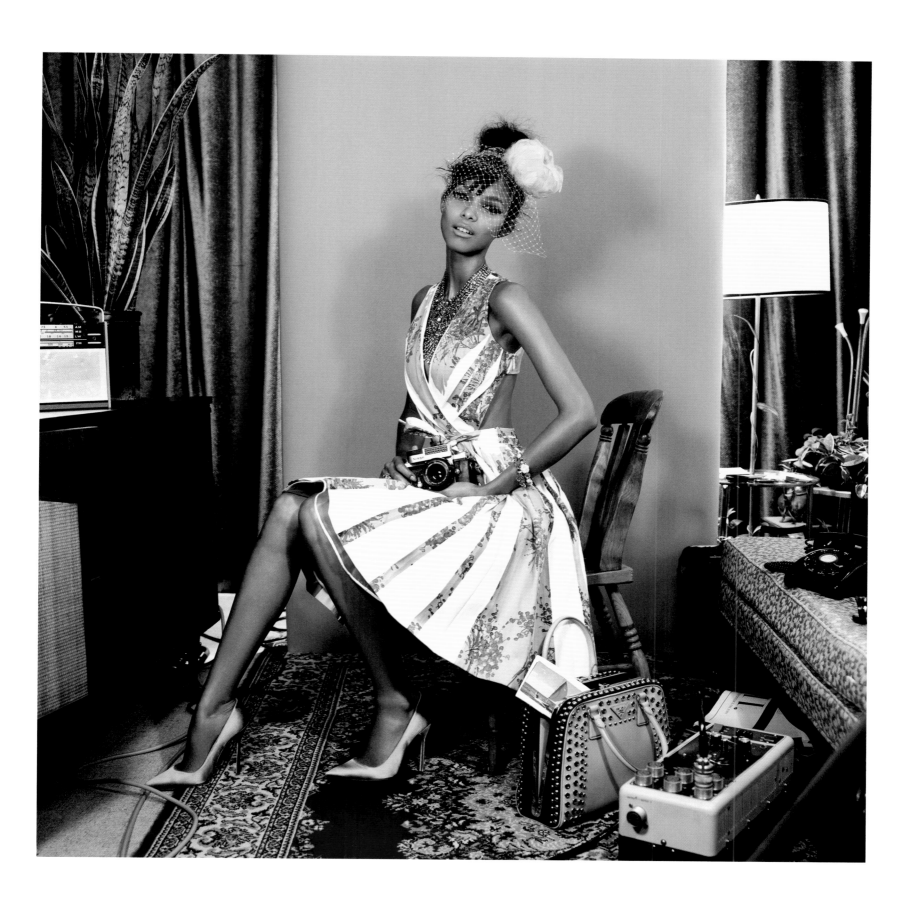

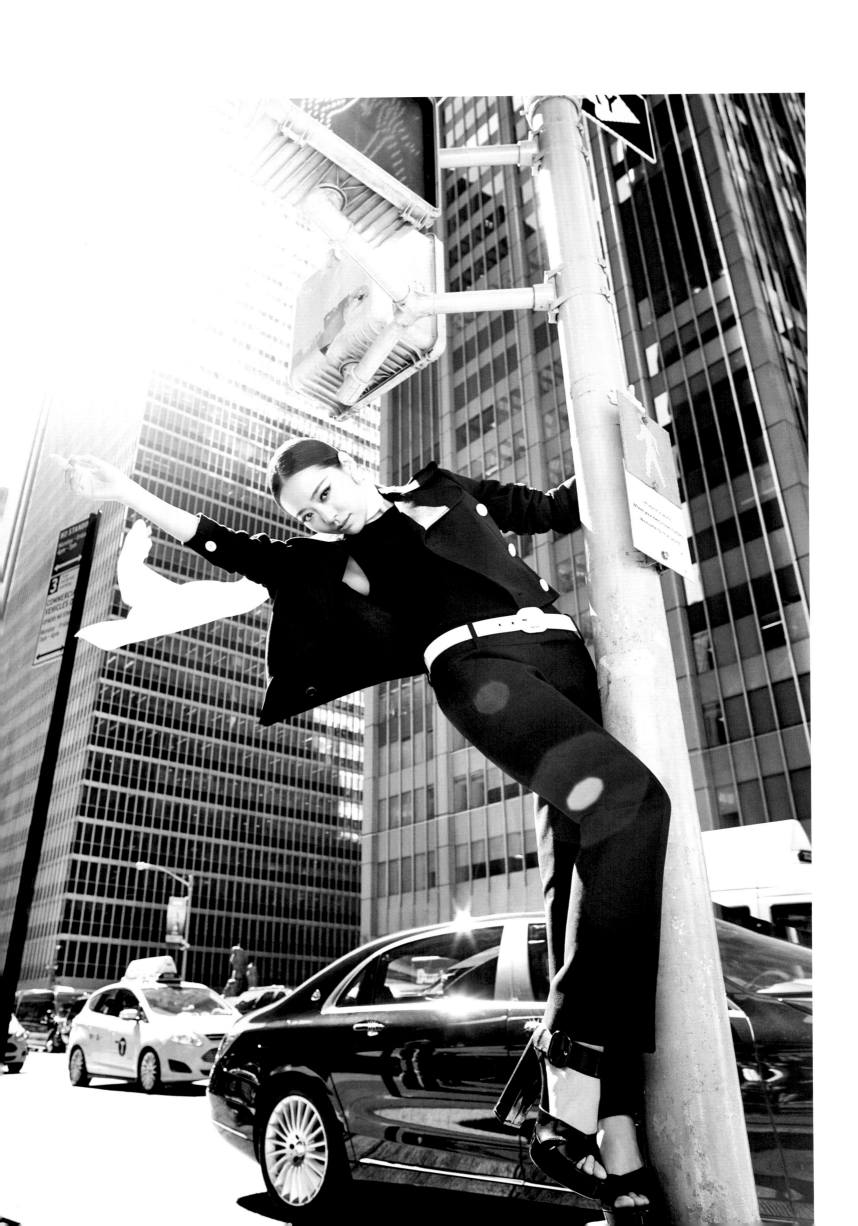

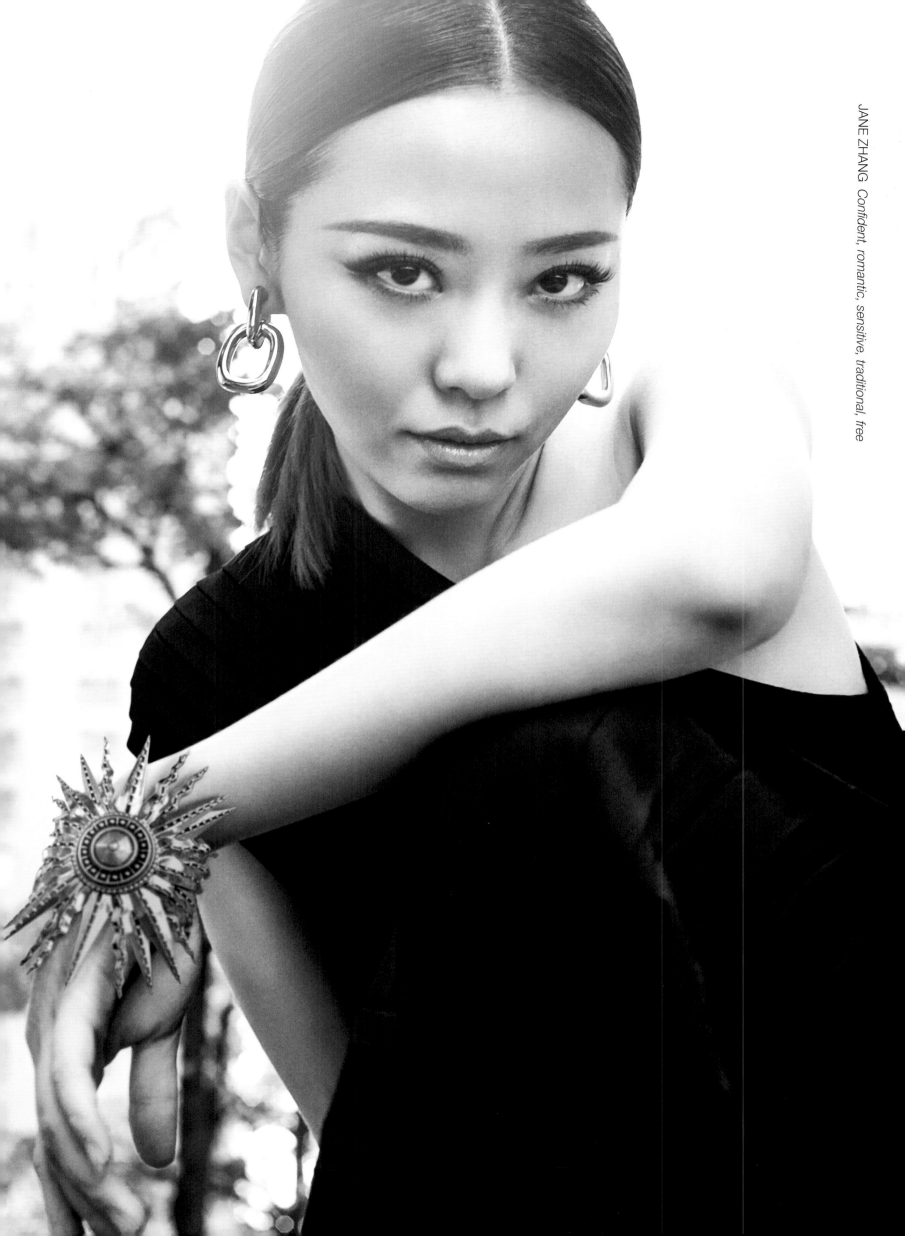

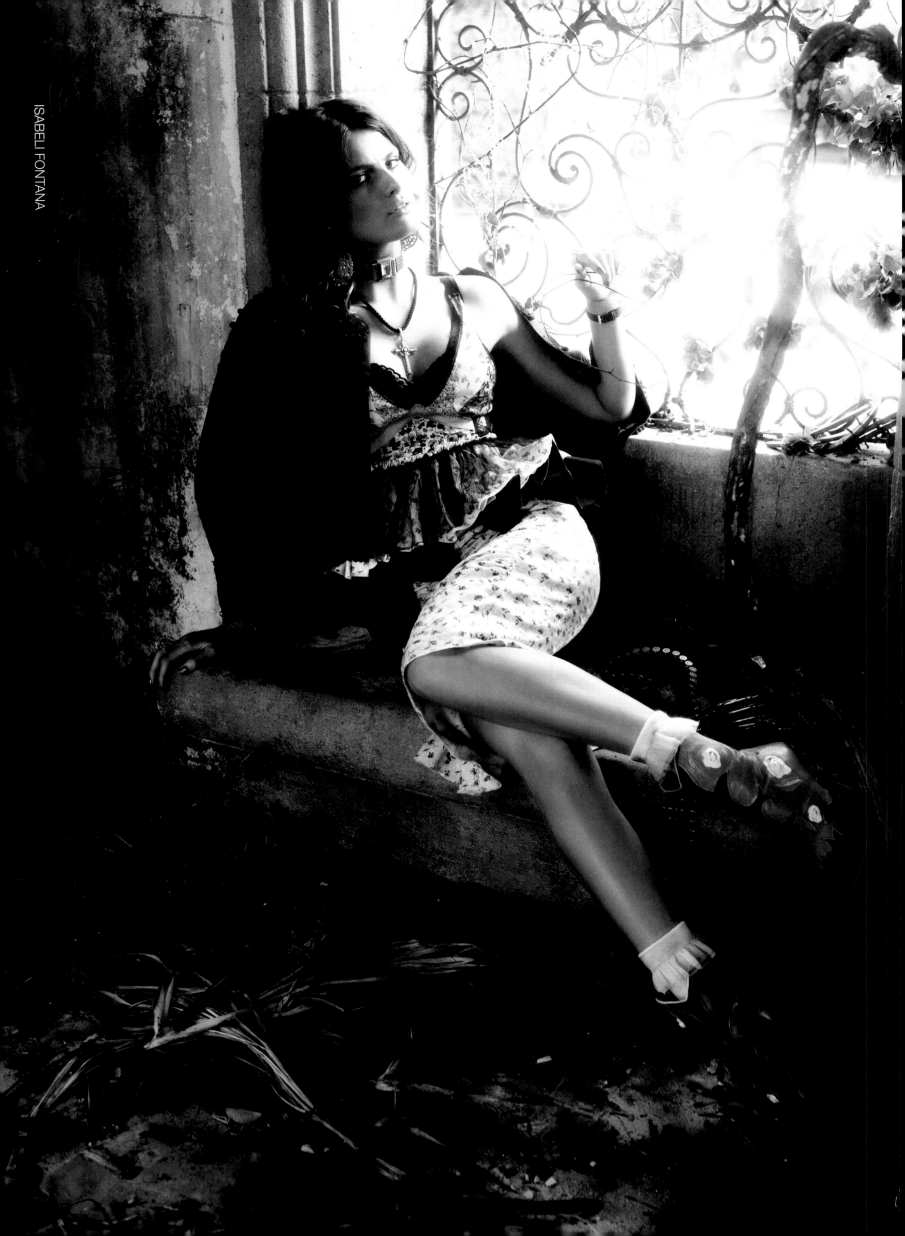

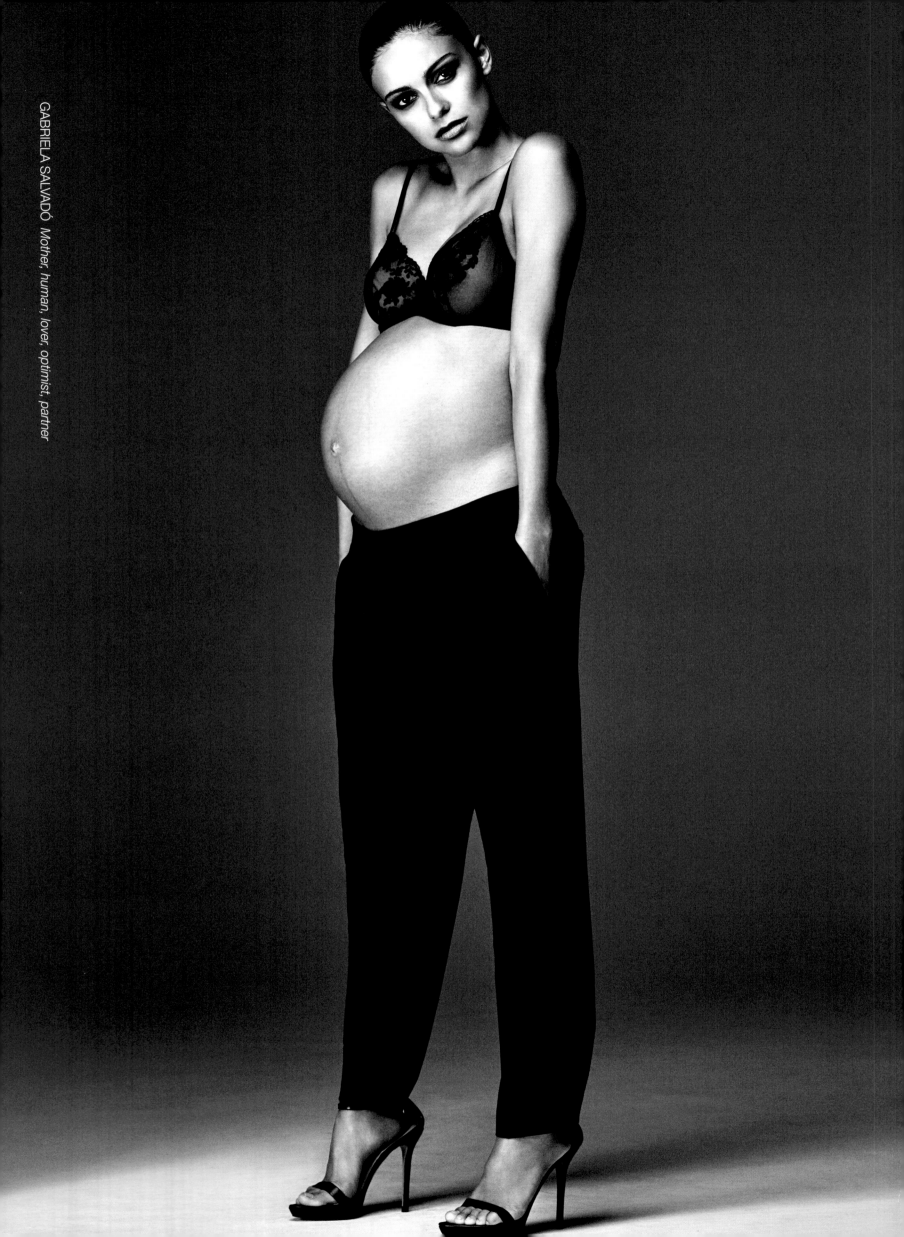

GABRIELA SALVADÓ *Mother, human, lover, optimist, partner*

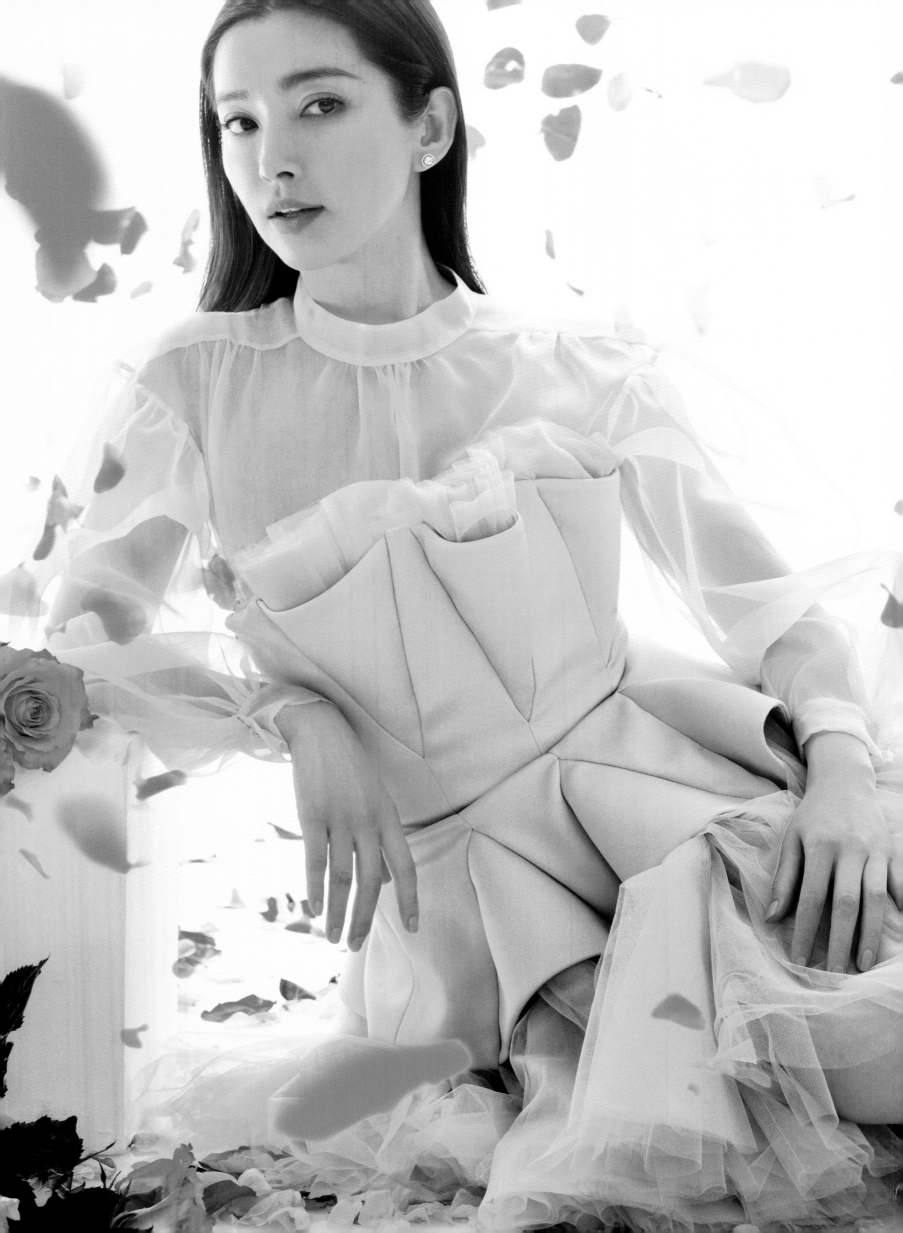

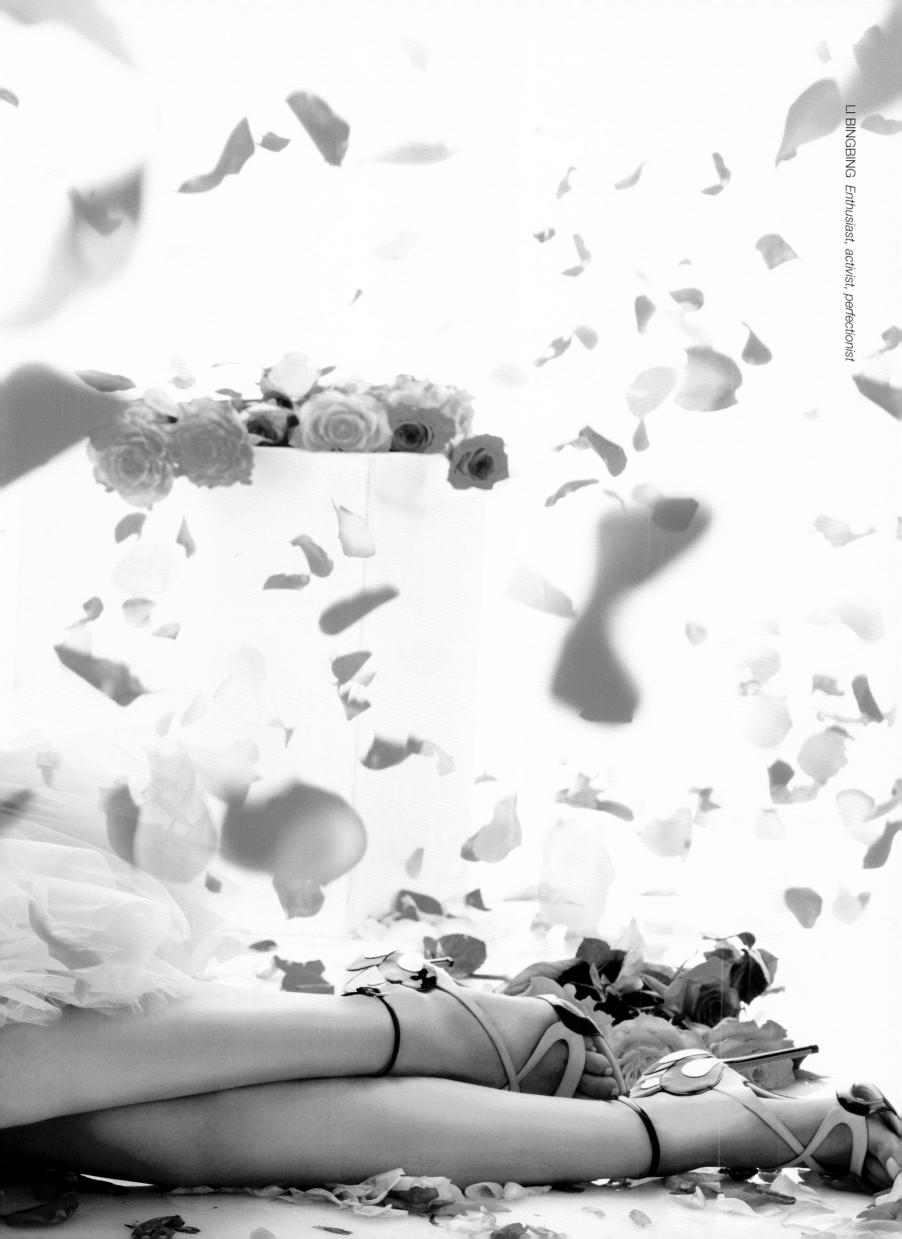

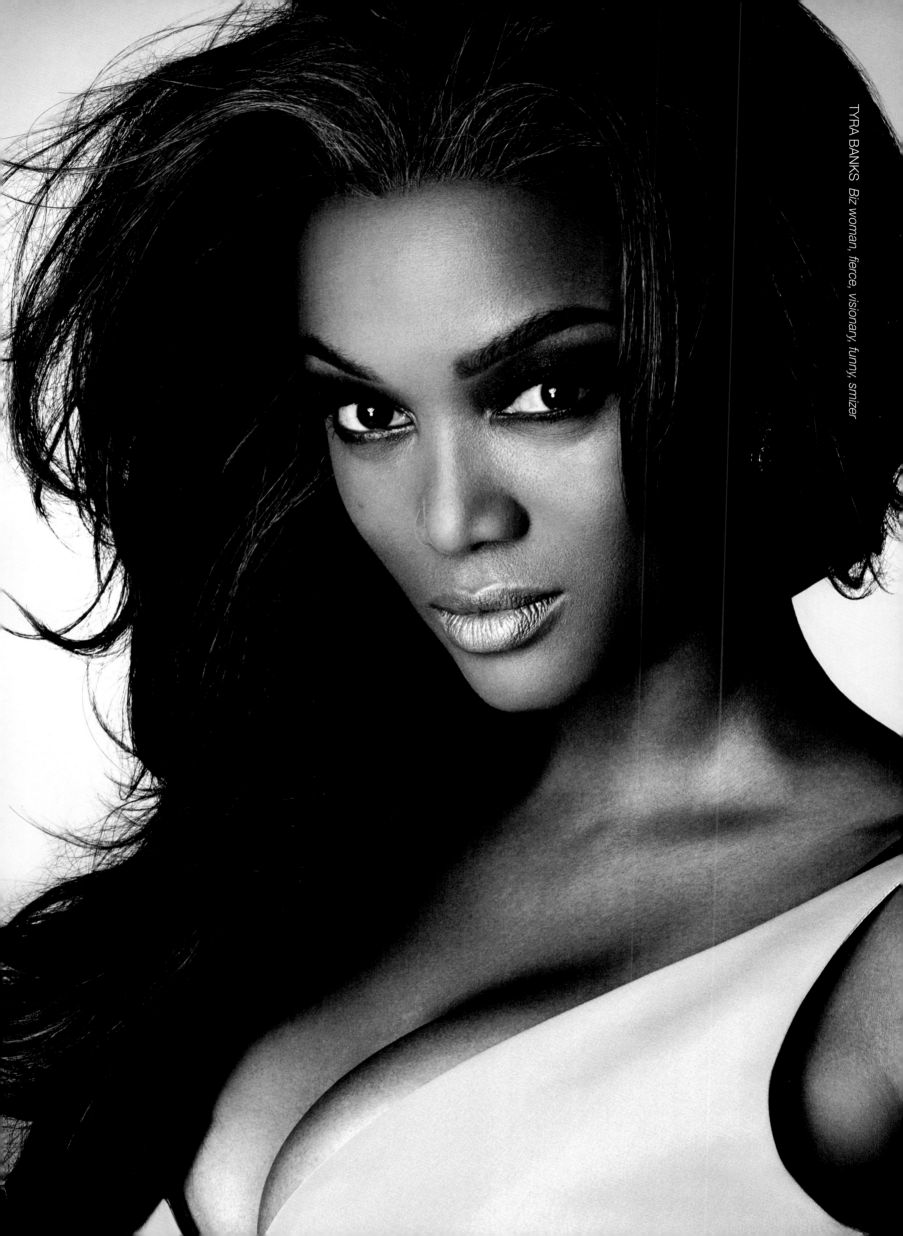

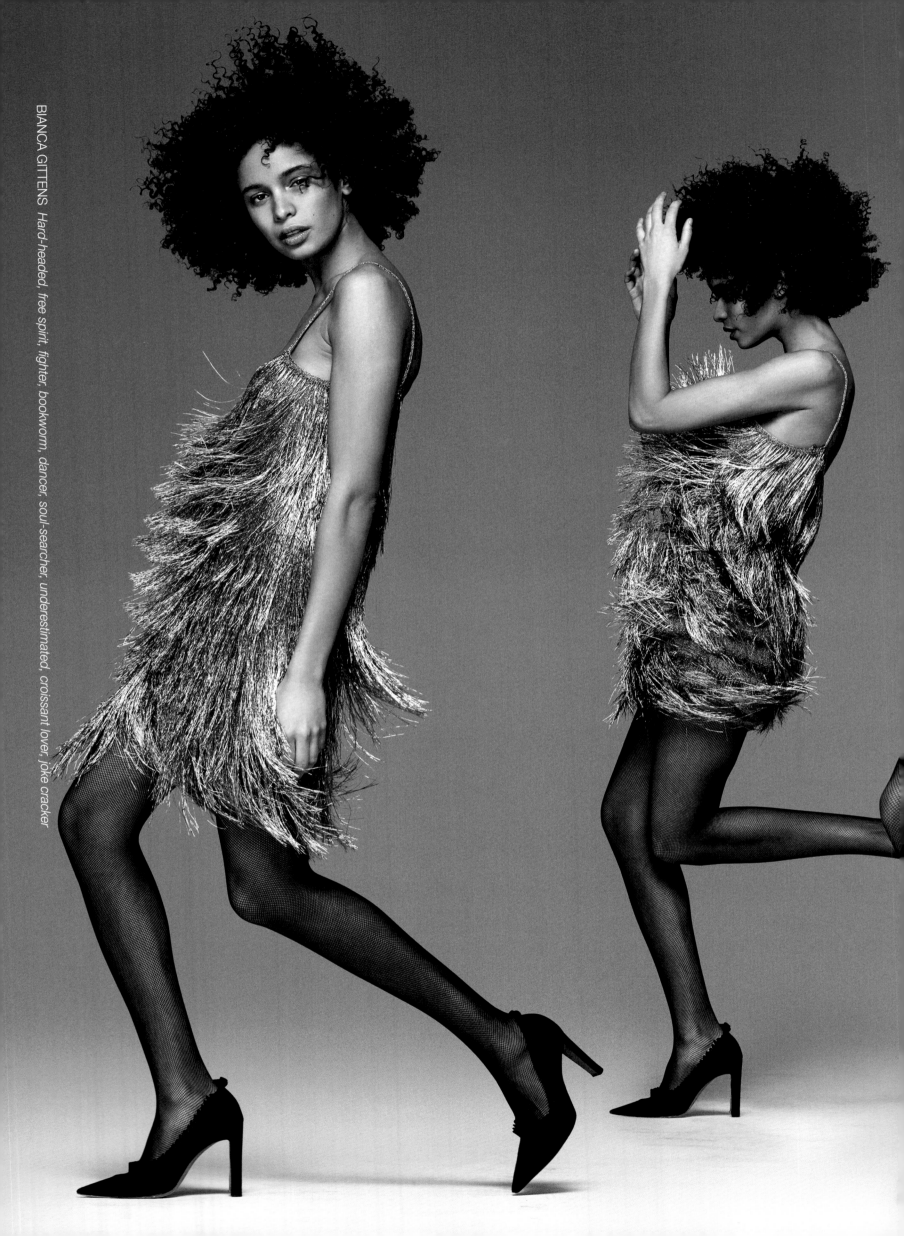

BIANCA GITTENS *Hard-headed, free spirit, fighter, bookworm, dancer, soul-searcher, underestimated, croissant lover, joke cracker*

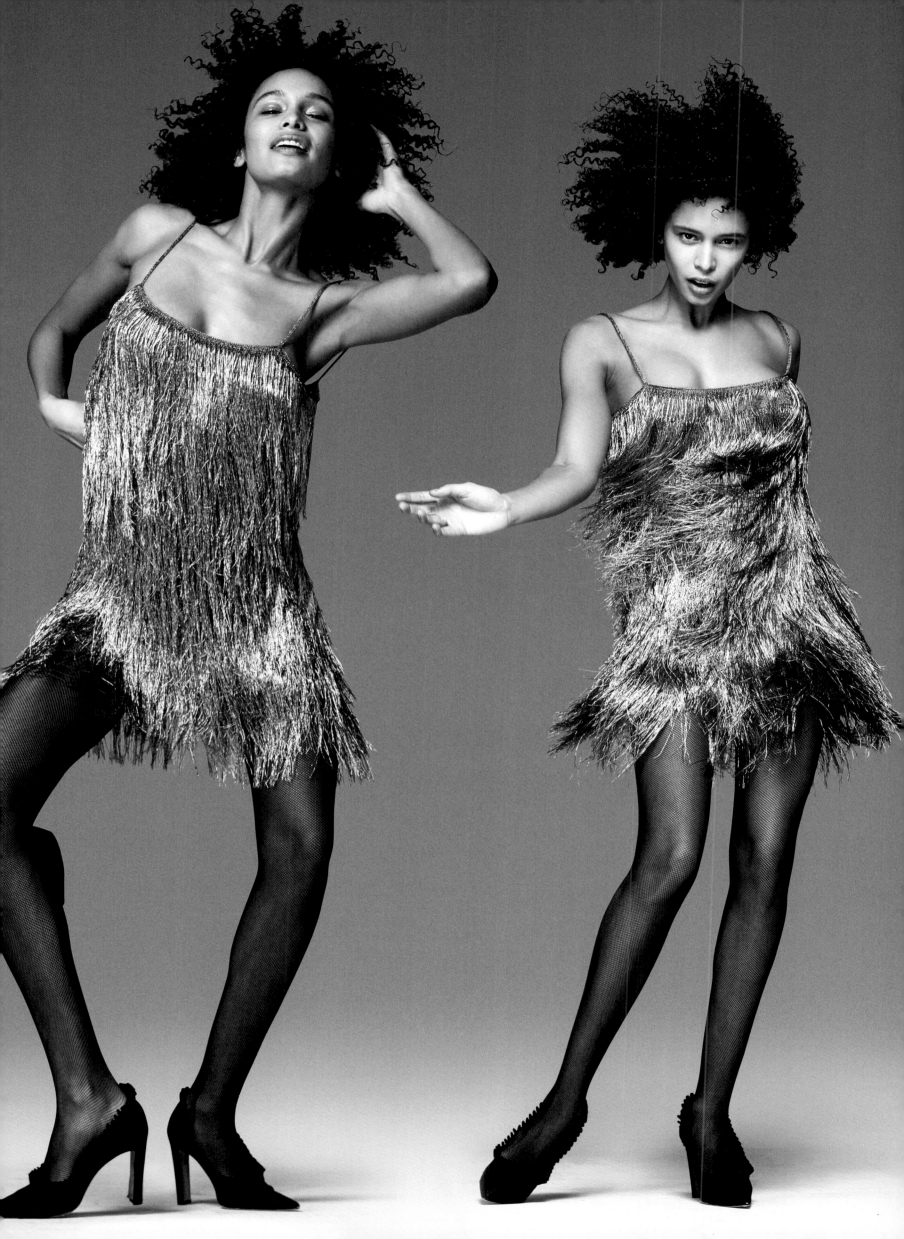

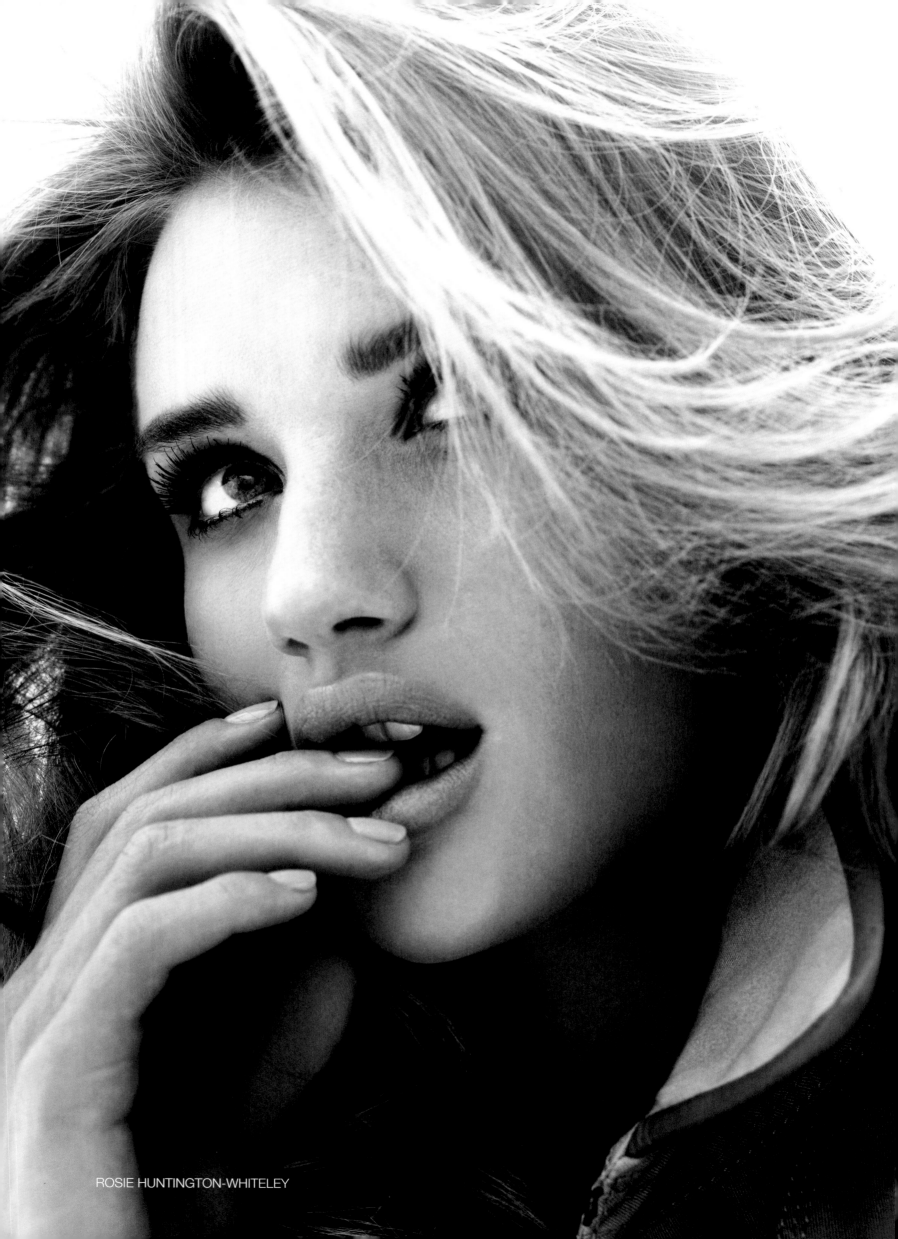

ROSIE HUNTINGTON-WHITELEY

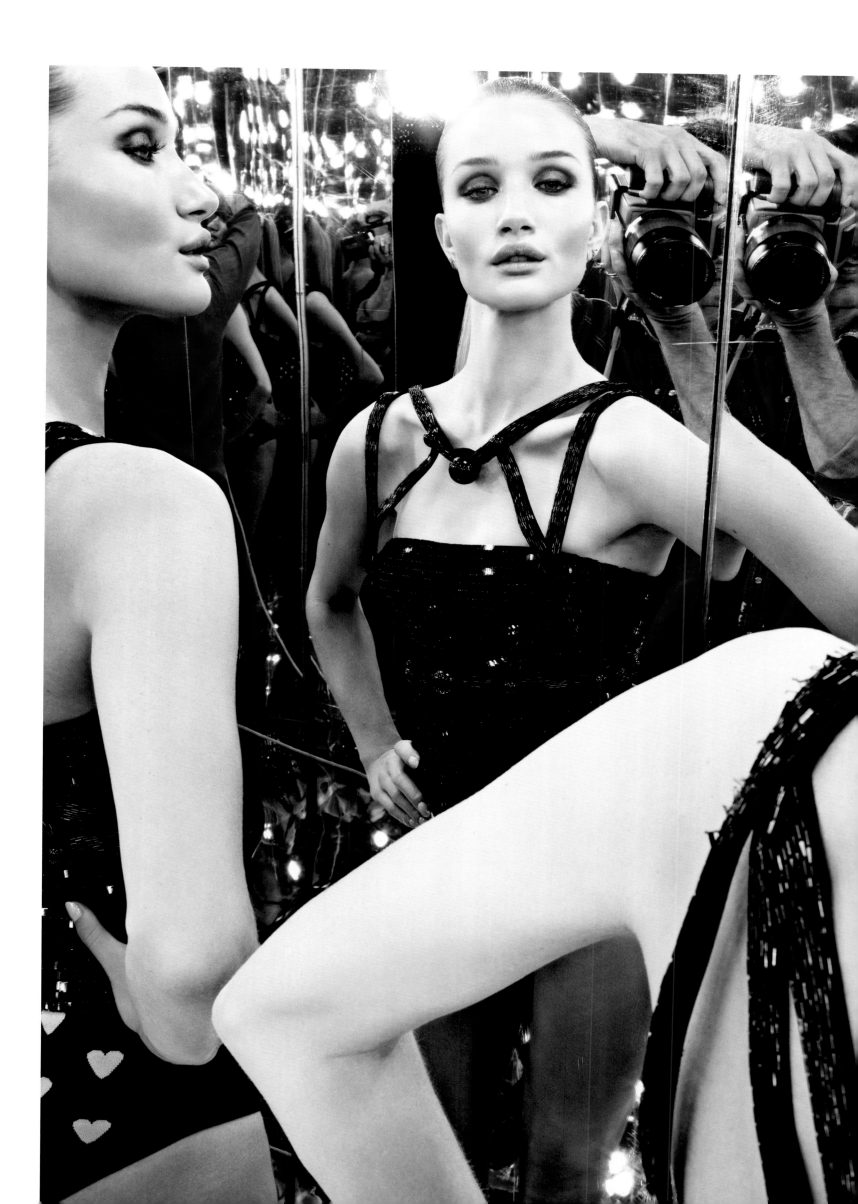

POOJA MOR *Funny, gorgeous (lol), actually it doesn't matter how you label me, lovable—need lots of love*

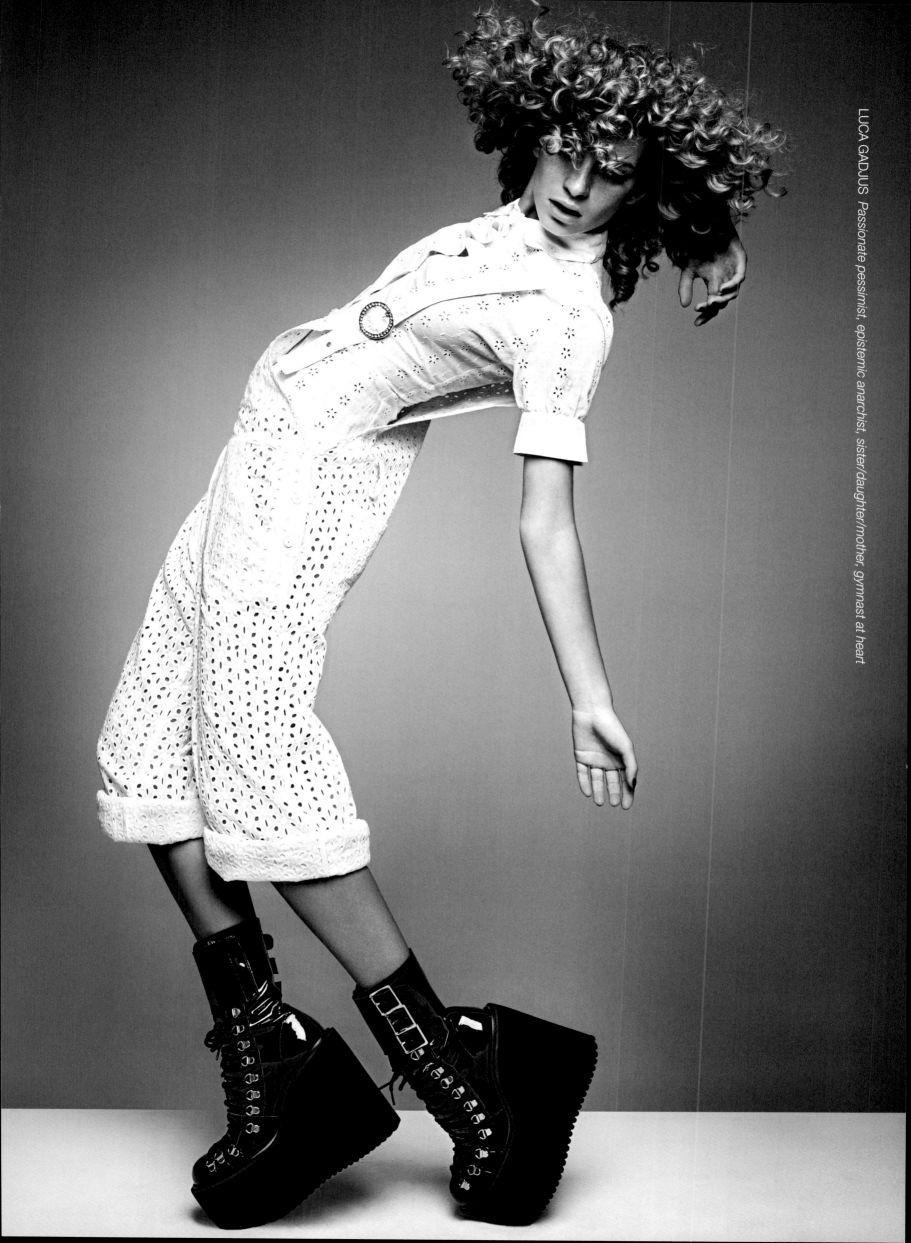

LUCA GADJUS *Passionate pessimist, epistemic anarchist, sister/daughter/mother, gymnast at heart*

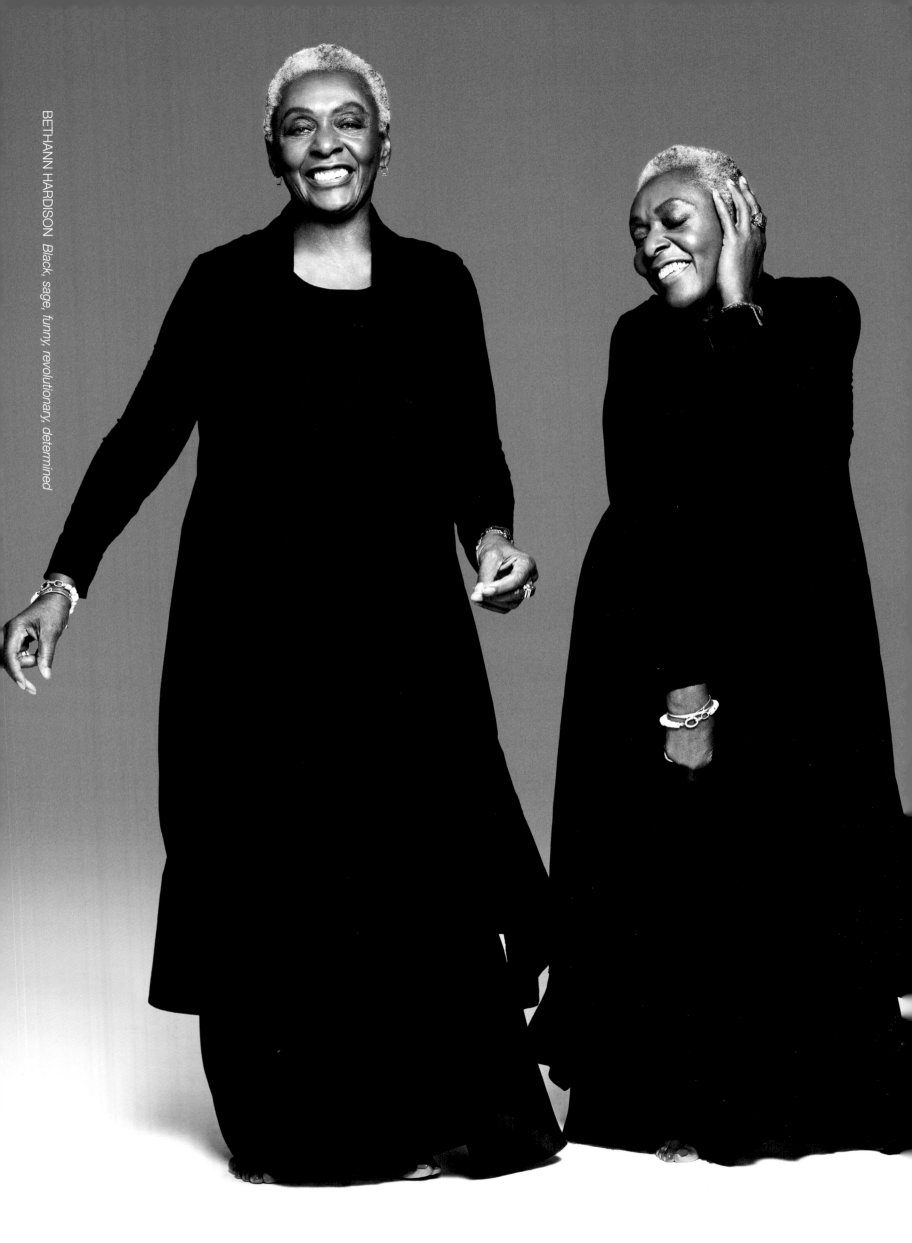

BETHANN HARDISON *Black, sage, funny, revolutionary, determined*

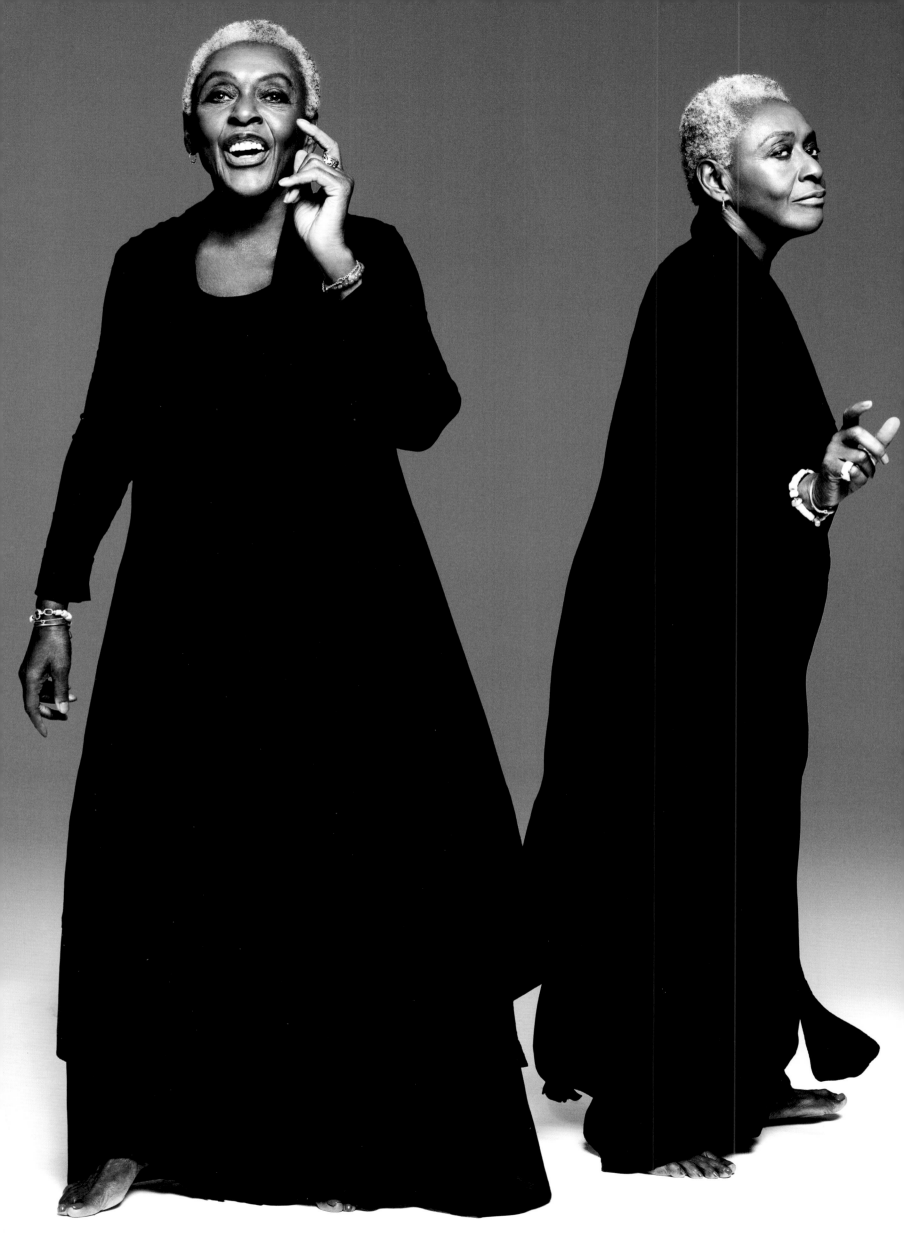

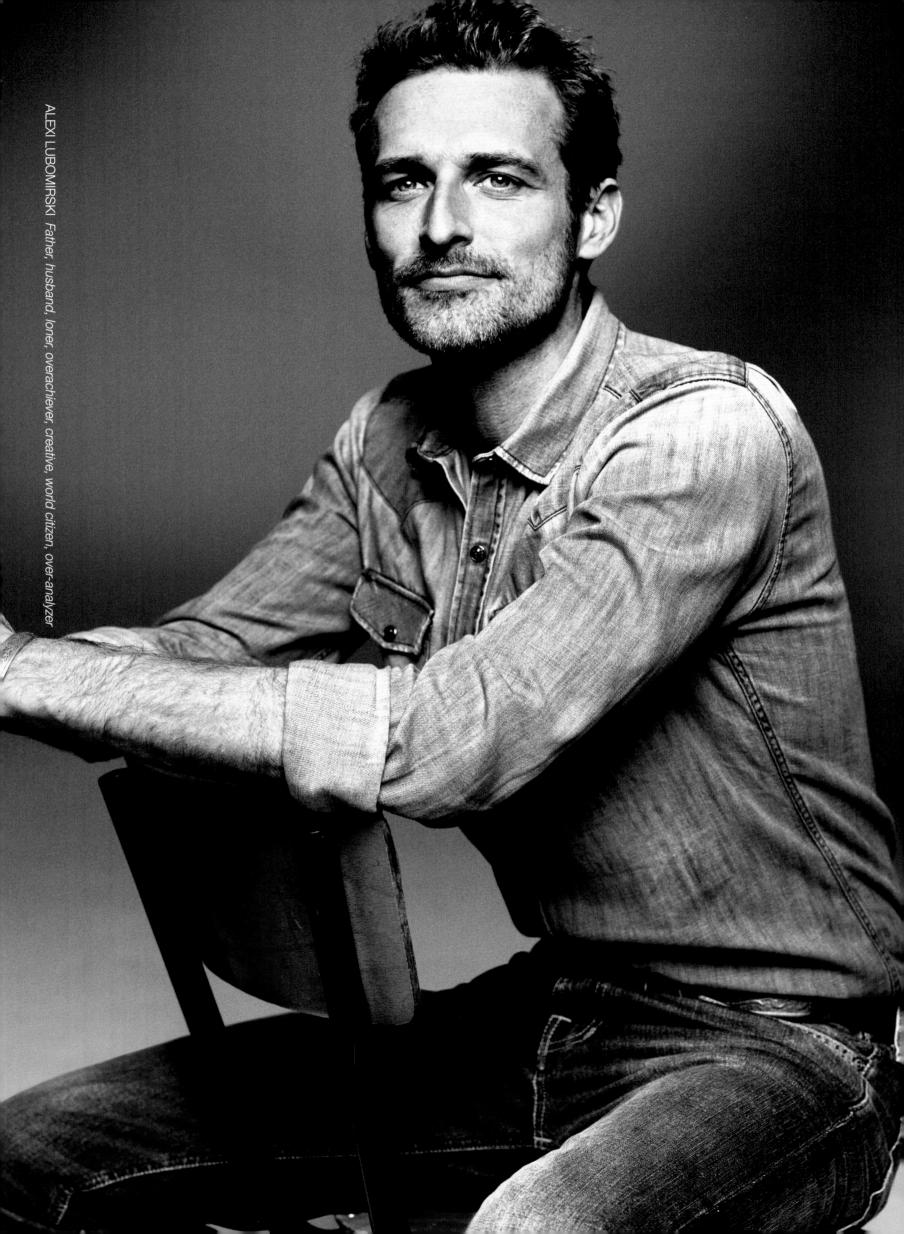

ALEXI LUBOMIRSKI *Father, husband, loner, overachiever, creative, world citizen, over-analyzer*

BIOGRAPHY

Alexi Lubomirski was born in England to a Peruvian-English mother and a Polish-French father. At the age of eight, he moved to Botswana with his mother and English stepfather. His stepfather gave him his first camera at the age of eleven. He developed a serious interest in photography while traveling in Peru during a gap year at college. His interest later shifted from social commentary to narrative-based fashion photography when he was studying for his degree at the University of Brighton in the UK.

Introduced to Mario Testino while making the rounds in London with his university portfolio, Lubomirski soon joined him in Paris as his assistant. Toward the end of his four years with Testino, Katie Grand hand-picked him to start shooting for the iconic *FACE* magazine and subsequently *Harper's Bazaar* US.

Since then, Lubomirski has become an established name within the fashion industry with an impressive client list, shooting for such publications as *Harper's Bazaar* US, *Harper's Bazaar* UK, *Vogue* Germany, *Vogue* Russia, *Vogue* Spain, *Vogue* Korea, *Vogue* China, *Vogue* Australia, *Vogue* Nippon, *Vogue* Mexico, *Elle* France, *Elle* US, *Men's Vogue* China, *Numèro* Tokyo, *W* Korea, *GQ* USA, *GQ* UK, and *Allure*.

He has also become a firm favorite with celebrities and has shot cover stars such as Beyoncé Knowles, Charlize Theron, Gwyneth Paltrow, Natalie Portman, Jennifer Lopez, Selma Hayek, Katy Perry, Sarah Jessica Parker, Jennifer Aniston, Julia Roberts, Nicole Kidman, and Scarlett Johansson, among others.

In 2008, Lubomirski had his first exhibition, *TRANSIT*, at Milk Gallery in New York, a mixed-media commentary on television culture comprised of preconceived film stills.

In 2014, he published his first photography book, *Decade*, a collection of his celebrity and fashion work from 2003–13. Also in 2014, Lubomirski wrote and published *Princely Advice for a Happy Life*, a book written for his two sons that has been translated into six languages and has raised thousands of dollars for the charity Concern Worldwide, to which all the proceeds from the book are donated.

Lubomirski currently lives in New York with his wife and two sons.

CONCERN WORLDWIDE

All proceeds from this book will be donated to Concern Worldwide, a non-governmental, international, humanitarian organization dedicated to the reduction of suffering and working towards the ultimate elimination of extreme poverty in the world's poorest countries.

Since its foundation in 1968, Concern Worldwide, through its work in emergencies and long-term development, has saved countless lives, relieved suffering, and provided opportunities for a better standard of living for millions of people. It works primarily in the countries ranked in the bottom forty of the United Nations' Human Development Report. Concern Worldwide implements emergency response programs as well as long-term development programs in the areas of livelihoods, health, HIV & AIDS, and education.

www.concernworldwide.org

ACKNOWLEDGMENTS

I humbly thank all the hair and makeup teams, stylists, producers, publicists, photography agents, assistants, set designers, retouchers, manicurists, interns, photographic studios, model agencies, publicists, actors, musicians, and models for lending their talents to each and every shoot. There are too many names to mention!

Special thanks to: Giada Lubomirski, John and Pamela Mainwaring, Ladislas Lubomirski, Massimiliano Di Battista, David Souffan and Lancôme, Joan Cargill, Felix De N'Yeurt, Savanna Widell, Gloria Maria Cappelletti, Freddie Leiba, Anita Bitton, Calvin Wilson, Nathalie Akiya, Kranky Produktions, Maury DiMauro, Christiane Arp, Angelica Cheung, Glenda Bailey, Katie Grand, Belen Antolin, Justine Picardie, Huw Gwyther, Grace Cobb, Paul Cavaco, Robbie Meyers, Cynthia Leive, Julius Poole, Dayna Carney, Curt Weber, Tyron Machhausen, Ben Skervin, Cash Lawless, Rose Marie Swift, Maud Laceppe, Mar y Soul, Chap, Mazdack Rassi and Milk Studios, Gloss Studio, Magnus Andersson, Raja Sethuraman, Tim Sexton, Paul Foley, Anne du Boucheron, Nick Mainwaring, David Livingston, Emily Ullrich, Max Hoell, Stephan Alessi, Ben Rosser, Marian Sell, Alex Galan, Andrea Albertini, Amy Wilkins, Takaaki Matsumoto, and Lupita Nyong'o.

Alexi Lubomirski: Diverse Beauty

Published by Damiani srl
www.damianieditore.com
info@damianieditore.com

Lupita Nyong'o (front cover, back cover, pp. 6, 10–13) shot exclusively for and association with Lancôme
Isabella Rossellini (pp. 16–17) shot exclusively for Lancôme
Hanaa Ben Abdesslem (pp. 75–77) shot exclusively for Lancôme

Design: Takaaki Matsumoto, Matsumoto Incorporated, New York
Editor and Production Manager: Amy Wilkins, Matsumoto Incorporated, New York
Color separations by Gloss Studio, New York
Printing and binding by Grafiche Damiani – Faenza Group, Italy

ISBN 978-88-6208-479-6